# WILLIAM WEGMAN
# BEING HUMAN

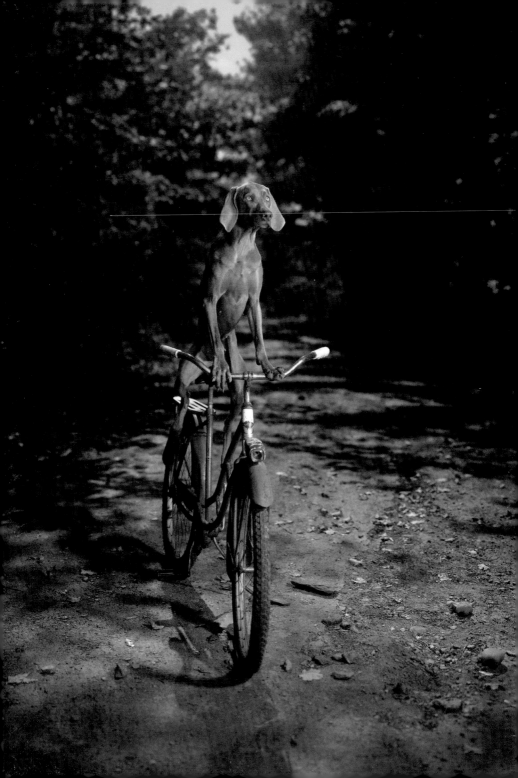

# WILLIAM WEGMAN
# BEING HUMAN

William A. Ewing

CHRONICLE BOOKS
SAN FRANCISCO

Page 2: Uphill, 1990

First published in the United States of America in 2017 by
Chronicle Books LLC.

First published in the United Kingdom in 2017 by
Thames & Hudson Ltd.

Library of Congress Cataloging-in-Publication Data available.

ISBN: 978-1-4521-6499-1

Manufactured in China

10 9 8 7 6 5 4 3 2 1

Chronicle books and gifts are available at special quantity
discounts to corporations, professional associations, literacy
programs, and other organizations. For details and discount
information, please contact our premiums department at
corporatesales@chroniclebooks.com or at 1-800-759-0190.

Chronicle Books LLC
680 Second Street
San Francisco, California 94107

www.chroniclebooks.com

# CONTENTS

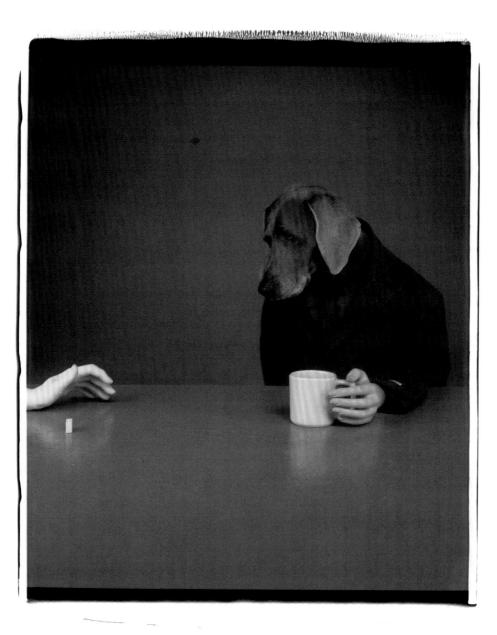

One Lump, 1999

# People like us / People we like

## William A. Ewing

"Our social personality is a
creation of the minds of others."

MARCEL PROUST

Who among visual literates isn't on familiar terms with William Wegman's famous collaborators—Man Ray, Fay Ray, their direct descendants and distant relatives? They're part of the family—his and ours. For years they've been posing good-naturedly for their portraits, presenting themselves as dignified and serious citizens, or hamming it up for a lark. Since the Weimaraner breed owes its existence, or at least its name, to the Grand Duke of Saxe-Weimar-Eisenach, its nobility of character can never be doubted. Perhaps it's the innate confidence that flows from being high-born that allows for such casual appropriation of the skin (and fur, scales, feathers, claws, beaks, antlers, etc.) of other animals, including furless and feckless Man. Still, the aristocratic Weimaraners aren't snobs or show-offs craving public adulation: they are happiest in the bosom of the family, with which they enjoy hunting, dining, strolling, racing, and so on, while guarding the home, and playing with the children of all ages. Some of those children are well over 70 and insist on bringing out the camera every time "their" Weimaraners come up with yet another seemingly wacky idea. Wegman's subjects take on many roles, don elaborate outfits, and strike fanciful poses, knowing their faithful photographer is always available when needed. Evidently they find him—and humans generally—wildly amusing, and never tire of parodying their supposed masters.

Still, I would not like to leave the impression that William Wegman's role is merely to snap the shutter once his sitters have dressed, positioned themselves, and given him the nod. He is listened to respectfully, and his ideas are often adopted. In fact, it is impossible to say which of the two parties (Wegman? Weimaraner?) came up with the idea for a particular set-up. Nor to know which one directed the action. It is best to think of the production as highly collaborative. Teamwork is and always has been a Weimaraner trait and, while

humans struggle with the concept, over the years this faithful photographer has learned to put his trust in it.

The reader might well then ask, "why is it only Wegman who signs the prints? Isn't this a little unfair, given the team effort?" In fact, the dogs are fine with it. The Weimaraners themselves feel no need to have their egos stroked, but they do understand that humans are very proprietorial, and they accept this vanity. Grace is another trait of the noble Weimaraner.

People cognizant of Wegman's stature in the art world may not be fully aware of the scope of his interests in photography, and it often comes as a surprise to see how over the years his work has dealt with so many subjects and genres. A comprehensive list includes: journalism and photojournalism (*Newsworthy*, 218–19); astronomy and gastronomy, sometimes in the same picture (*Gastro-astronomical*, 283); the theater and the opera (*Madame Butterfly*, 182–83; *Peter Grimes*, 310–11; *Curtain Call*, 293); fashion, from casual elegance (*Loosely On*, 71), through idiosyncratic flair (*Dressed to Boots*, 254; *Platform Shoes*, 268), to haute couture—indeed, the reader may well ask: have André Courrèges' simple, modern geometric designs ever been worn so artfully (*Courrèges*, 250)?

Still other subjects include political philosophy (*Trotsky*, 201; *Apolitical*, 263); gardens, landscapes, and seascapes (*Time Garden*, 227; *Breakers*, 232–33); Wegman even gets far from civilization on occasion (*Iceland*, 236–37). Sports and sportsmen are also a constant motif (*Metro*, 132; *Rocket*, 133)—and here we must acknowledge that his wrestling pictures are second to none (*Wilson I*, 285). Even the current preoccupation with big data provides subject matter for Wegman's investigations (*Sheet of Information*, 70). His gritty social documentary work is also somewhat unexpected (*Working I*, *Working II*, 320–21; *Night Man*, 307); few of his admirers are aware that in pursuit of in-depth investigative reporting he has been known to follow forest workers and sportsmen (*Coffee Break*, 312; *Ardent Angler*, 298; *Oarsman*, 313). There is also a deep strand of metaphysical thought running through Wegman's work (*Perhaps Religious*, 61; *Freudian*, 164–65; *From the Spirit World*, 55). Nor does he shy away from difficult existential questions (*The Dark Side*, 208).

Much in Wegman's oeuvre deals with issues of interest to art and artists (*Paint Stand*, 281; *Palette*, 162; *Like in the Painting*, 322). Cubism and other early 20th-century art forms are constant motifs; Cubism predominates (*Cube Adjustment*, 102), but Dada (*Nevadada*, 230–31), Surrealism (*The Deal with the Surreal*, 235), and Constructivism also have a certain hold on the artist's imagination—he will occasionally even photograph a Constructivist in action (*Constructivism*, 93). Sculpture (*Floor Piece*, 222; *Evolution of a Bottle in Space V*, 245), color field painting (*Red to Yellow*, 202–203), and conceptual art (*Left Right Black White*, 156–57) also count among Wegman's art concerns. Fernand Léger is given special tribute (*Léger*, 192) and worth noting as well are the tongue-in-cheek references to Henri Rousseau (*Le Douanier Fay*, 335) and Jasper Johns (*Target Animal*, 37). Earlier art influences include the Renaissance, most notably the

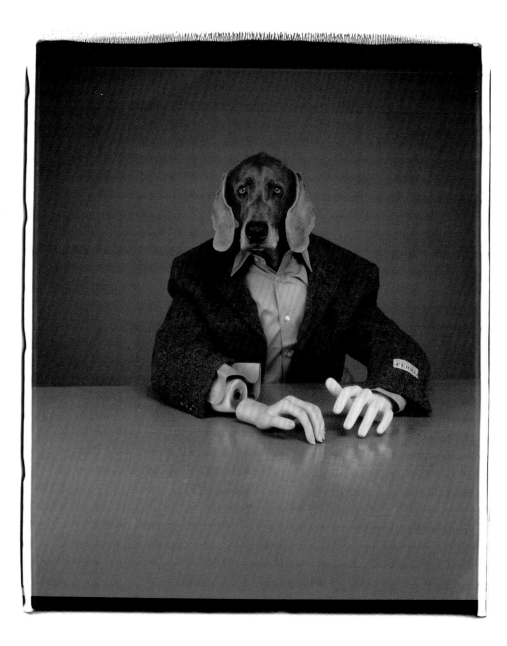

Handy, 1999

fantasist Giuseppe Arcimboldo, with echoes of the painter's famous portrait of Emperor Rudolf II as Vertumnus, the Roman God of plant life, growth, and the change of seasons (*Harvest*, 45).

The mid-20th-century movement known as American Color Field Painting also needs to be acknowledged by any observant Wegman critic. In this approach, as all diligent art students know, color becomes the chief element and focus of the picture: the practice is characterized primarily by large fields of flat, solid color spread across the canvas, creating areas of unbroken surface and a flat picture plane. The movement places less emphasis on gesture, brushstrokes, and action characteristic of Abstract Expressionism. Kenneth Noland, Clyfford Still, and Mark Rothko are among Color Field's best-known practitioners. It was the latter who famously said, "A picture lives by companionship," a philosophy Wegman's sitters adhere to very strongly. They love to run riot in the color fields (*Red to Yellow*, 202–203).

Drawing, too, is an interest Wegman shares with his collaborators, as when he records them working out interesting forms, sometimes formally geometric (*The Line About*, 273; *Vertical Lines*, 248; *Horizontal Lines*, 249)—might they have been influenced here by Bridget Riley? And at other times he works freely and spontaneously (*Cursive Display*, 191). The latter calls to mind Paul Klee's famous phrase, "taking a line for a walk." Going for a walk is something Wegman's subjects know a great deal about and find deeply inspiring.

Still, I venture to propose that the most touching single picture relating to the long-running homage to art and artists is the portrait of a woman painter (the photographer has respected her wish to remain anonymous) caught in an unguarded moment, musing over her final touch (*Artist Contemplating*, 302).

Writing in 1982 about Wegman's principal collaborator and muse, who had already become a celebrity on television talk shows, critic Laurence Wieder wondered, "Does Man Ray understand his place in art?" Implicit in the question was the suggestion that, yes, indeed he does—but he is far too modest to acknowledge it. Talking generally about Wegman's models, Ingrid Sischy has underlined the modesty of Man Ray and his colleagues, and quotes Wegman as saying Man Ray and his partners "don't need first-class air tickets or fancy hotels." Describing how they show up at the studio for their fashion work, Sischy reports that they "explode on arrival, and say 'hi' to everyone." Unlike many successful models who suffer from a prima-donna syndrome, Wegman's models remain professional and respectful of their studio workers, and have never been known to snap at anyone, or ever to utter a harsh word, even when an overly demanding stylist or fashion editor is barking orders. Having worked with Wegman and his models in Milan some years ago, fashion editor Carla Sozzani praises the discipline of the team, noting how the photographer takes orders from his models without complaint, and "will always do what he's told."

However, art is not the only preoccupation of the photographer and his collaborators. The sciences also figure among their interests. At the top of this list is a fascination with zoology, and this extends to paleontology (*Dino Ray*, 116). Bats, cats, swans, mice,

frogs, elephants, caterpillars…even dogs feature occasionally in this bestiary (*Early Dog*, 64)! (On this subject, the reader will discover from the index that only three or four works in this book actually concern dogs—the photographer is obviously far more attracted to other kinds of animals, human beings included.) And while fauna is privileged over flora in Wegman's oeuvre, botanical forms also clearly intrigue his sitters (*Pumpkin*, 40; *Harvest* 45).

The above observation about the subject of dogs deserves a short elaboration. In his scholarly overview, *The Pawprints of History*, Stanley Coren asks, "How many times has the fate of a man, or even a nation, hung from the collar of a dog?" The answer Coren gives is many, "Had it not been for dogs, the last imperial house of China might not have fallen; Columbus's first attempts at colonizing the Americas might not have been so successful; some of Wagner's operas might never have been written; the American Revolution might not have been fought; the freeing of the American slaves might have been delayed for decades; the way that we educate deaf children might be different; and great and well-loved books like *Ivanhoe* might never have been written…"

And, yet, do the countless editions of *Ivanhoe* ever give credit to the canine side of the equation? Do statues of Columbus ever include his own intrepid friend? Do the military historians ever talk about a Weimaraner at Waterloo? Sadly, no. History is claimed unfairly as wholly human. Today, canines are mostly thought of merely as our "best friends," and their distinguished roles as actors on the historical stage have been overlooked, purposely or simply irresponsibly. As the eminent Professor Shaler acknowledged in 1895, the dog has led us to take "the first steps on the path of culture, and lifted man out of his primitive selfishness." Indeed, even a single breed can lay claim to greatness, as Wegman has proven again and again with his partners. And so it stands to reason that while the human being—or, put more abstractly, being human—is the principal concern of this album, dogs do make their occasional appearance in it (*Dog as Dog*, 35).

The Weimaraner, as we have noted, is very tolerant of human foibles, even if Wegman's particular foibles sometimes test their patience to the limit. The writer Cees Nooteboom has suggested that the modern zoo, if transformed, could help human beings come to terms with their animal nature: "Surely one zoo in the world should have the courage to draw the ultimate conclusion about our ancestry? A cage with Homo sapiens in all its varying forms, perhaps then we would understand ourselves better." But Nooteboom is cautiously prudent, observing that "the question, of course, is whether the other animals would approve of it." I would think the enlightened Weimaraners, at least, would welcome this idea.

We have seen how Wegman's interests and those of his sitters range far afield (literally and figuratively), and so their preoccupation with anatomy should come as no surprise. What is surprising, however, is the use of x-Rays to show the inner structure and workings of the body (*Skelly*, 65). (These x-Rays should not be confused with the Man Rays and Fay Rays.) At the opposite end of the material spectrum, Wegman has also shown interest in the outer reaches of reason and logic, dealing with that intangible element known as spirit or soul (*Behold*, 256; *Being There*, 316). On a less high-minded and more material note,

Wegman's subjects show a great interest in home décor, and in particular exhibit a love for benches, sofas, stools, and chairs—possibly because they share with them a four-legged structure. Weimaraners appreciate both classical and modern forms, but admit to a particular predilection for High Modernism (*Eames Low*, 170).

However, the impressive panoply of interests aside, much of Wegman's collaborative work, though far from all of it, might be resumed under the venerable photographic traditions of the portrait and the nude. In both genres the photographer borrows from strategies and techniques with deep histories, finding models in 19th- and 20th-century practices. In the 2014 exhibition "Picturing Dogs, Seeing Ourselves," historian Ann-Janine Morey thought about "what it means to be human, and about how that meaning might shift across times and places." She notes how our fellow mammals "were for the first time pampered and shown as members of the family in studio portrait art." The portraits were "…meant to look proper and often posed on ornate chairs." Indeed, occasionally we do find Wegman setting up the portrait studio in high Victorian style, complete with heavy drapes—if only for some of his more aristocratic subjects (*Evil Empress*, 161). Mostly, as we have acknowledged with his interest in furniture, he is drawn to modernist motifs, with a particular interest in engineering conundrums (*Cantilever*, 155).

Wegman's portrait work sits comfortably in the tradition of such notable practitioners as Richard Avedon and Arnold Newman, but is still distinctively his own. Wegman's subjects are predominantly ordinary folk, mostly middle class, going about their daily lives as best they can, and sometimes taking a free moment to visit Wegman in his studio, sometimes allowing him to photograph them at work or at play. For the most part he likes to get in close (torso, head, and shoulders), and, even though his subjects are carefully posed, he likes to catch them in an unguarded instant, when something of the character or personality comes through. Like all good portraitists, Wegman talks to his subjects, coaxing them into relaxed poses. Together they usually try several positions, while varying their expressions. Wegman has a knack—that of all accomplished portraitists—of putting his subjects at ease, breaking through that first outward reticence.

Some of Wegman's portraits are closer to Arnold Newman's "environmental" approach, where we see the subject at home or at work, allowing us to get a sense of the worker, sportsman, clerk, etc., doing what they do, or like, best. This approach has taken the photographer to a welder's workshop (*Acetylene*, 306), a nightclub (*Entertainer*, 309), a church (*Choristers*, 188–89), and even a golf course (*Ardent Golfer*, 299). Like Newman, Wegman respects his subject's "natural" environment: he would never stoop to inventing something, or even to re-arranging things for the sake of a better picture; what he finds, he accepts and does his best to capture. (On a personal note, I must say that I have never heard one word of criticism from his sitters!) Mostly, however, Wegman's portraits fit the late 20th-century minimal, modernist form we associate with practitioners such as Richard Avedon: the sitter and the sitter alone, with no background distraction; mostly it is the subtle expressions on the face that count, and often minimal hand gestures.

What do we see when we take a closer look at Wegman's subjects? Well, mostly people like us. Take the portrait of *George* (127). Wegman generally holds back on his subject's biographical information, preferring that the portrait speak for itself. I'd wager that George is possibly an engineer, perhaps in management. (However, I admit that I may have this wrong; a friend of mine swears he's a retired astronaut, now working as a consultant for the Jet Propulsion Laboratory in Pasadena, and claims they once met.) A California resident, certainly—though I suspect that he was born out East. Diligent, a good family man… anxious about financing his children's way through college. Wegman has caught George in a reflective moment. It's a respectful portrait of an upstanding American citizen.

Another portrait merits mention, that of Eustace Tilley (175). Readers will recognize the celebrated dandy from his annual appearance on the cover of the *New Yorker*, captured doing what he does best and is famous for: studying the flight of butterflies with the help of his signature monocle.

Sometimes Wegman prefers portraits of types rather than individuals. *Western Blond* (137) represents a kind of fun-loving, free-spirited woman. Similarly, elsewhere in the book, a hockey player has his identity withheld (*Rocket*, 133); he stands for proud, young, aggressive sportsmen the world over. And how easily we can identify with another type: the "desperate housewife," struggling with one of everyday life's banal vexations—lists (*What to Do*, 140)! On the other hand, *Surgeon* (141) represents a type of expert we'd all rather see minimally during our lives, at least in his work environment. We're glad he is there when we need him, but we'd rather not need him. Wegman's powerful portrait of this unnamed surgeon forces us to confront the fragility of our existence.

By contrast, *Estella* (138) comes across not as a "type," but as a vividly real, flesh-and-blood person. Possibly from a small town and now a little lost in the big city, caught at a sad moment (as a reasonable judge of these things, I'd wager that her fiancé has just left her for another woman). Also shown very much as an individual is Wegman's portrait of *Shawn* (136), catching the much-admired tennis player (now retired) in the easy, relaxed mood for which he was famous on and off court, and sporting his trademark unruly hair!

Not all of Wegman's sitters are so renowned, though they do their jobs well and with pride: the lawman of a small town in Colorado, met quite by chance on vacation (*Sheriff*, 142), or the usher Wegman encountered on a Friday night at the Odeon (*Usher*, 143). We also meet the questionable "business partners" from New Jersey (*Aside*, 139), or the male model concerned about his future, as younger rivals appear on the scene (*Male Model*, 129). We may be looking at other people, but we see in these faces friends, acquaintances, even roads we may have taken had fate dealt us a different hand.

In *The Theater of the Face* the critic Max Kozloff faces off, as it were, with a slew of postmodernist art photographers who veto all but blank—or as he puts it, anemic—expressions before the lens. Kozloff implies that this fashionable strategy is pseudo-realistic, and ultimately self-defeating; it has ended up enfeebling the art of portraiture. It gives us slick, blank façades. Passport photographs tell more truths, Kozloff seems to

be suggesting. Certainly he could never accuse Wegman of this emotionless approach; his sitters need to communicate their emotional states, and the photographer helps them achieve it. His is a humanist approach: his people are dealing valiantly with life's slings and arrows, and he allows the scars to show. Writing on the subject of portraiture years ago, photo-historian Ben Maddow observed, "We are not solitary mammals, like the elephant, the whale and the ape. What is most profoundly felt between us, even if hidden, will reappear in our own portraits of one another." Wegman's portraits are therefore best compared with earlier masters than with trendy postmodernists: Berenice Abbott, Man Ray (that other, two-legged one), August Sander, Brassaï, to name a few, where some indefinable human quality shines through. Wegman's portraits have that rare quality of reflection, in both senses of the term: like mirrors, we find that we are staring at ourselves.

If portraits comprise the lion's share of Wegman's studies (I am wondering if one of his captions signals a subtle shift away from his prime focus on the portrait [*Dying Lion*, 118]), nudes come a close second, and deserve a brief comment. Some people see echoes of John Coplans' "self-nudes" in Wegman's fragmented studies (*Slide*, 20–21), and the body-blending-into nature studies of Arno Minkkinen (*Garden*, 238–39); others have commented on striking similarities with Robert Mapplethorpe's nudes (*Wall*, 17). Some of Wegman's more assertive sitters remind us of Herb Ritts' muscle-bound young males (*Façade*, 19), though they lack the latter's slickness.

As he does with portraiture, Wegman likes to toy with both 19th- and 20th-century approaches to the nude. We see nudes that would sit comfortably next to 19th-century studies—the classic, full-length body in repose, partially draped in fabric (*Fay Lay*, 334). In the Physique chapter, we see the aforementioned fragmented nudes, a tradition that emerged in the 1920s with the arrival of the small hand-held camera that freed the camera from the tripod and allowed the photographer to move around the subject, over and under it, the free mobility resulting in a quasi-total abstraction of form. Bill Brandt, known for extraordinary nudes in the landscape that find their echoes in Wegman's work, explained, "When I began to photograph nudes, I let myself be guided by this camera, and instead of photographing what I saw, I photographed what the camera was seeing. I interfered very little, and the lens produced anatomical images and shapes which my eyes had never observed." Wegman's *Nevadada* (230–31), to give one example, bears a striking resemblance to Brandt's seashore nudes, where purposely distorted segments of the body resemble rock formations, or even rolling sand dunes (*Breakers*, 232–33).

I have not done full justice here to the extraordinary range of Wegman's concerns and passions, but I believe that the essential element of humanism comes through loud and clear. In *The Naked Ape*, zoologist Desmond Morris argued that "this unusual and highly successful species spends a great deal of time examining his higher motives and an equal amount of time ignoring his fundamental ones." Wegman's work helps us right the balance. Franz Kafka's reflections on the portrait also apply to the artist's humanist

approach. When Kafka looked at the simplest of portraits he was "always astonished by the force which ties us together," yet something remained elusive—call it soul, or spirit. Wegman's Weimaraner collaborators (partners is a better word, really), like the photographer himself, know this, and yet they persist in hunting for it. Persistence is, after all, a good part of what it means to be human. "Dogs are people too," argued neuroscientist Gregory Berns in the *New York Times* a few years ago, and he proved his case with solid MRI evidence, even going as far as laying out the case for canines to be legally protected with rights. Wegman never had a doubt that dogs are people too. They are, indeed, people like us. And they, in turn, are people we like.

# PHYSIQUE

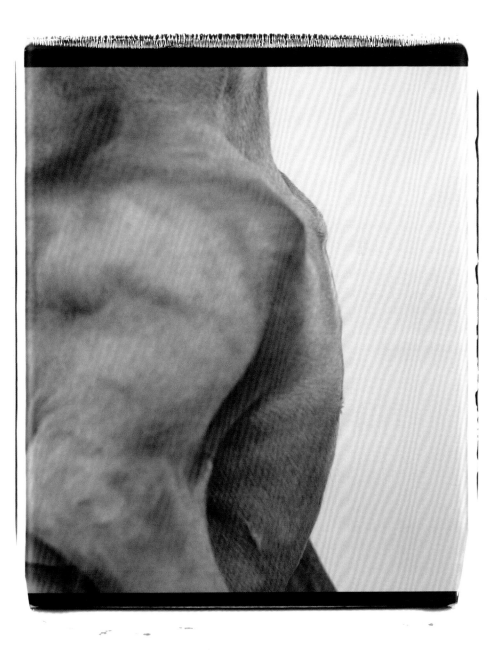

Wall, 1997

Gray Wall, 1998

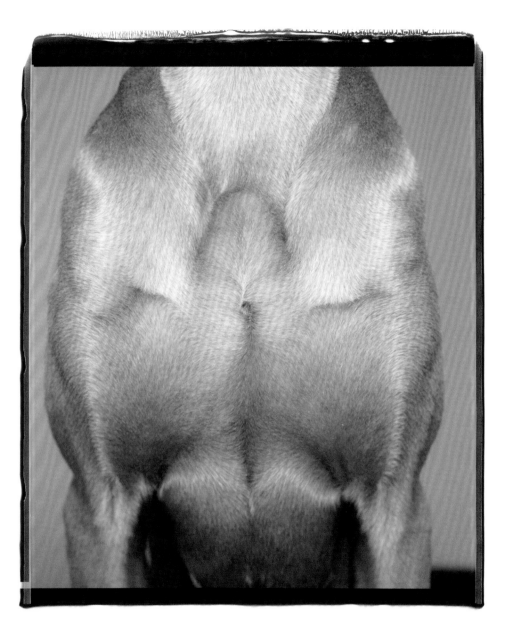

Façade, 2000

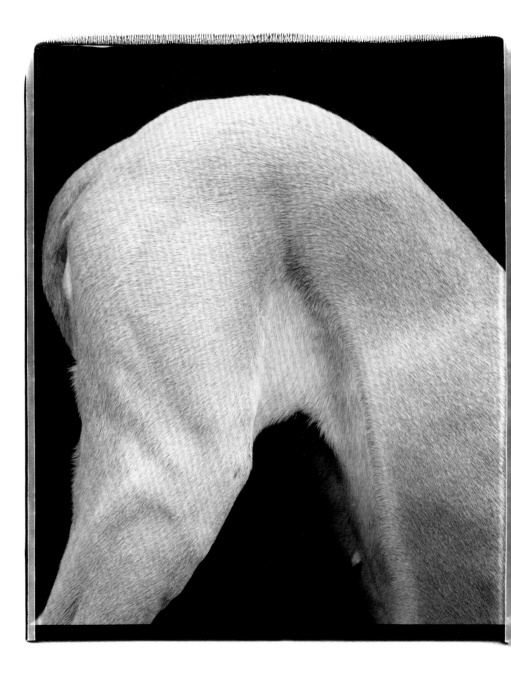

Slide, 1998

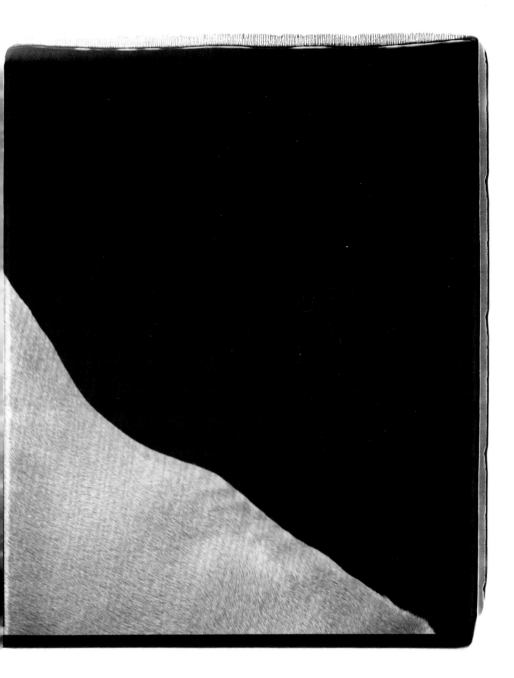

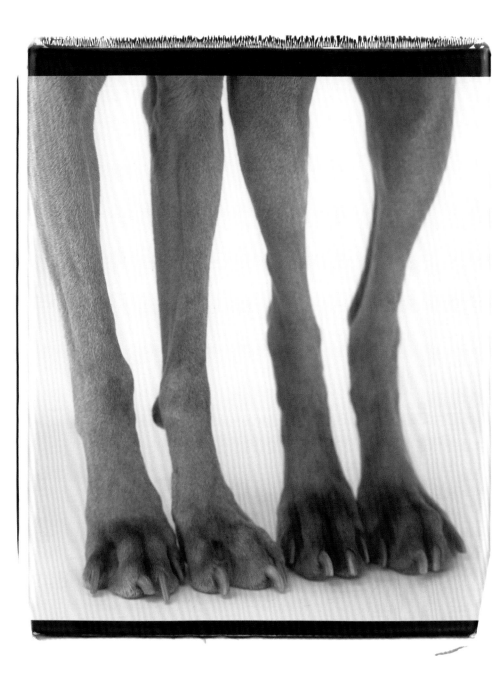

Front Foot Side Back, 1998

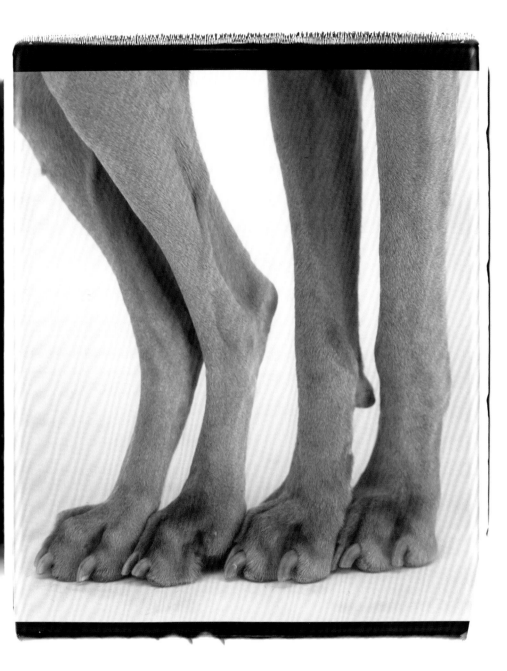

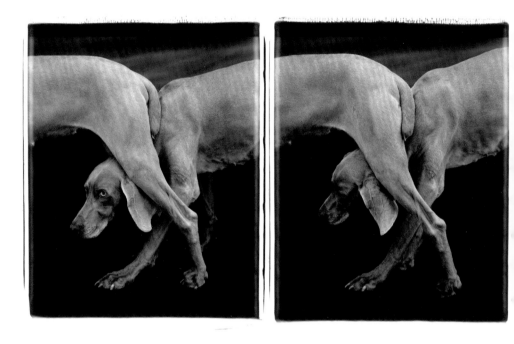

Interlocker, 1994

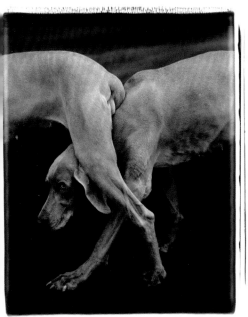
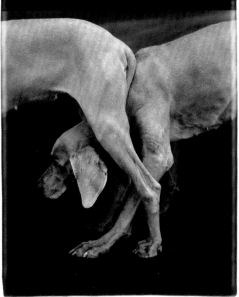

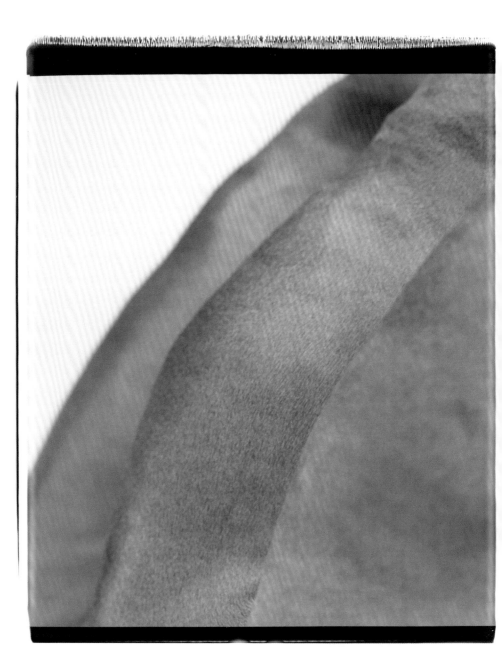

Mountainous, 1998

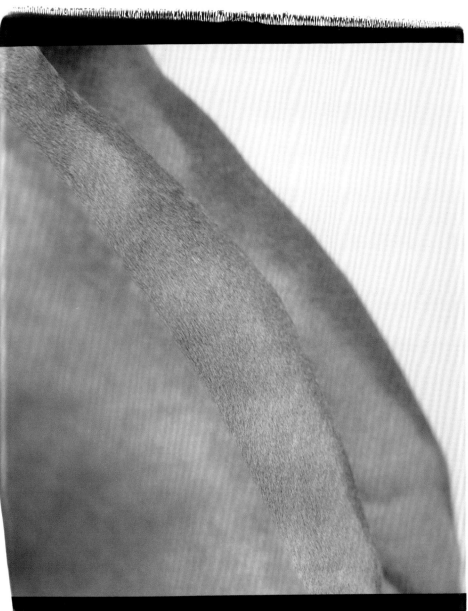

# MASQUERADE

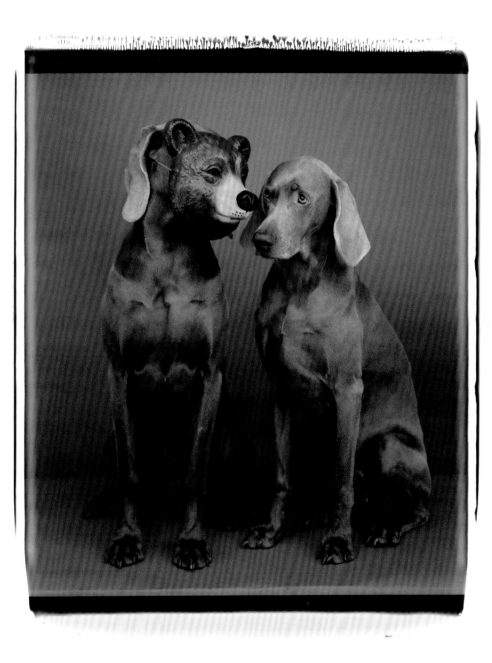

A Secret, 1994

Vehicle, 1989

Dolor Oratus Vox Dicam, 1992

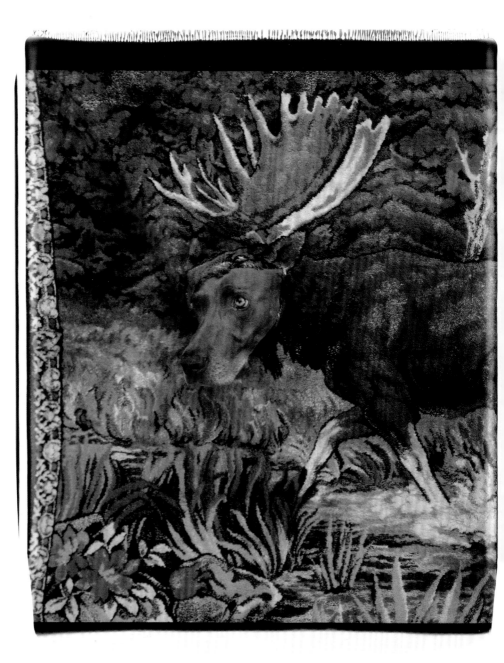

Moose on the Wall, 1992

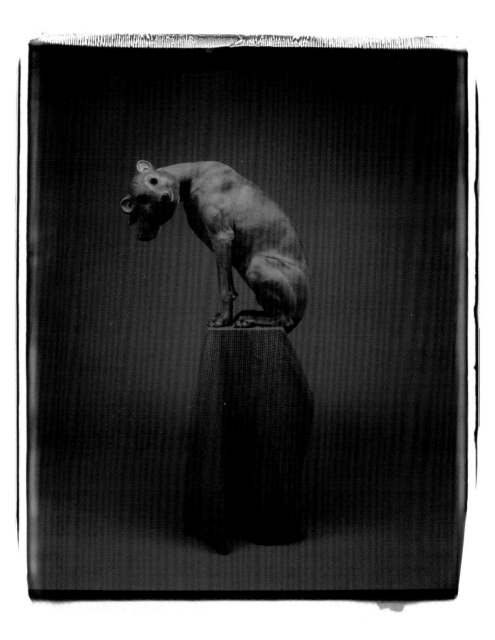

Dog as Cat, 1990

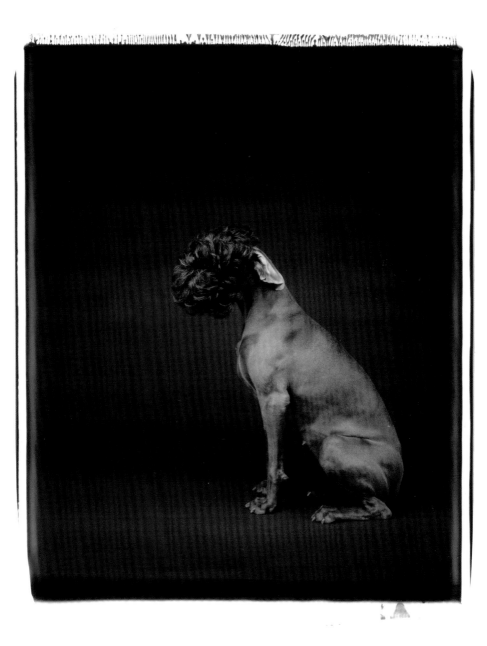

Dog as Dog, 1989

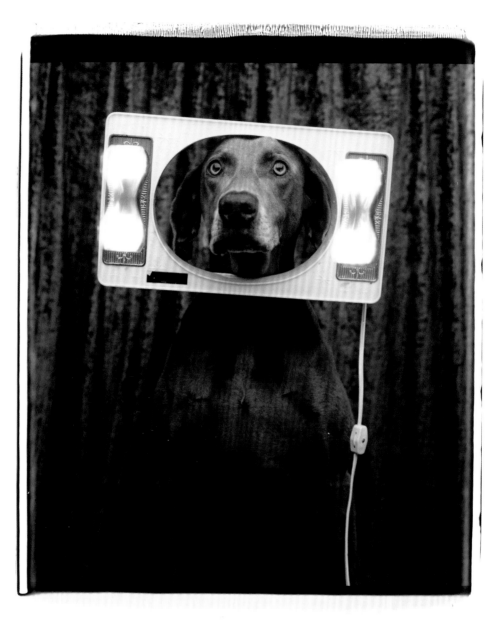

Makeup Sitting, 1992

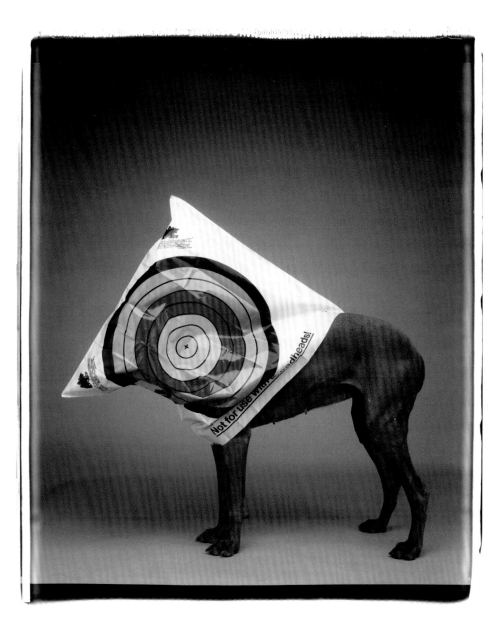

Target Animal, 1990

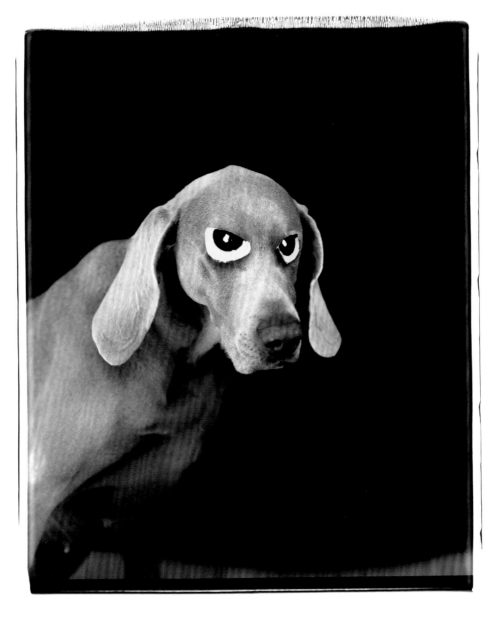

Eye-on, 1997

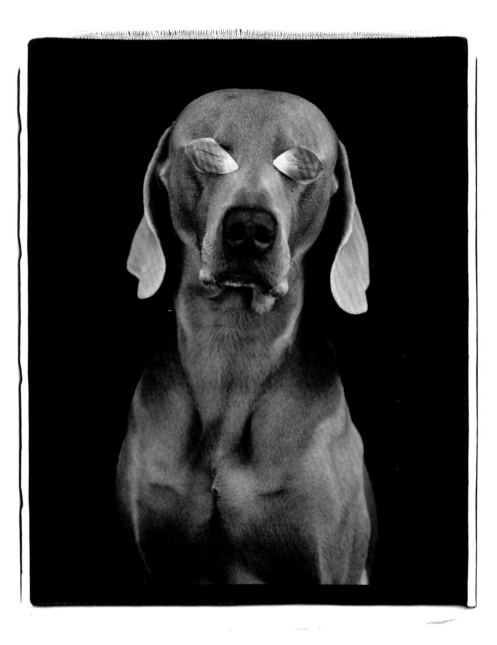

Red-eye, 2004

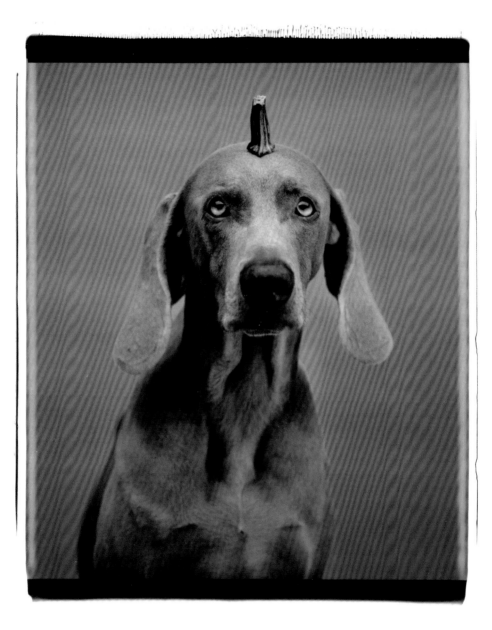

Pumpkin, 1995

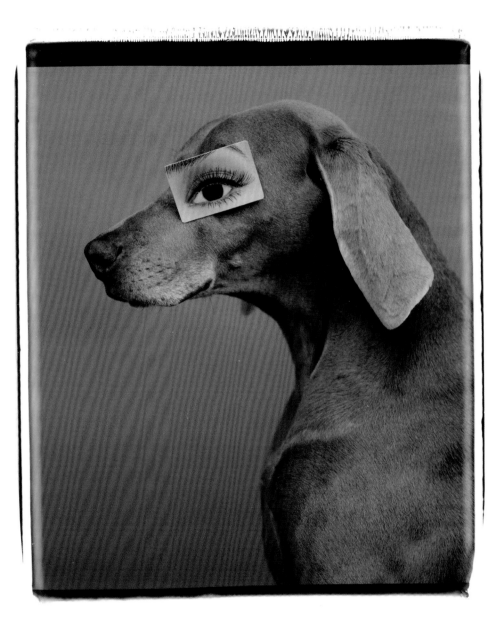

Eyewear, 1994

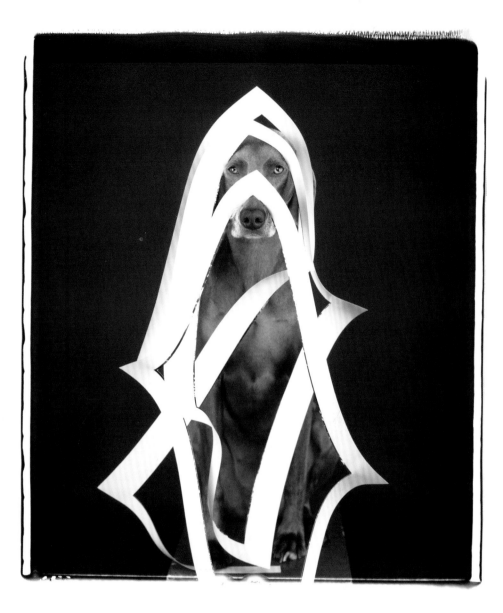

Loosely Framed, 2007

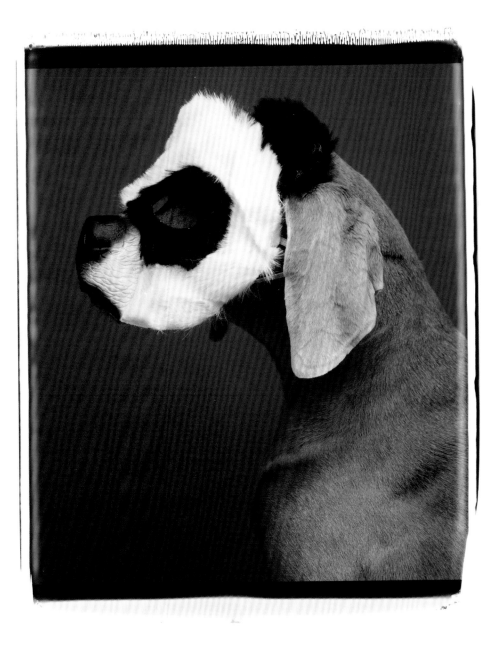

Animalque, 1994

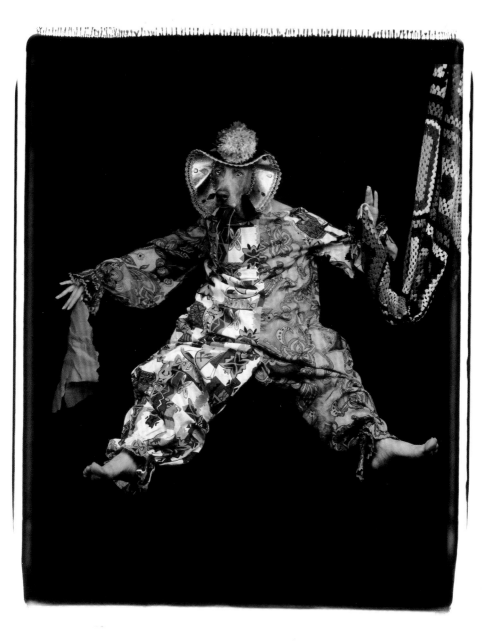

Jestering, 1993

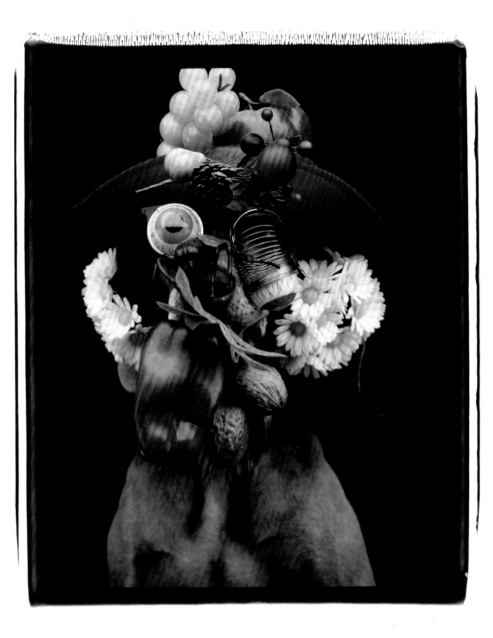

Harvest, 1994

# HALLUCINATIONS

Eyes, 2005

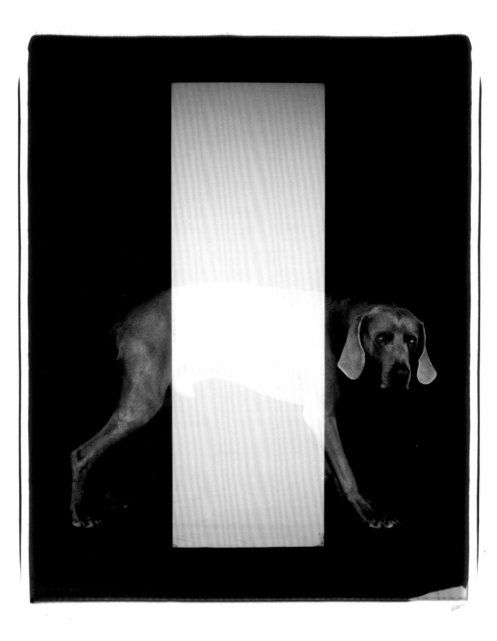

Thru, 2003

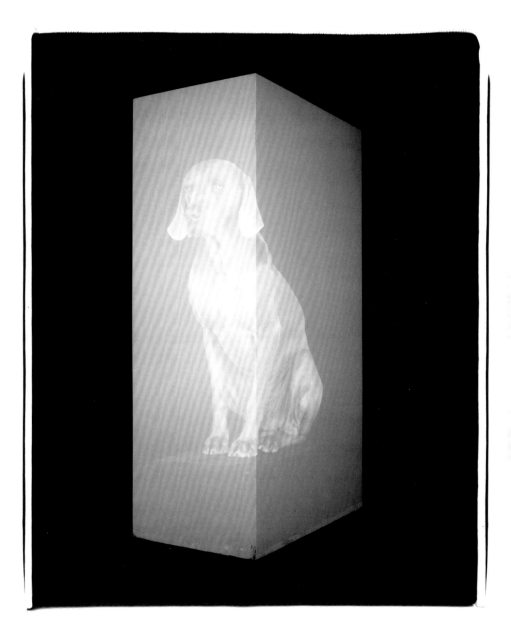

Classical, 2003

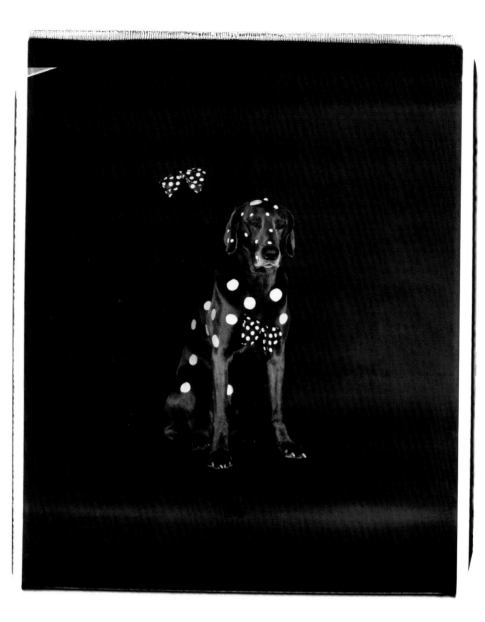

Breakout, 1980

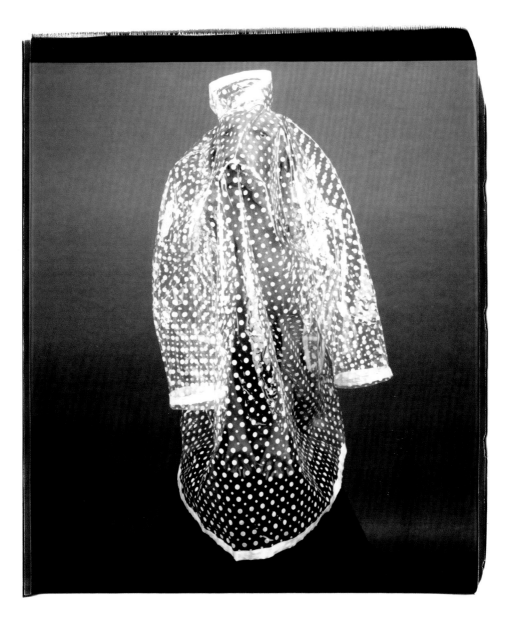

Jellyfish, 1997

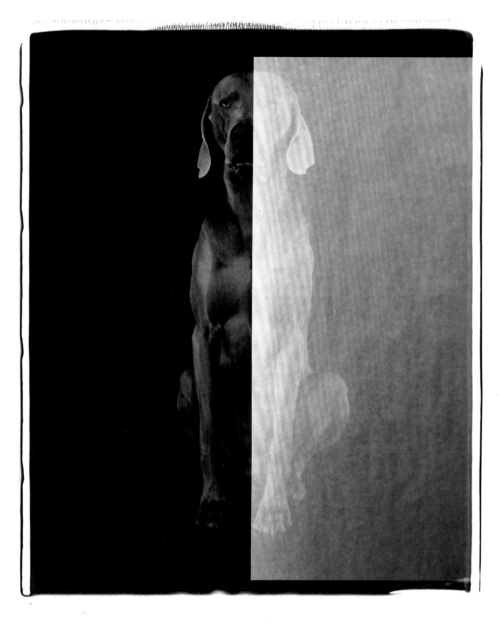

Split Personality, 2004

Smoke, 2001

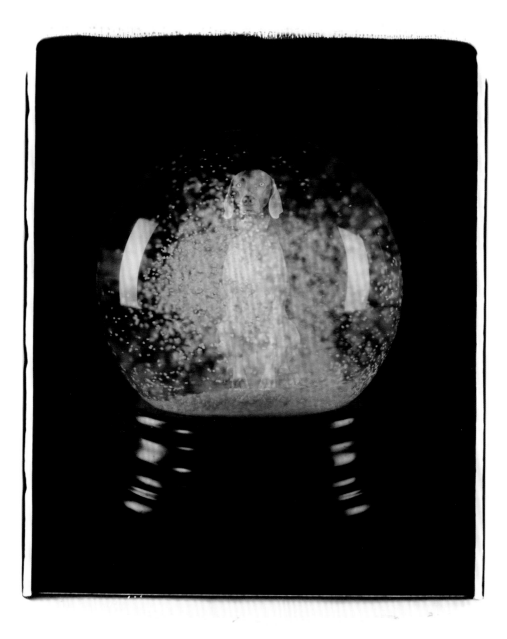

Nostalgia, 2006

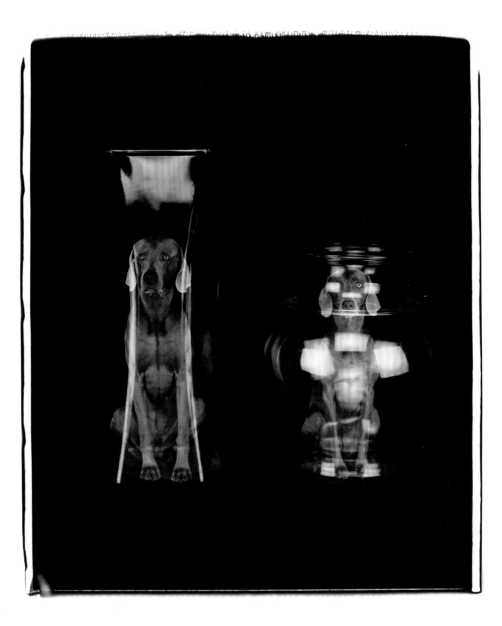

From the Spirit World, 2006

Armored, 2005

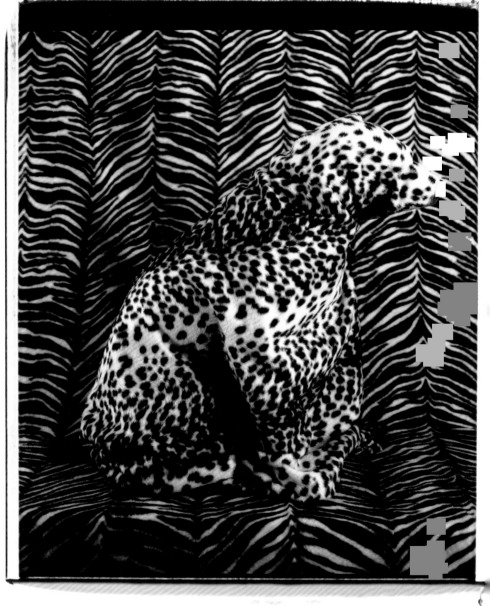

Leopard / Zebra, 1981

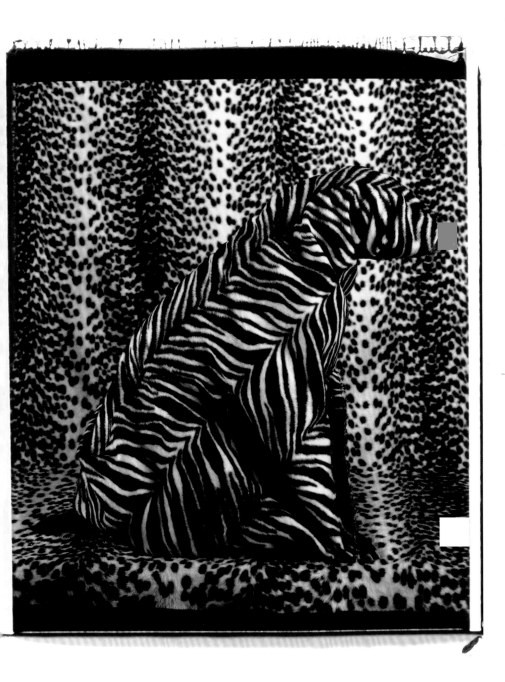

59

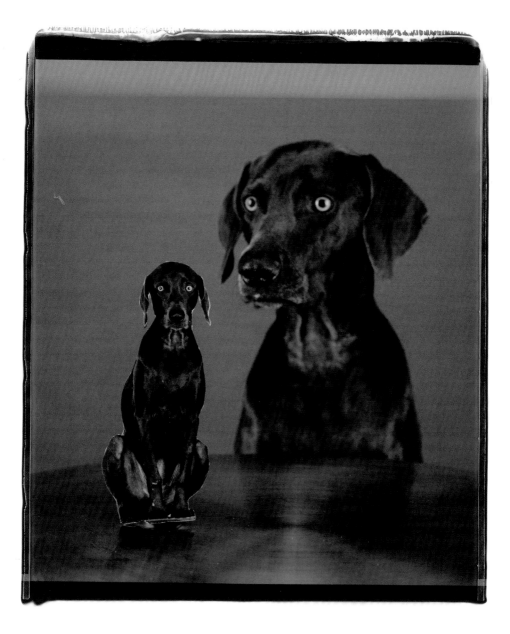

Splitting Image, 2005

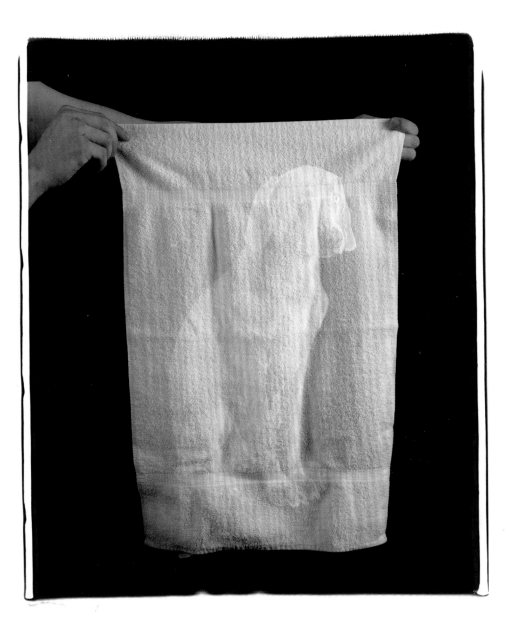

Perhaps Religious, 2004

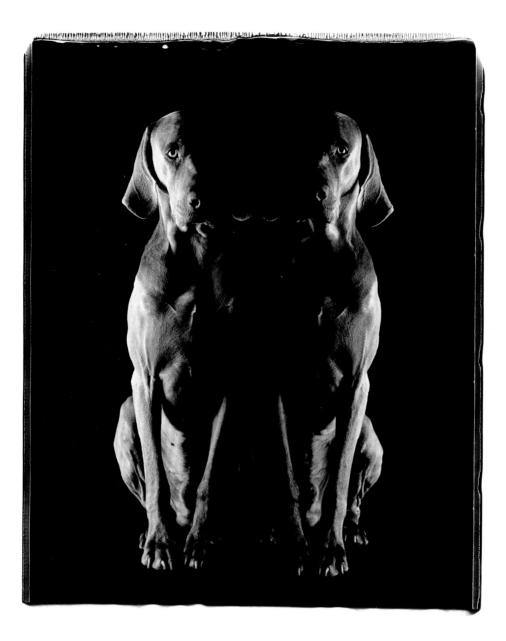

Psychology Today, 2000

To Be Delivered, 2004

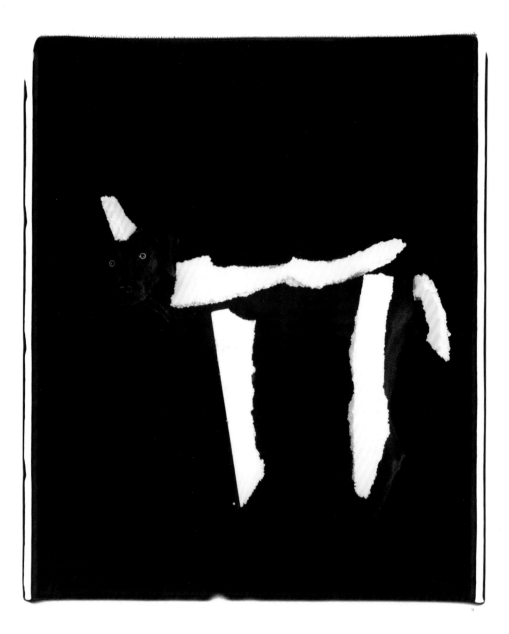

Early Dog, 2004

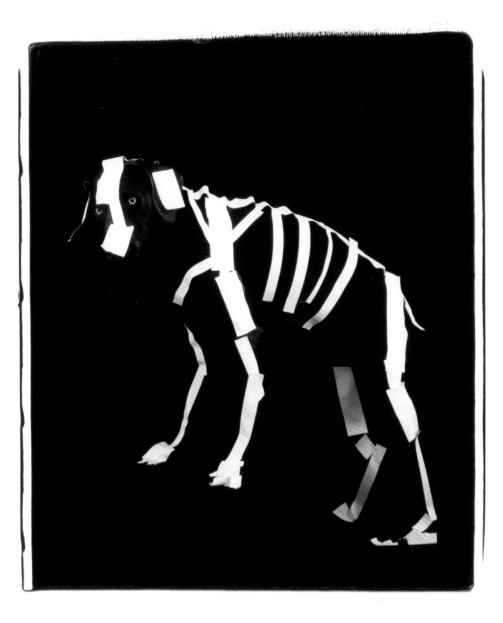

Skelly, 2005

VOGUE

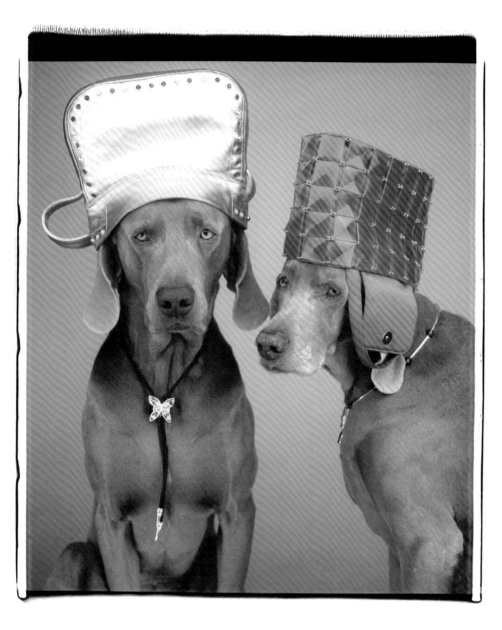

Head Wear, Neck Wear, 2000

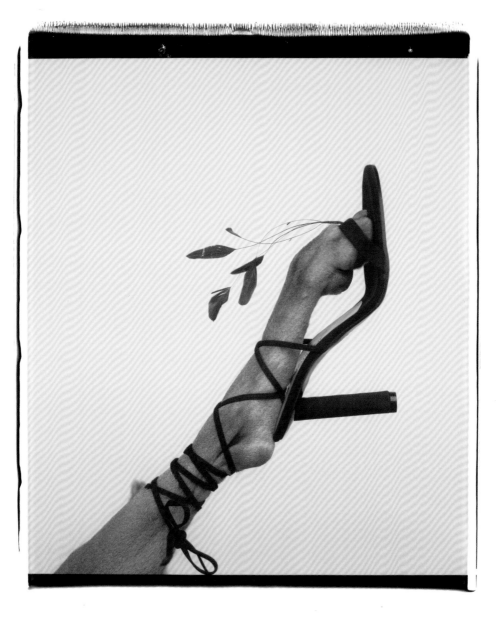

Feathered Footwear, 1999

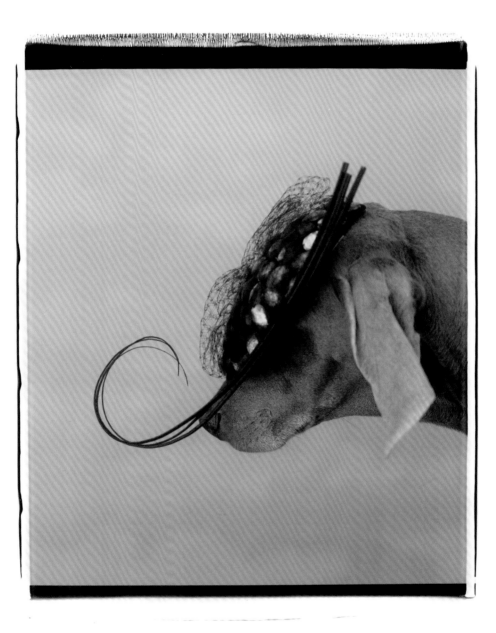

Migratory, 1999

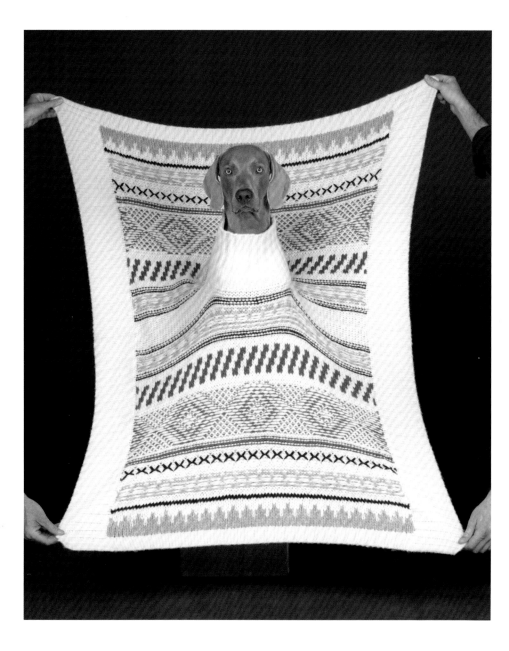

Sheet of Information, 2015

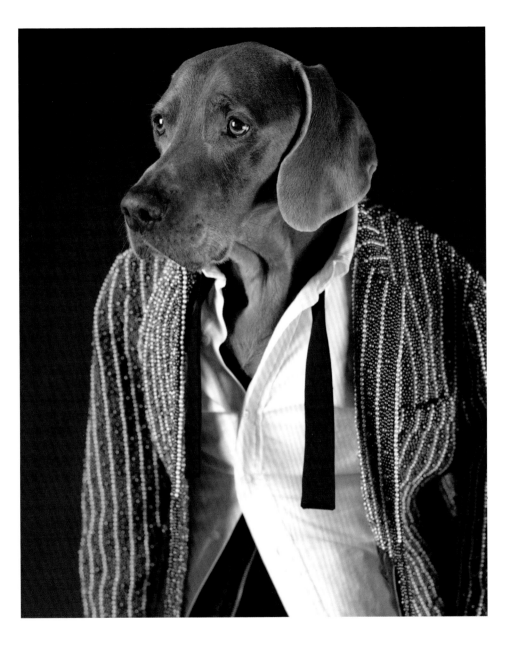

Loosely On, 2012

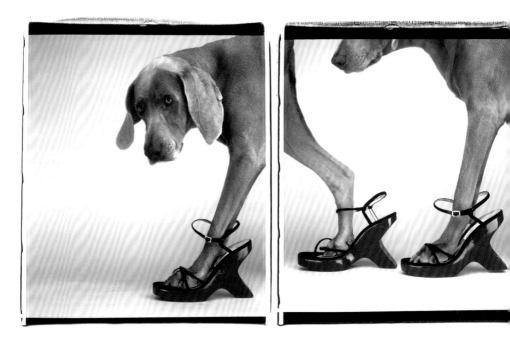

Walk-a-thon, 1999

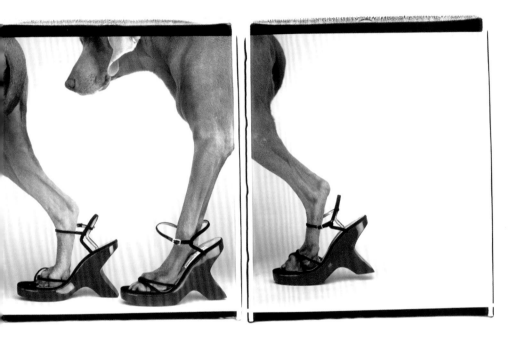

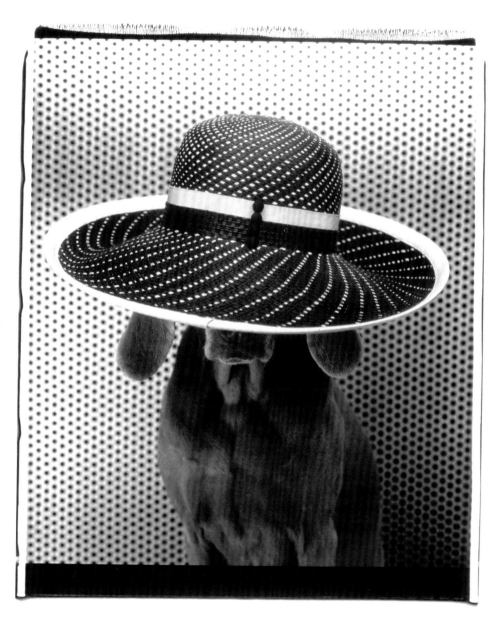

Ben Day, 1999

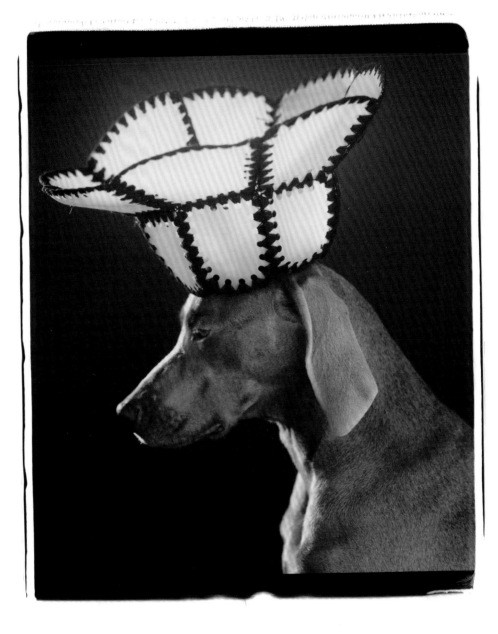

Way to Wear, 2005

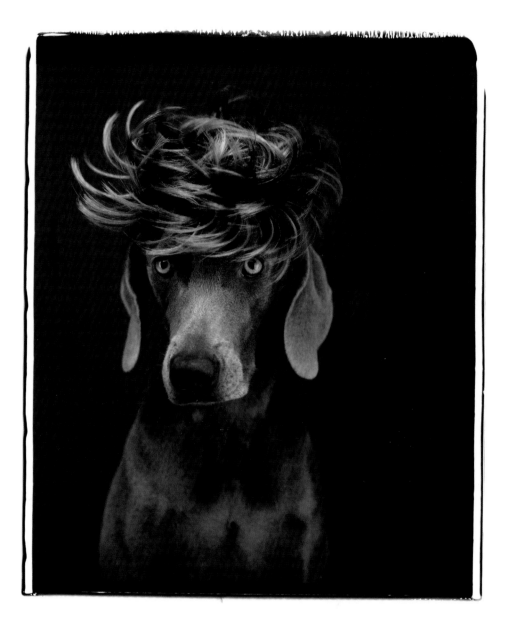

Swirly Shirley, 2005

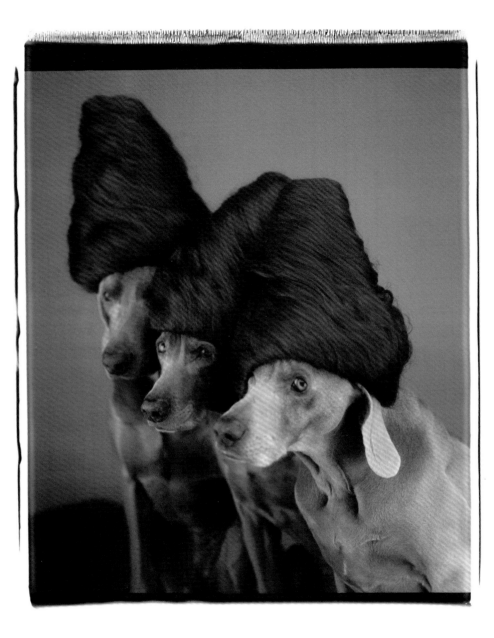

Soul Sisters, 1999

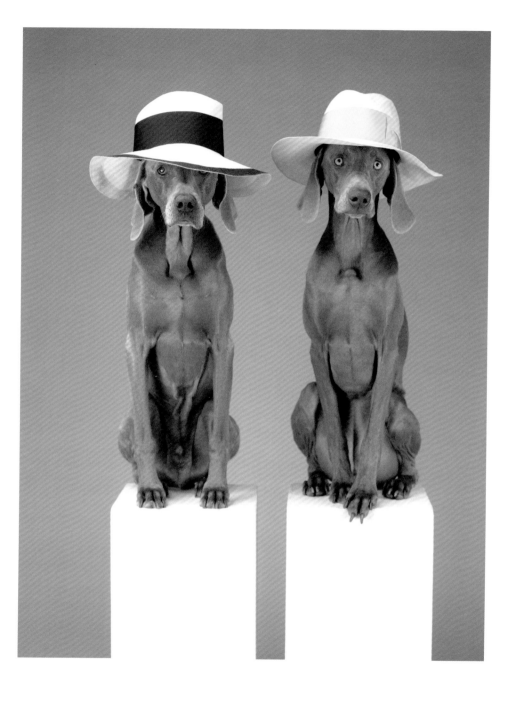

Hat Dogs, 2013

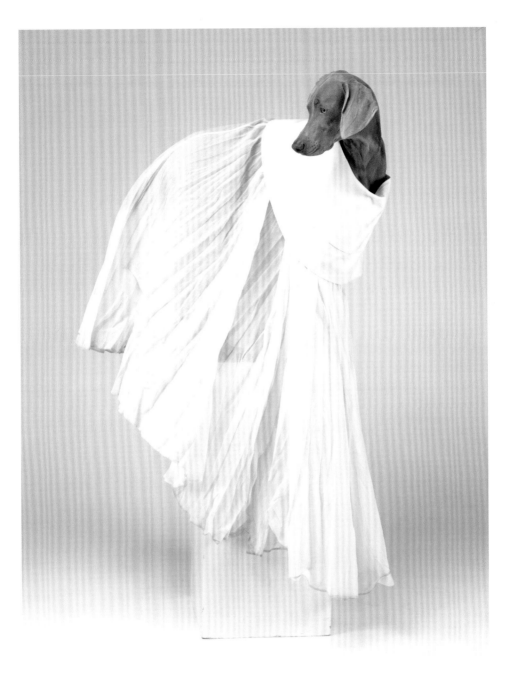

Ceremonial, 2013

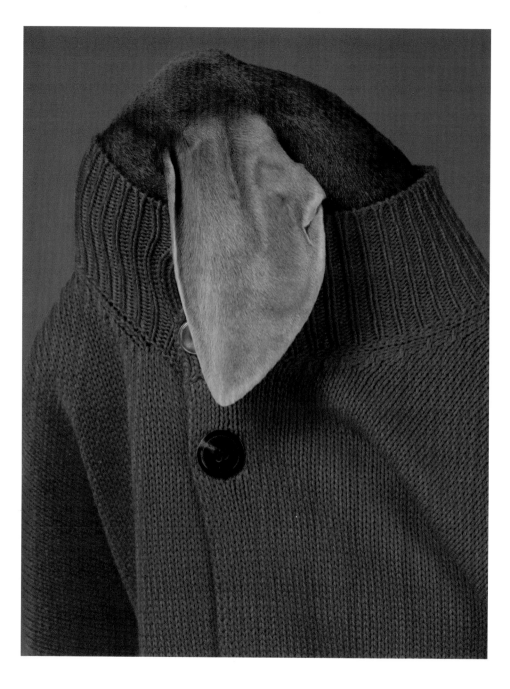

Gray Note, 2012

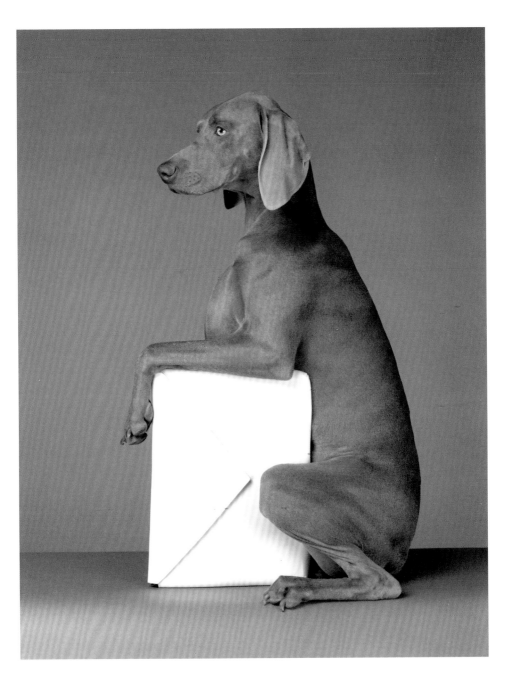

The Letter, 2014

# CUBISTS

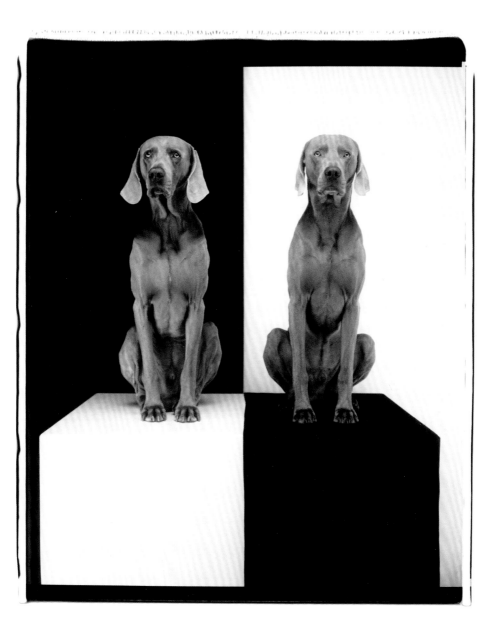

Game Cube, 2003

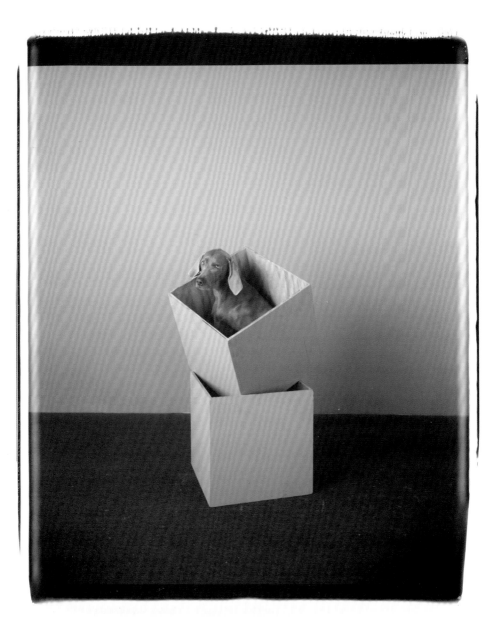

Gray in Gray, 1993

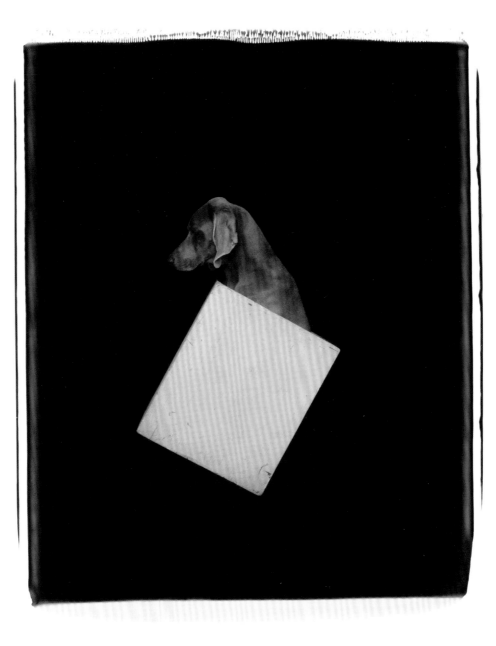

Yellow Peril, 1992

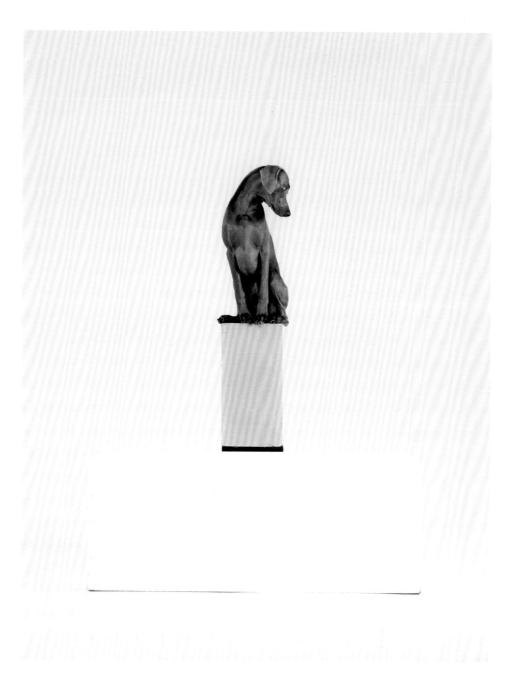

Lower Case, 2014

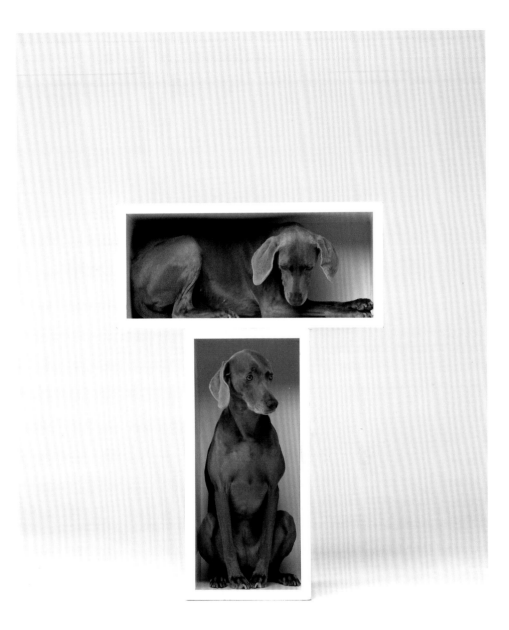

Split Level, 2010

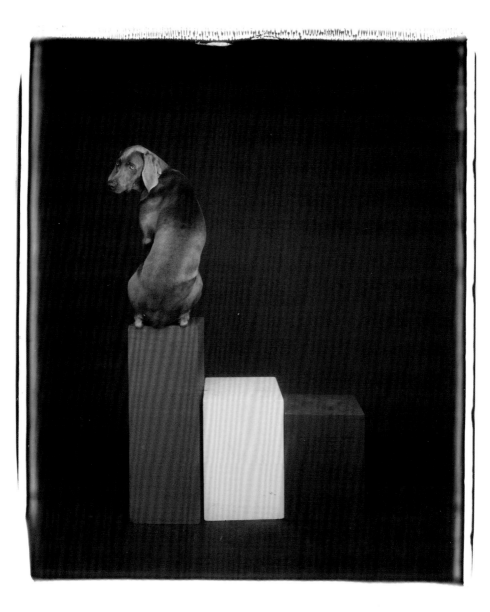

Stop, 1991

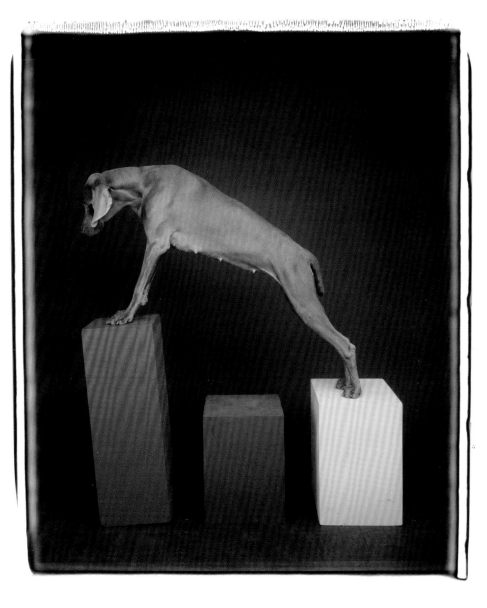

Primary Position, 1991

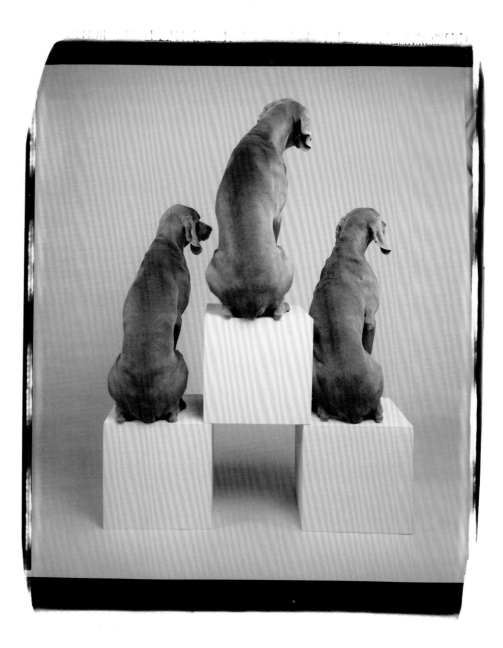

3 on 3, 1994

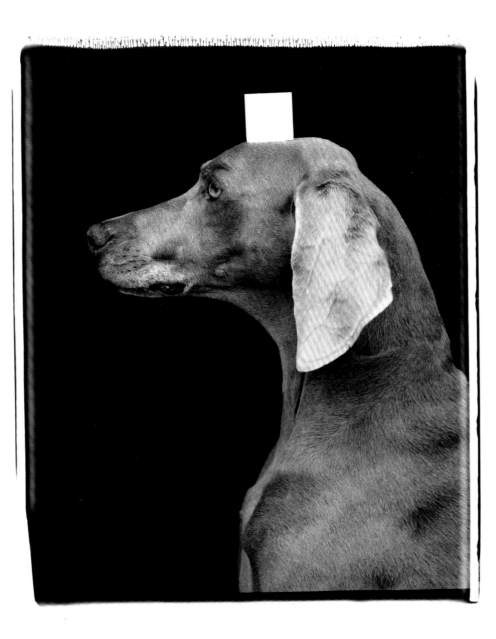

White², 1994

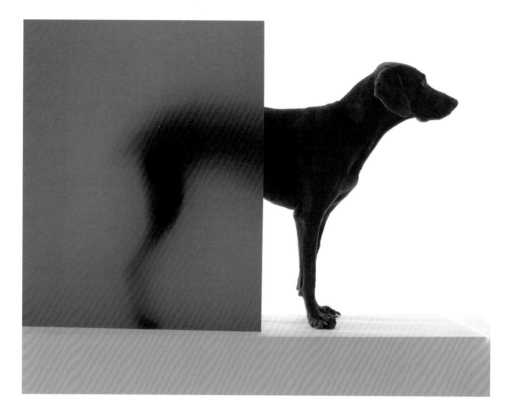

New Dawn, 2006

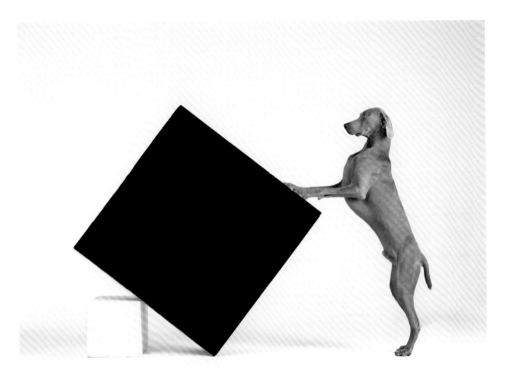

Constructivism, 2014

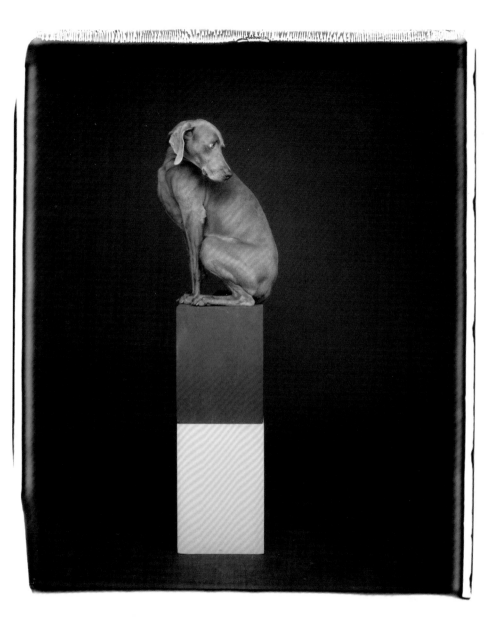

Over Blue, 1991

In Hiding, 1989

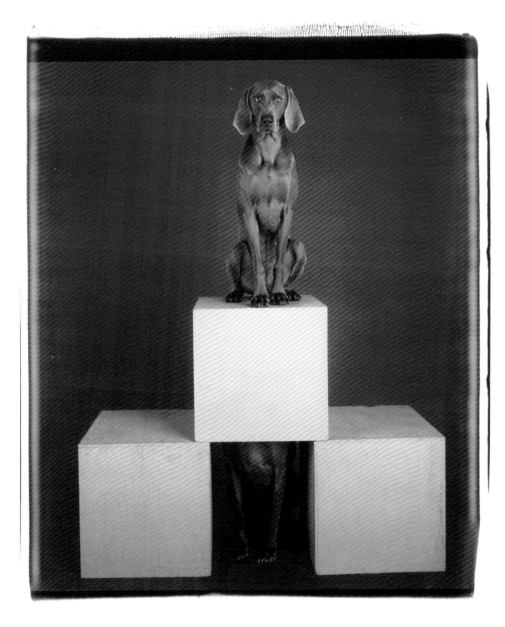

Top Dog, 1993

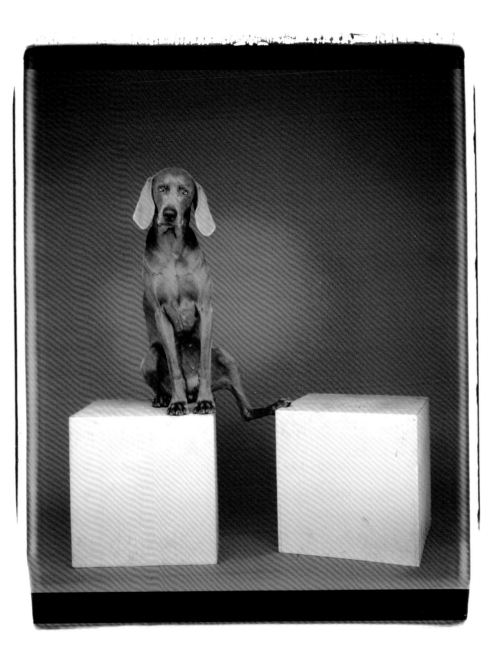

Connector, 1994

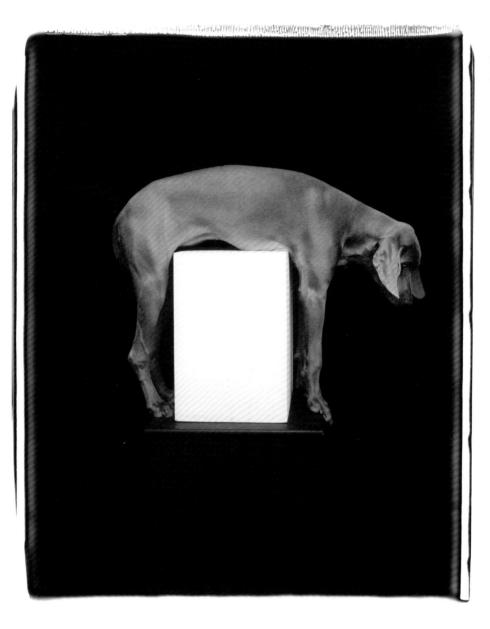

Negative Space, 1990

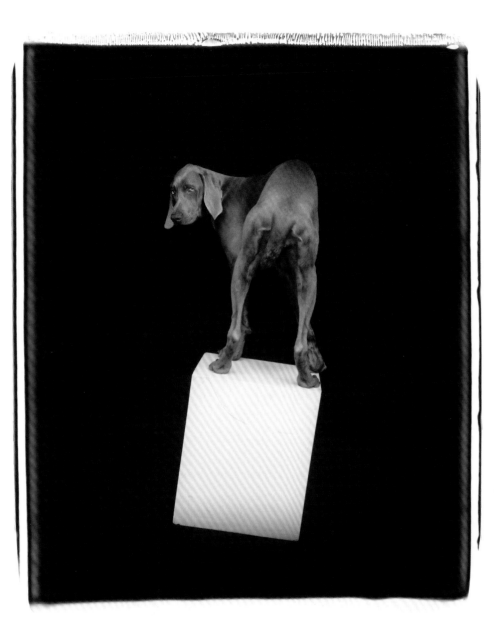

On Tilt, 1990

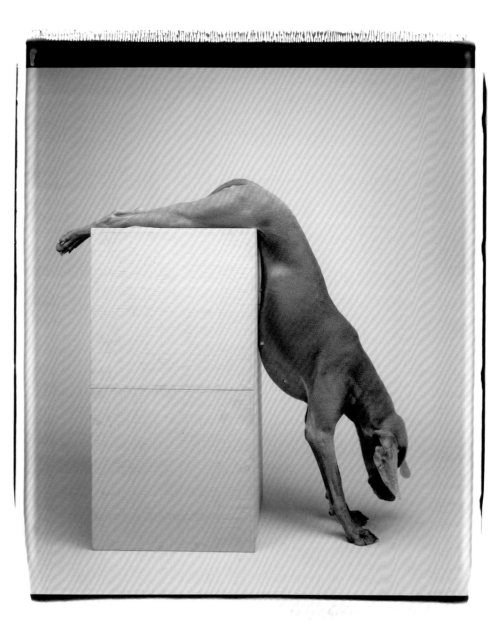

Double Up, 1989

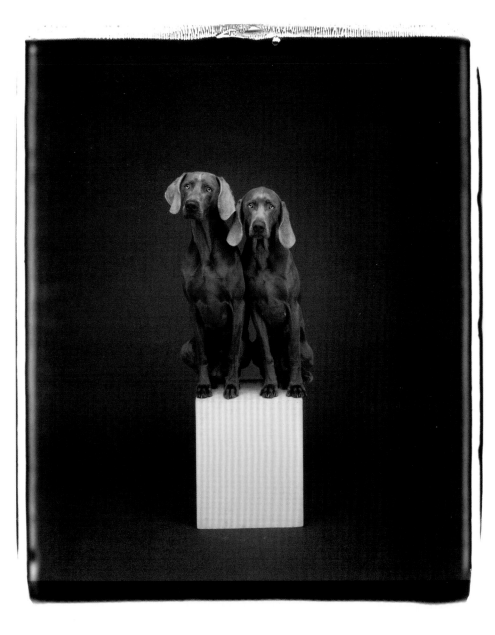

Two On, 1991

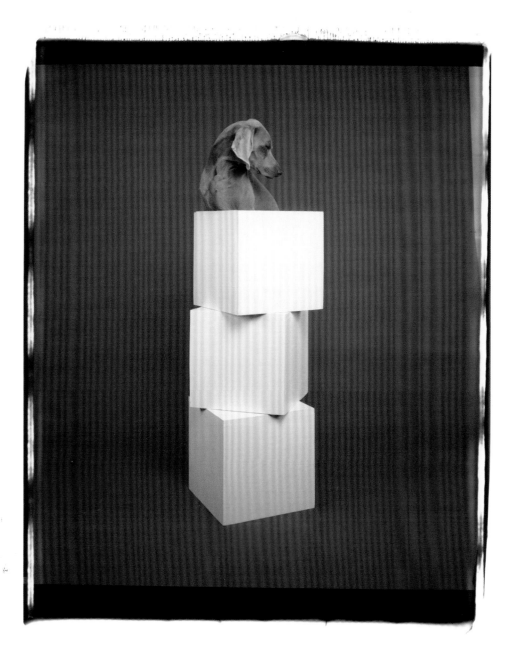

Cube Adjustment, 1993

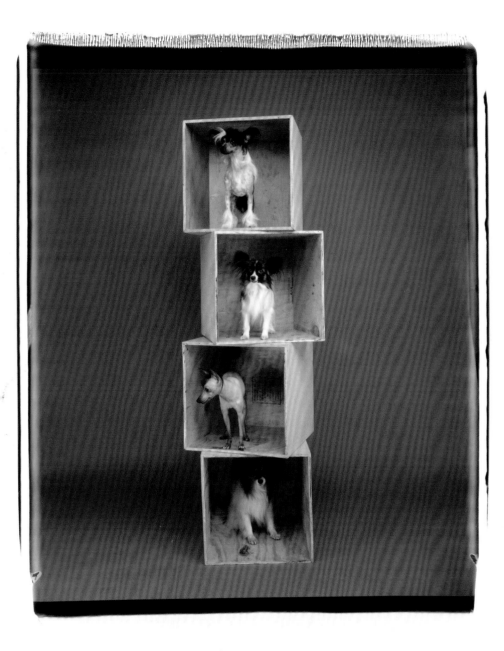

Condos, 1993

ZOO

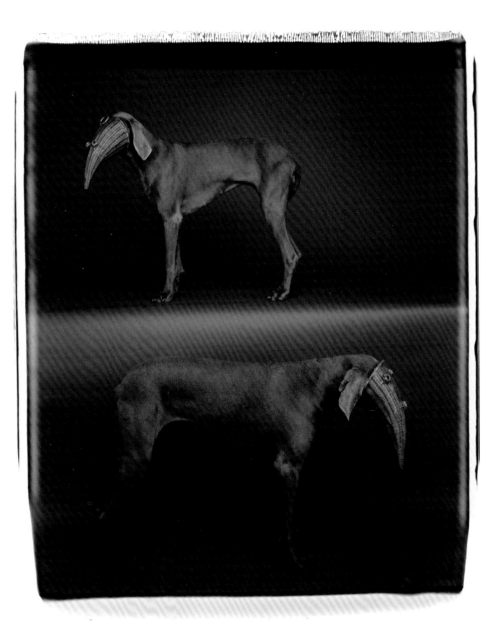

Early, 1991

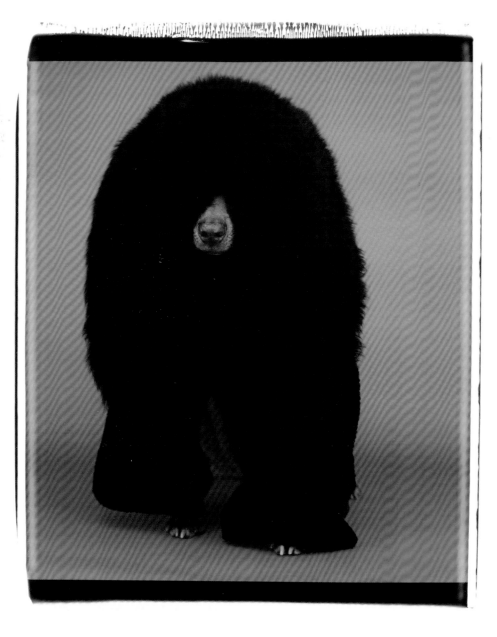

Chow, 1994

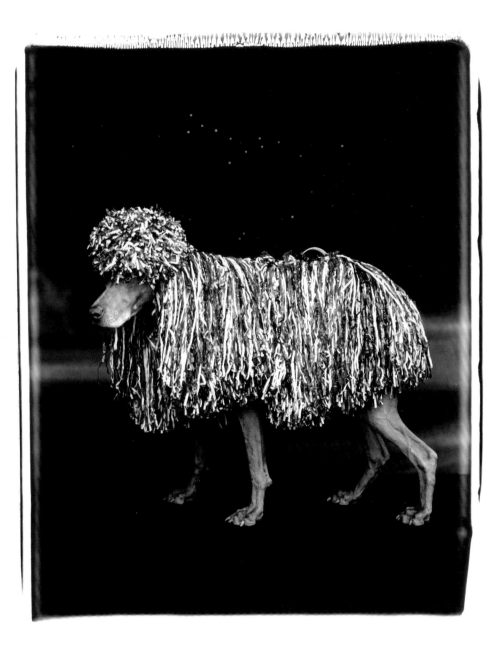

Patriotic Poodle, 1994

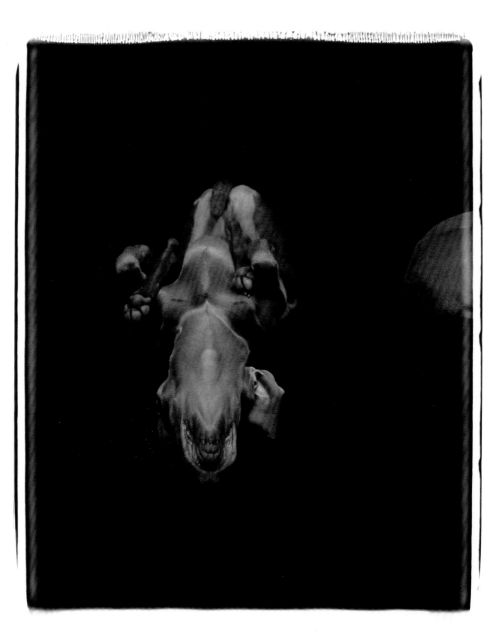

Bomb, 1990

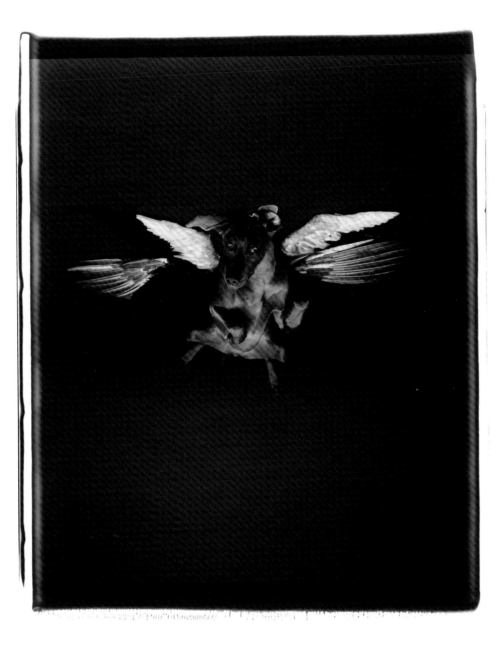

On the Wing, 1990

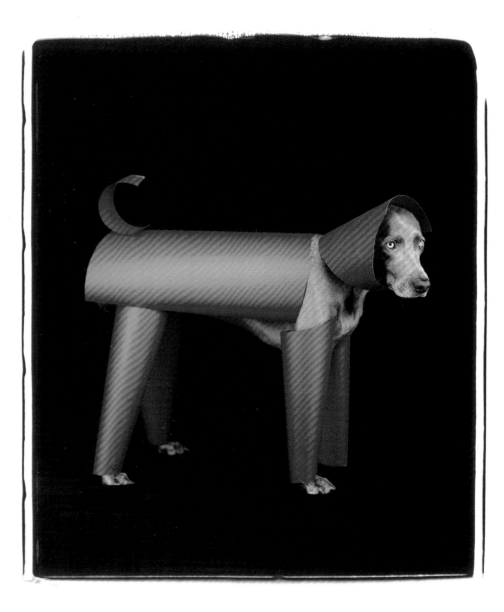

Red Toy, 2006

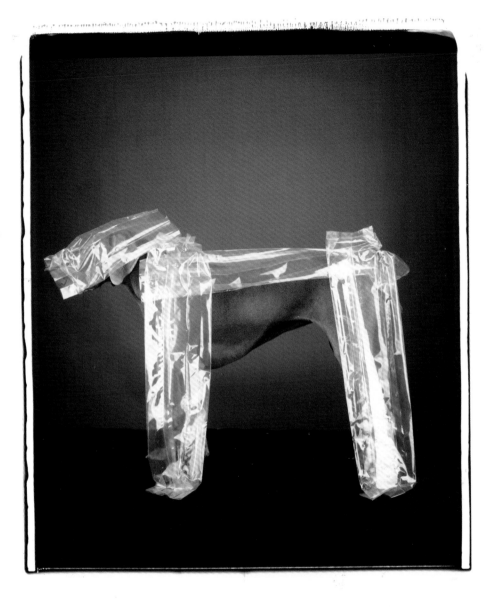

Simple Toy, 2008

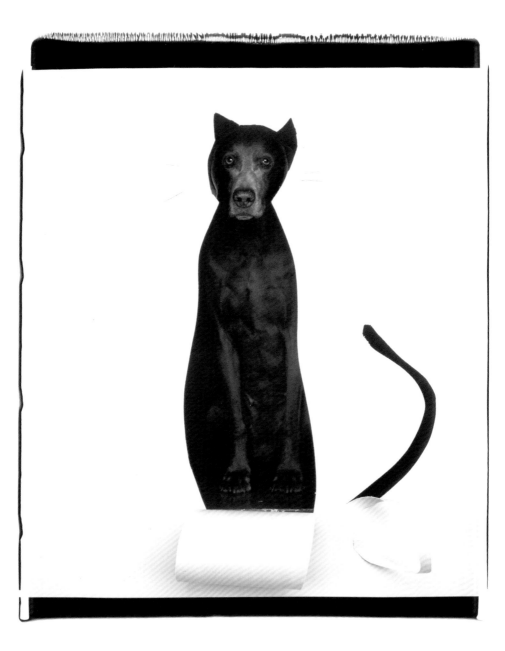

Catty, 2000

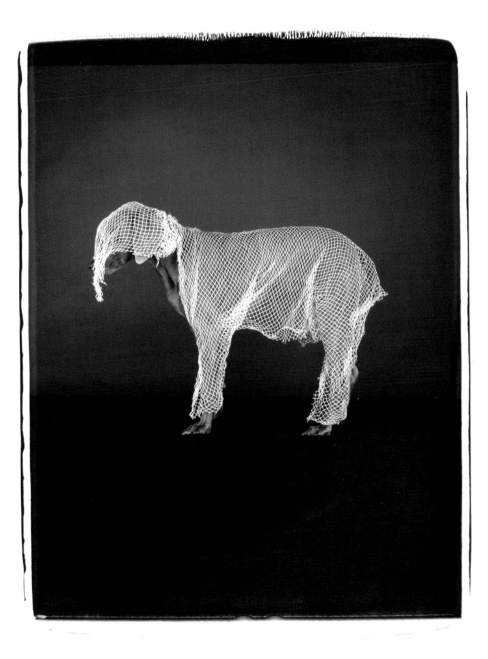

Elephant Ghost, 2007

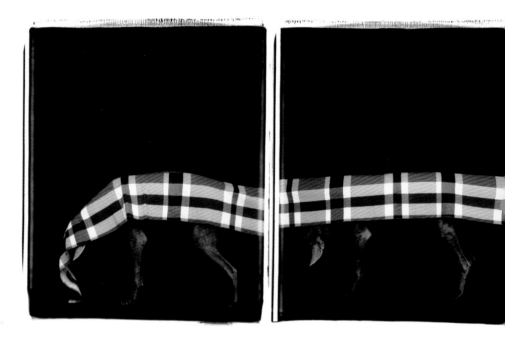

Plaiderpillar, 1994

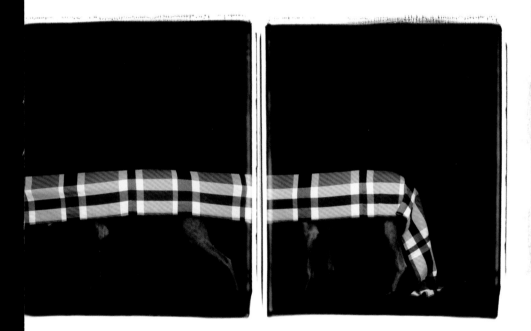

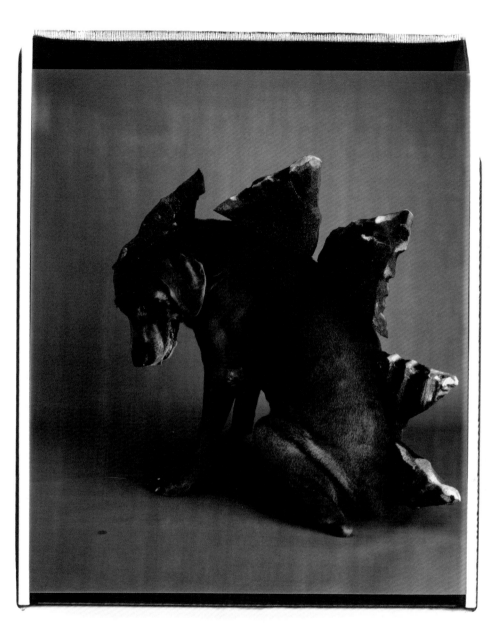

Dino Ray, 1981

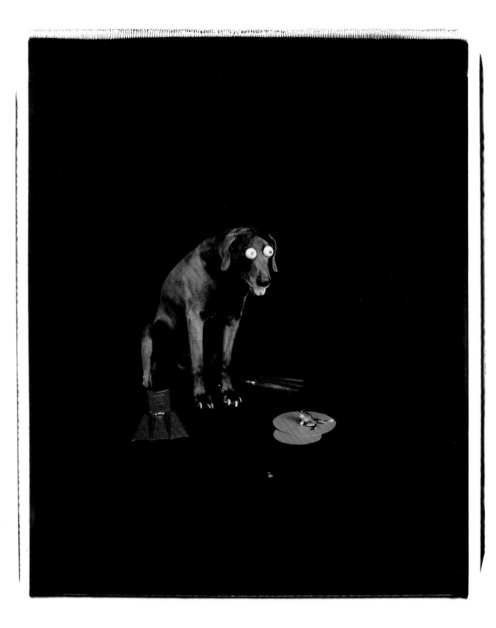

FROG / Frog II, 1982

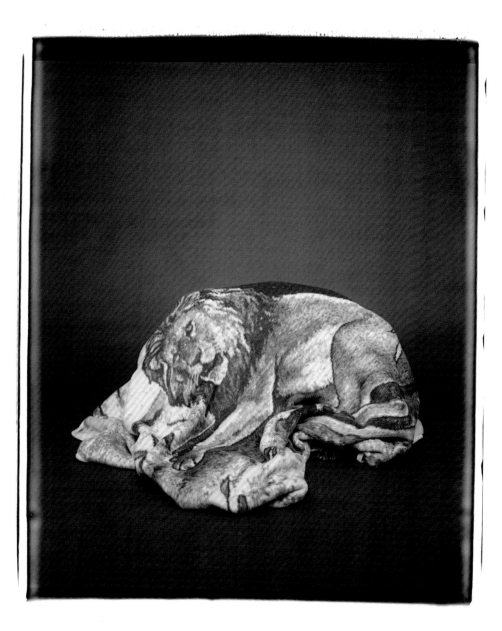

Dying Lion, 1990

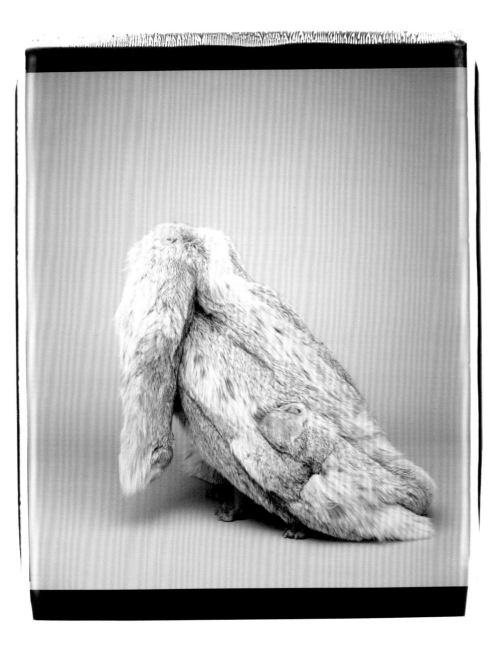

From the Vault, 1988

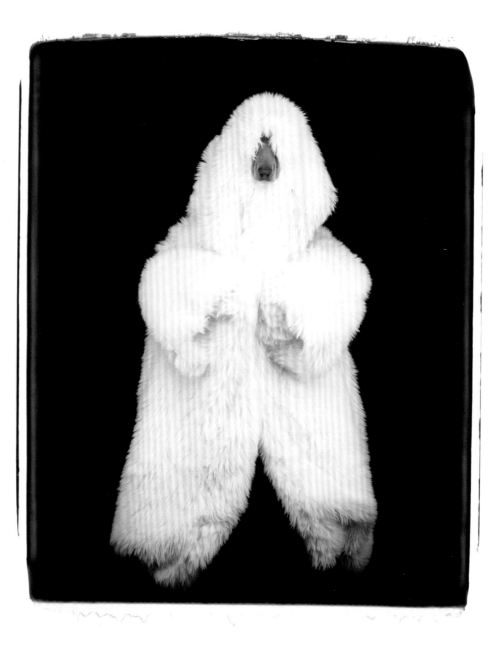

Polar Bearing, 1994

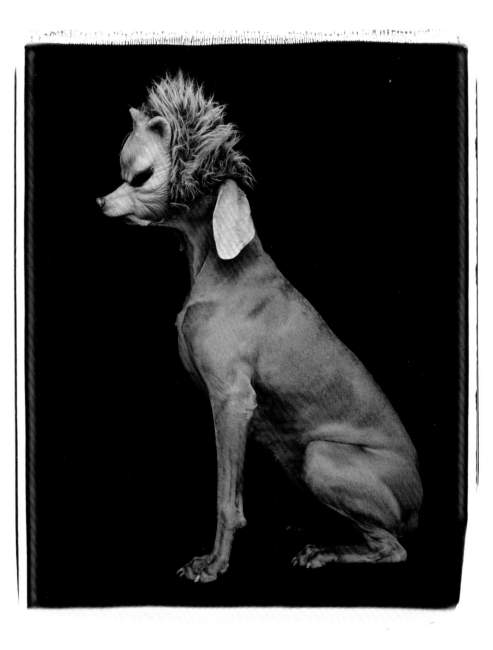

Wolf, 1994

Old Crow, 1988

Buffy, 1991

# PEOPLE
# LIKE US

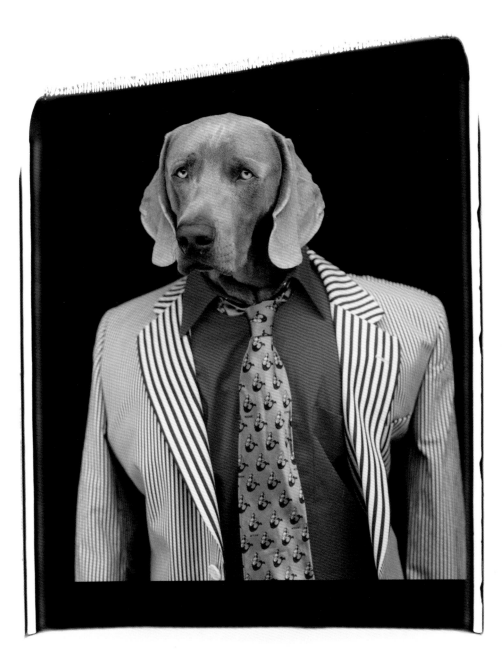

Good Looking, 1996

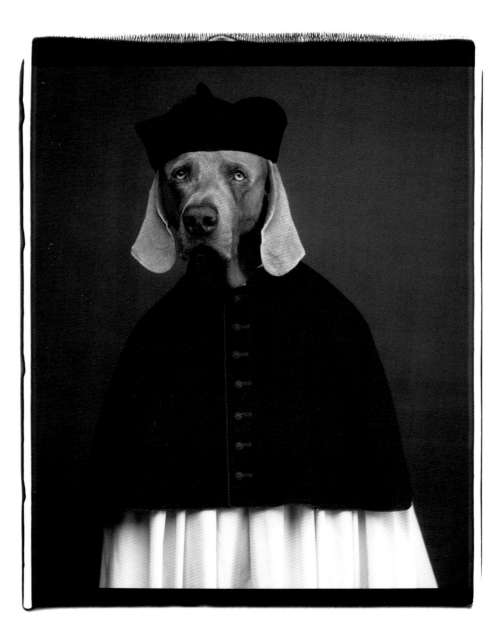

Ecclesiastical, 2000

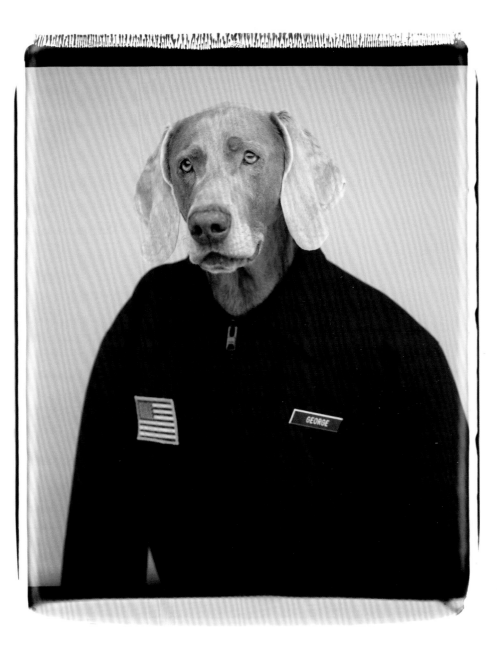

George, 1997

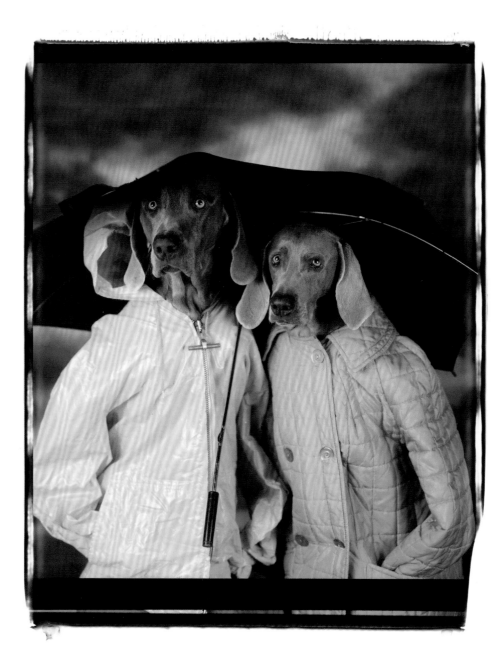

Stormy Weather, 1996

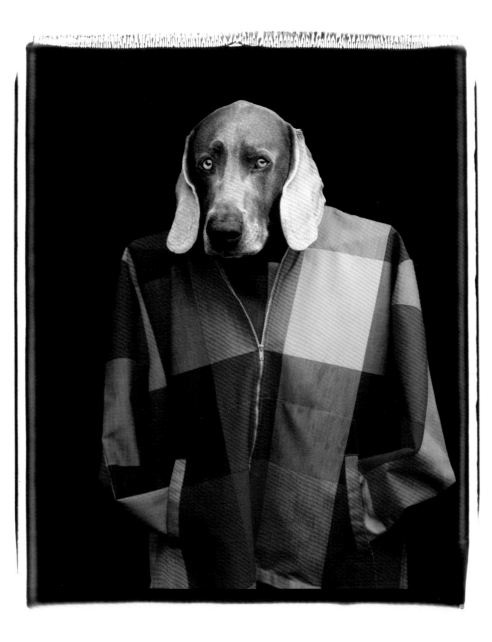

Male Model, 1994

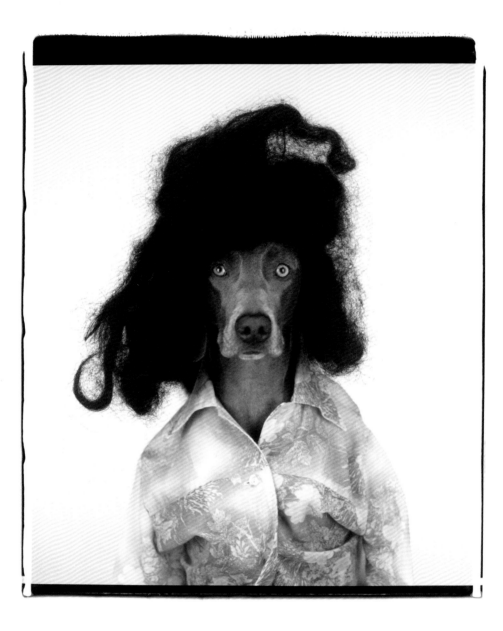

Ionian, 2005

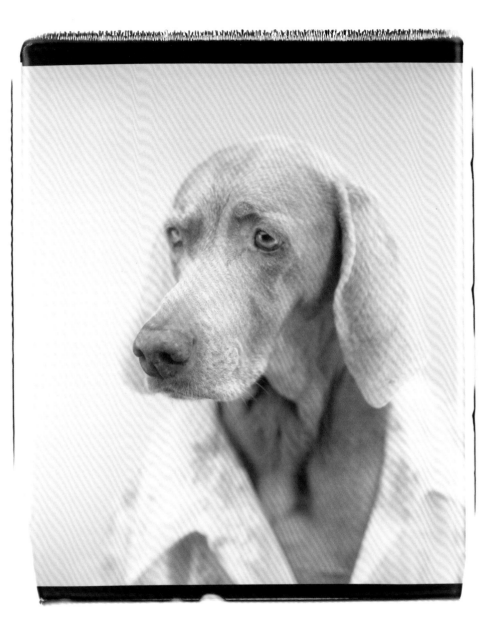

Whisper, 1998

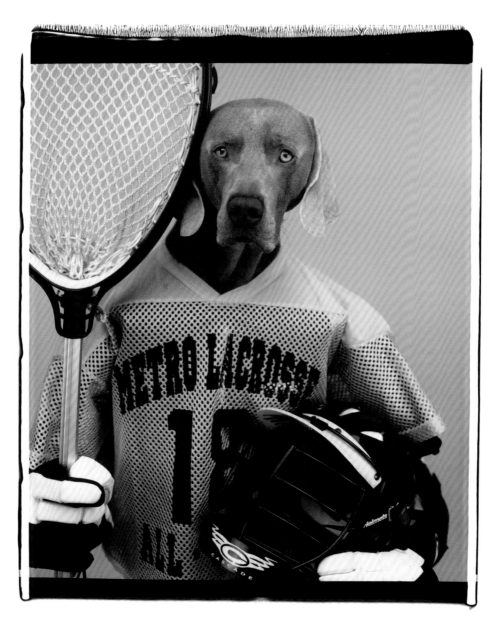

Metro, 2002

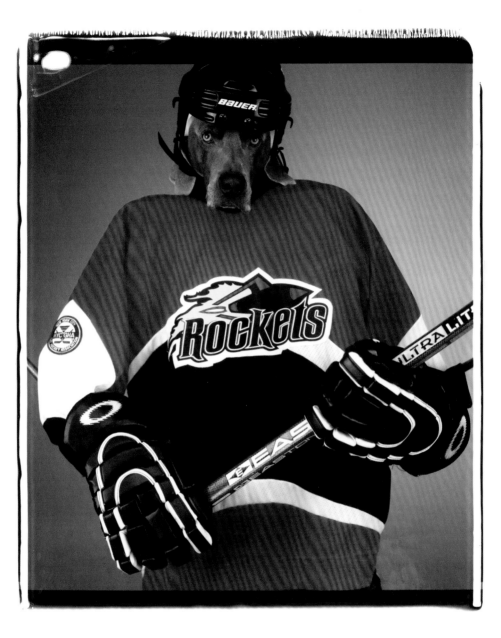

Rocket, 2005

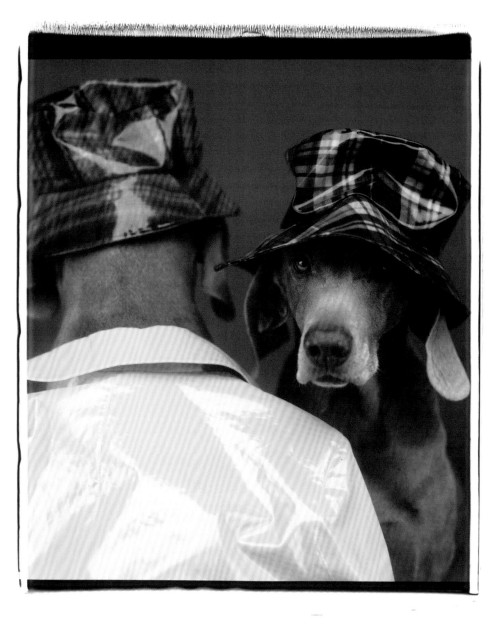

Plaid Hatter, 1999

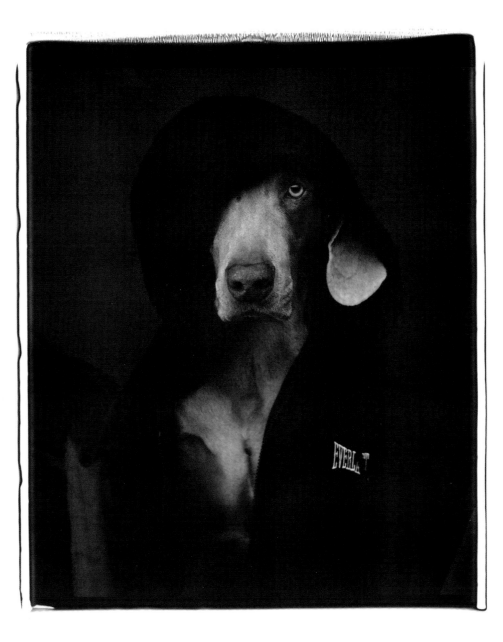

Everlasting, 2001

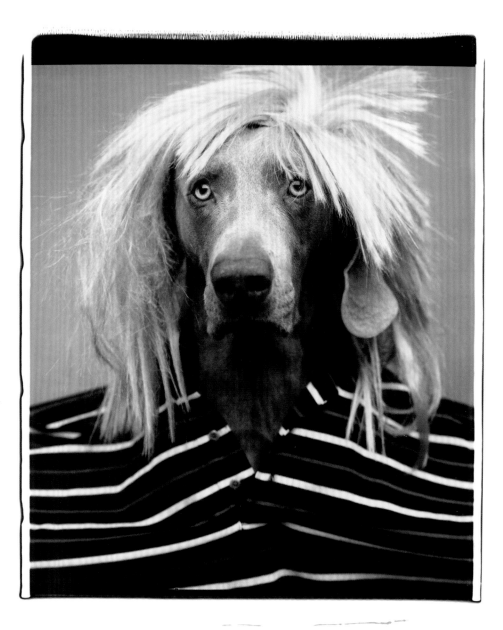

Shawn, 2000

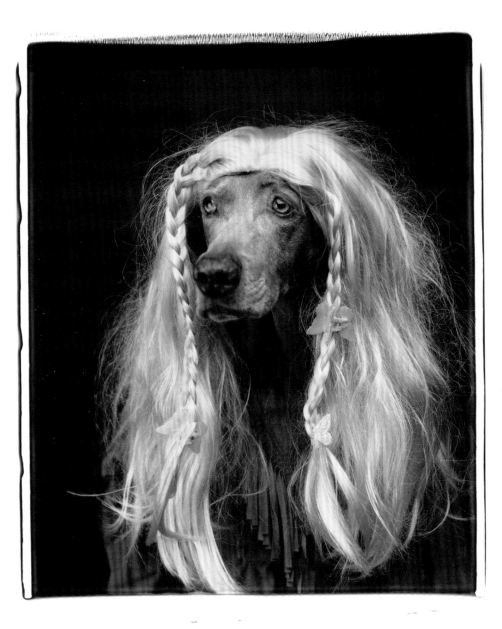

Western Blond, 2001

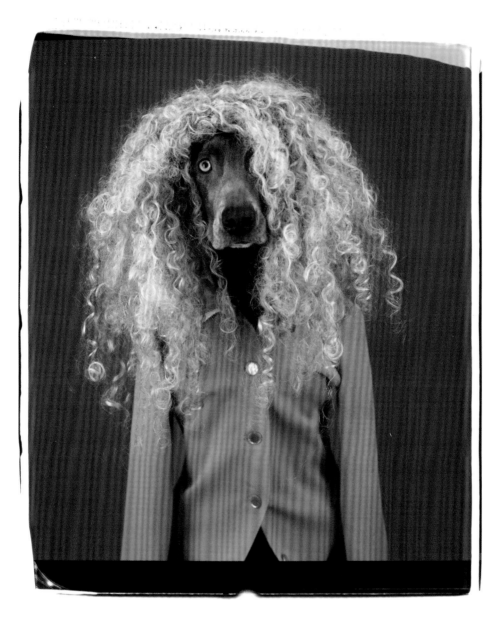

Estella, 2005

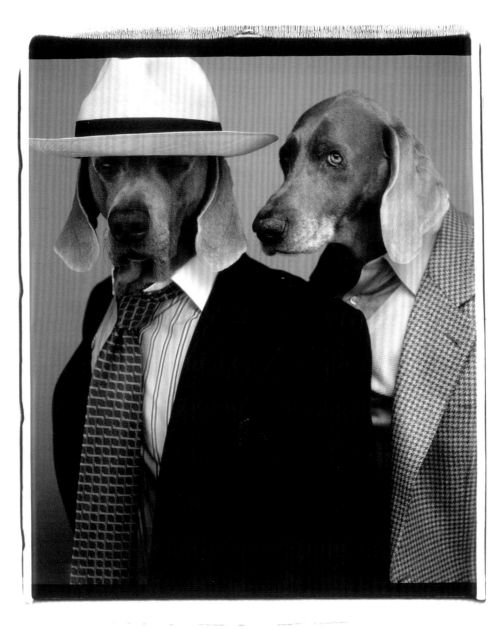

Aside, 1999

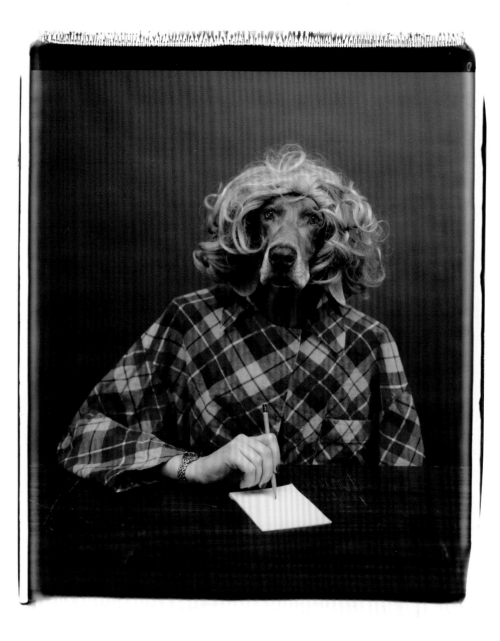

What to Do, 1995

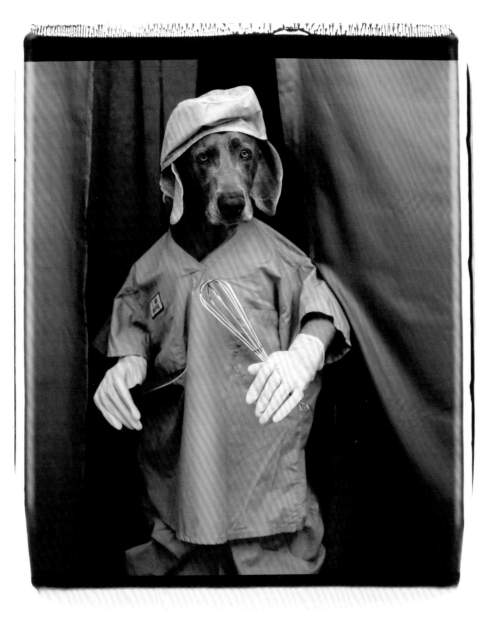

Surgeon, 1995

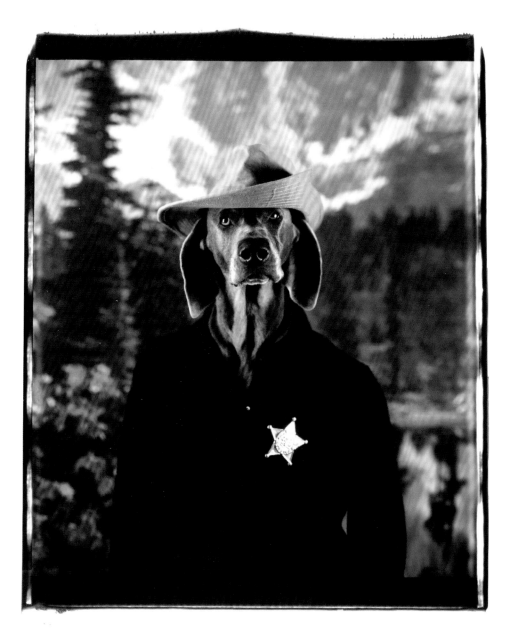

Sheriff, 1994

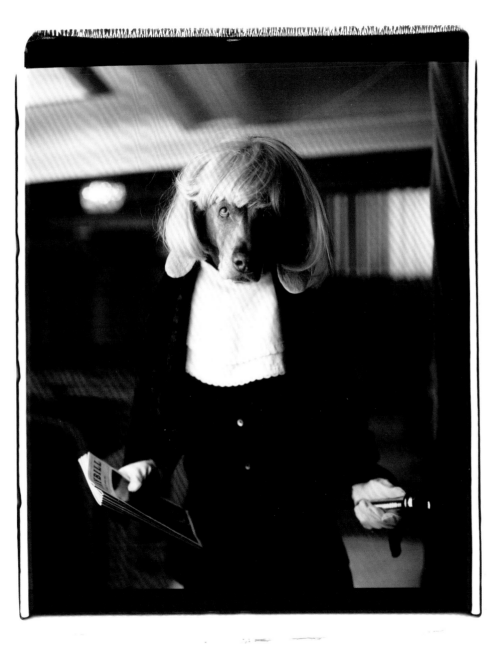

Usher, 2002

# SIT!

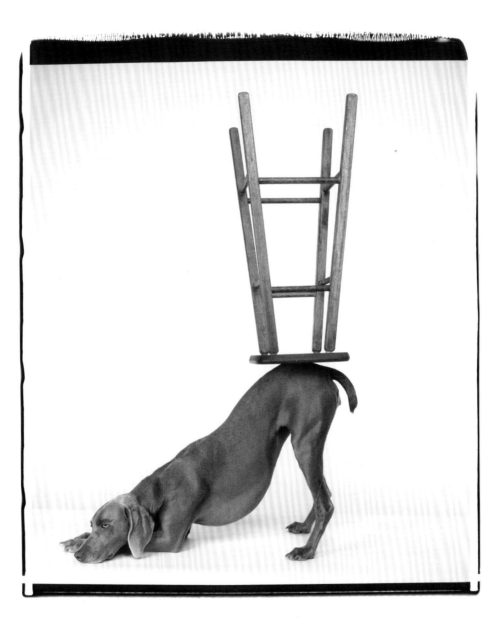

Upside Downward, 2006

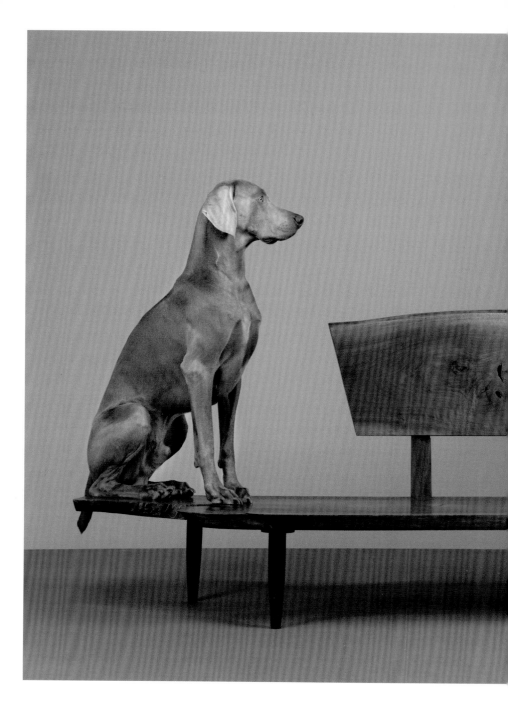

Looking Over, 2015

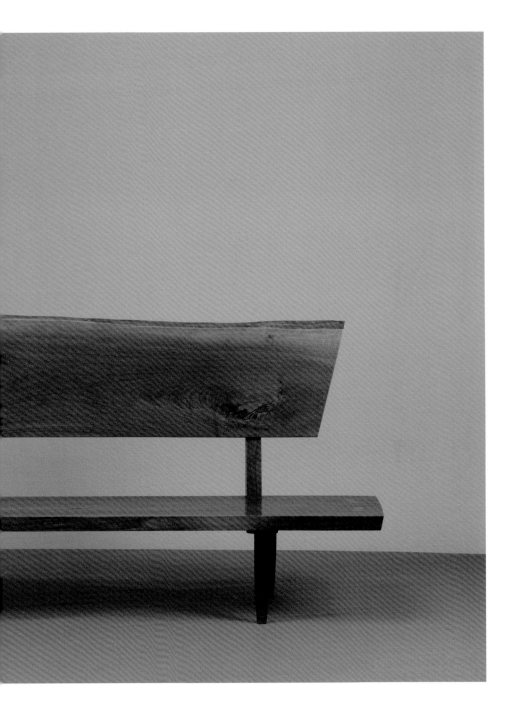

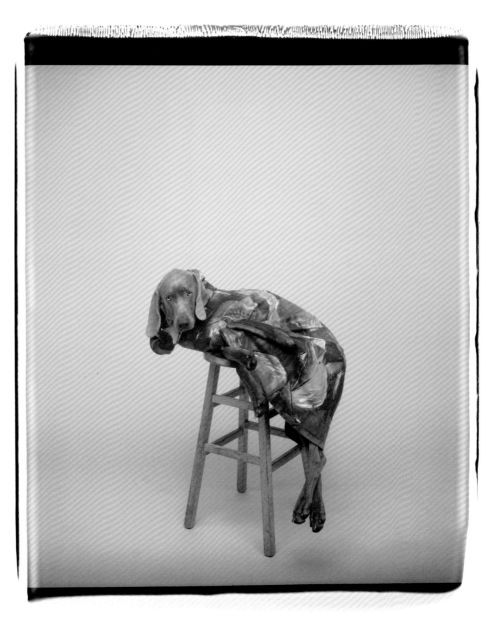

Shrimpy, 1991

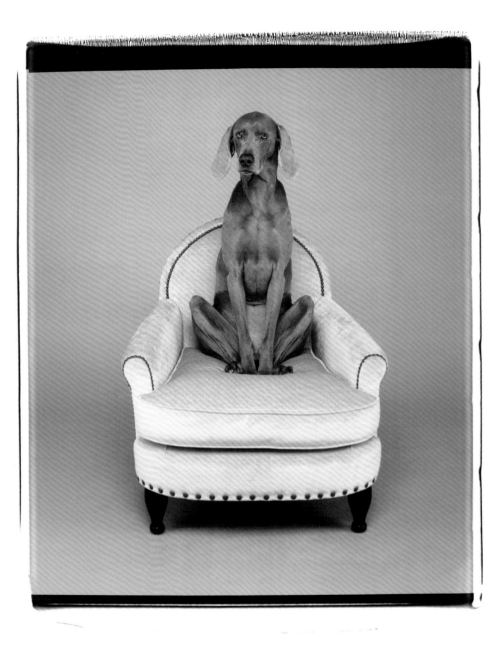

Yoga, 1997

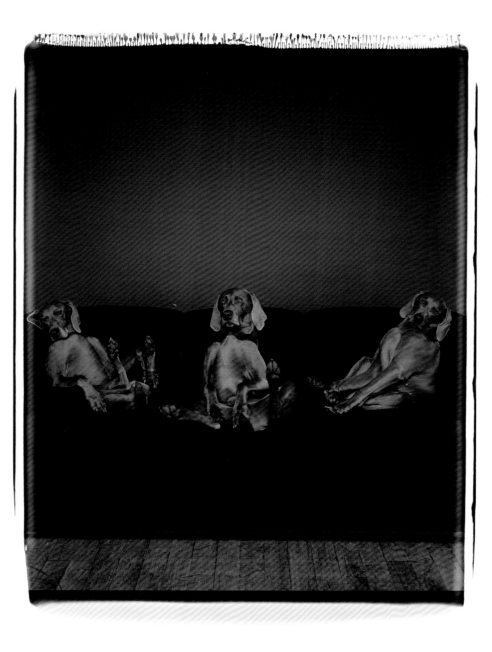

Couch On, 1994

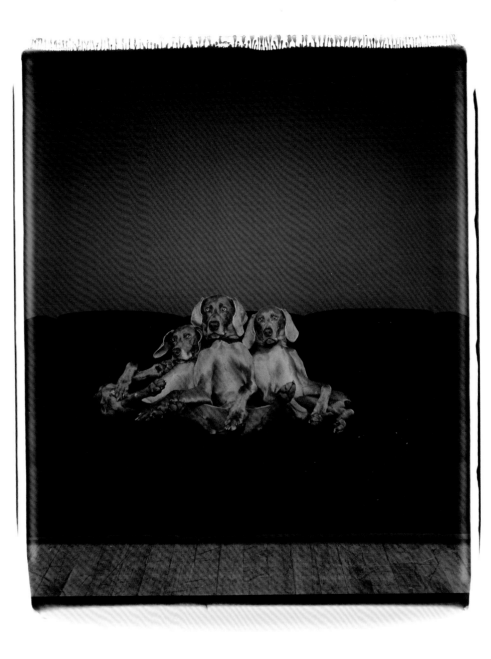

Couch Up, 1994

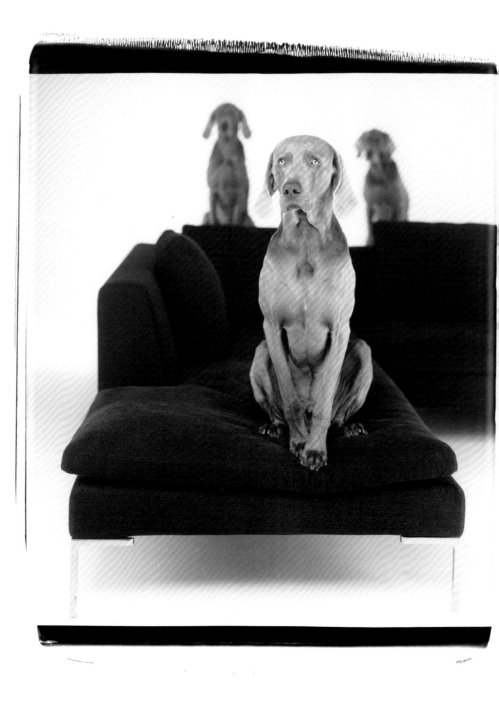

In, On and Around, 1997

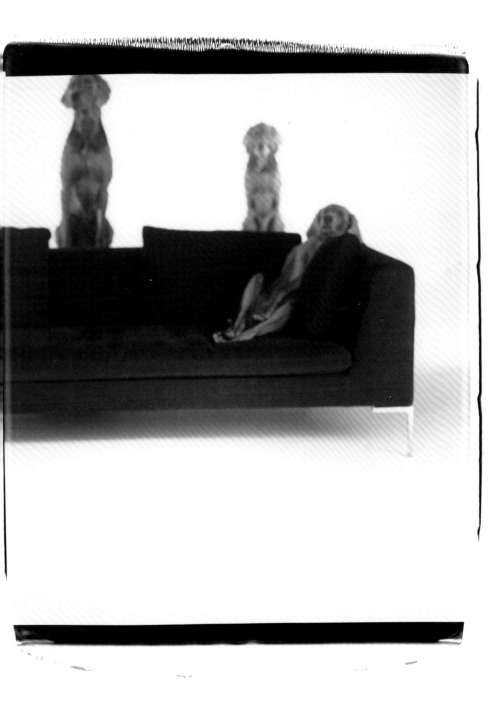

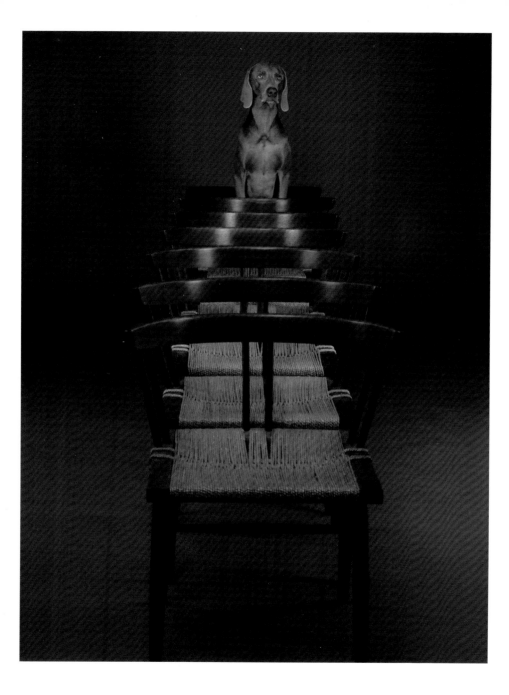

Hello Hello Hello Hello Hello, 2015

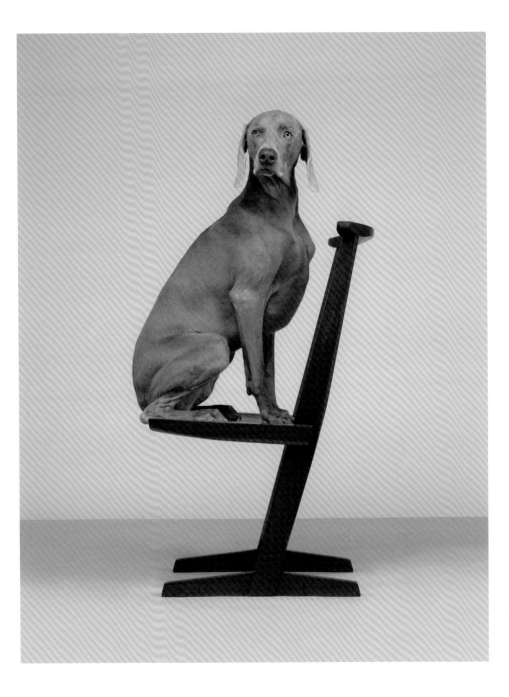

Cantilever, 2015

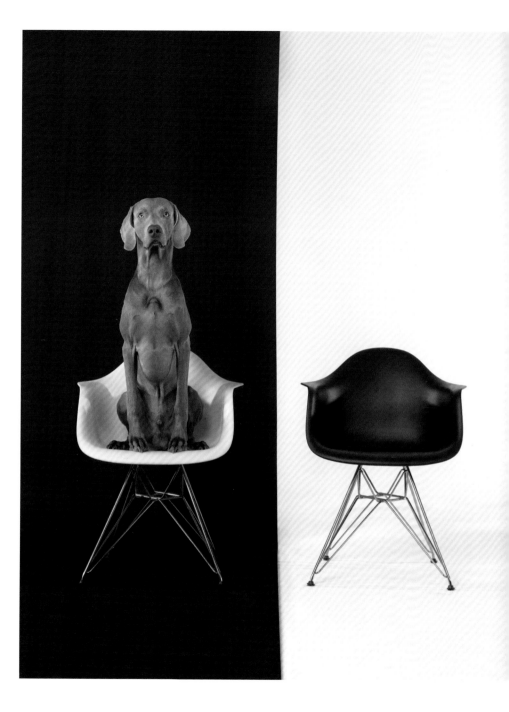

Left Right Black White, 2015

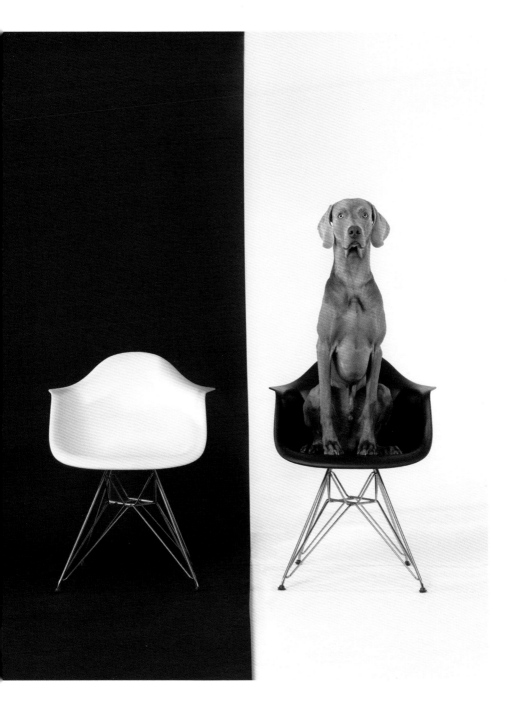

On Up, 2015

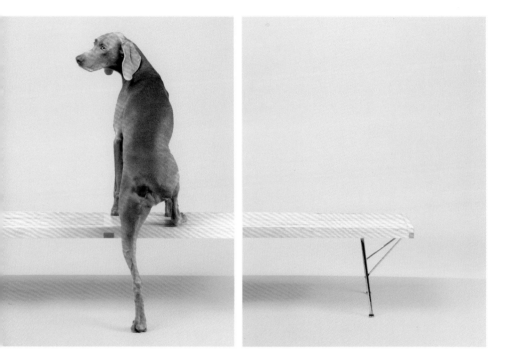

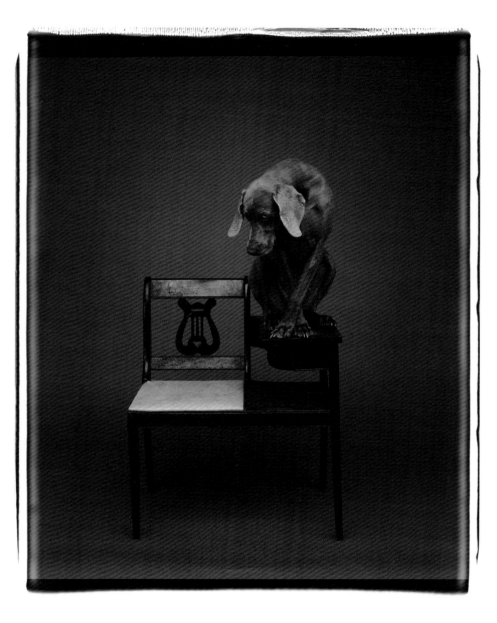

Crossed Lines, 1990

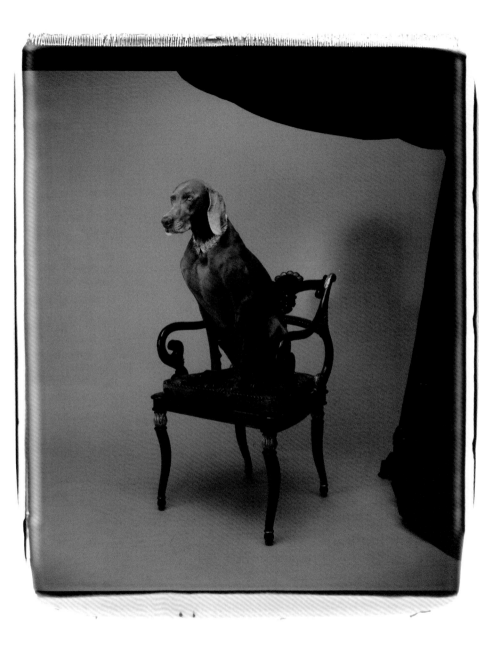

Evil Empress, 1992

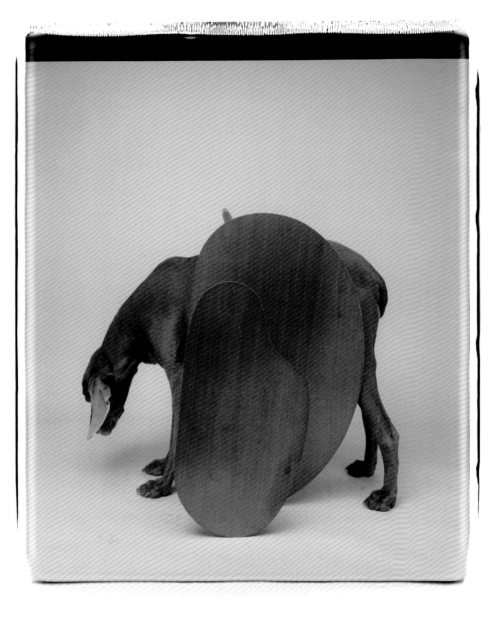

Palette, 1992

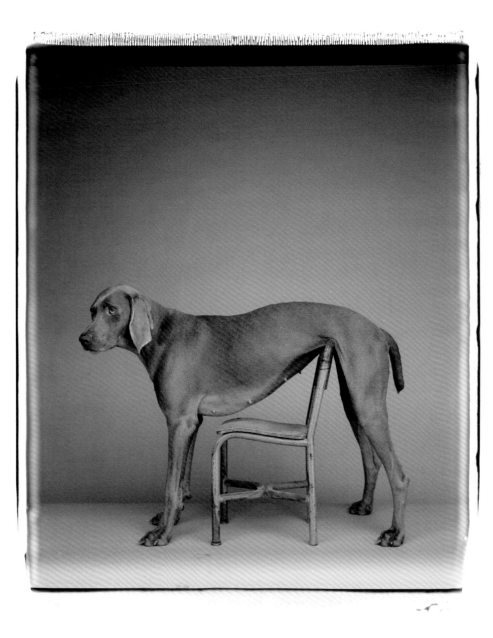

Hung Up, 1992

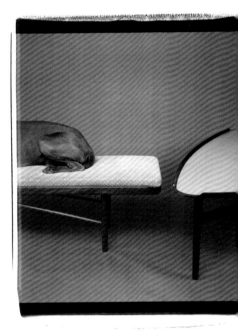

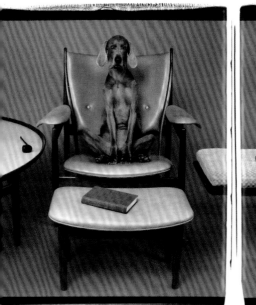
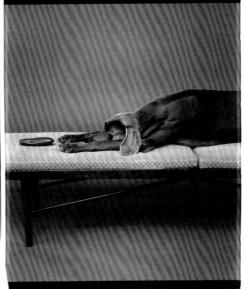

Freudian, 1997

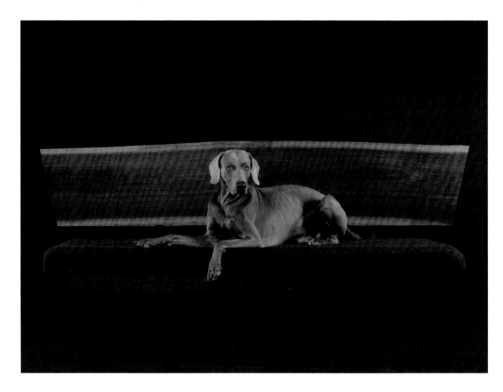

Benchmark, 2015

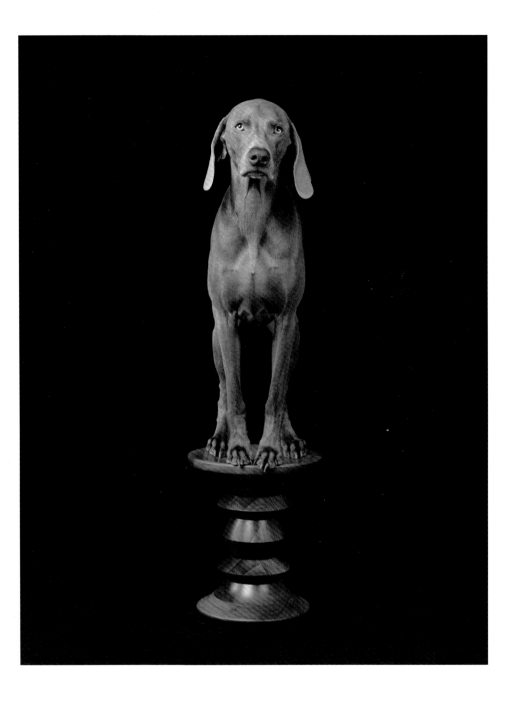

Figured Base, 2015

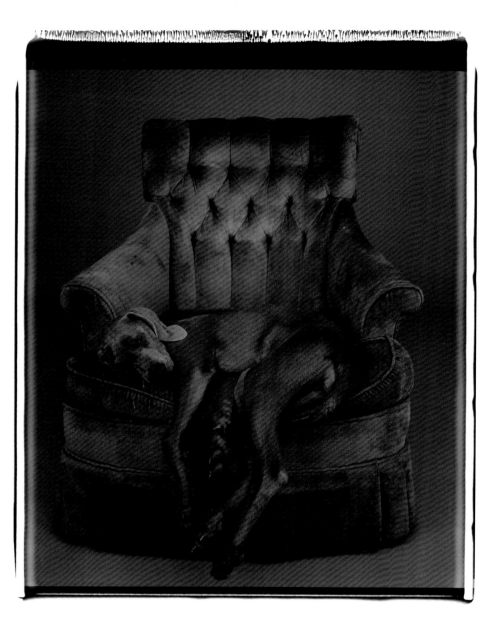

Very Tired, 1989

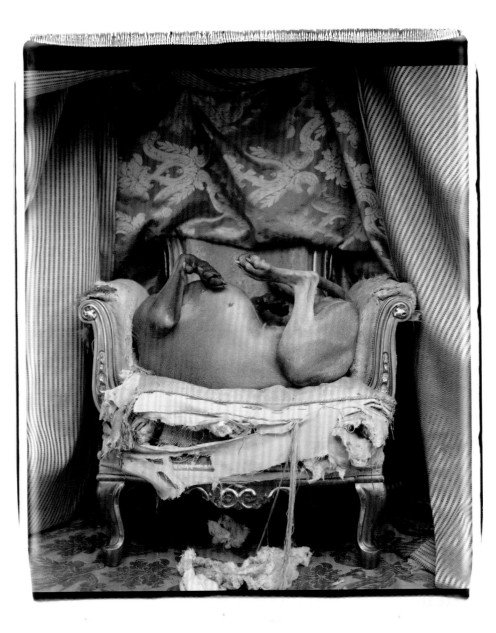

Looks and Comfort, 1992

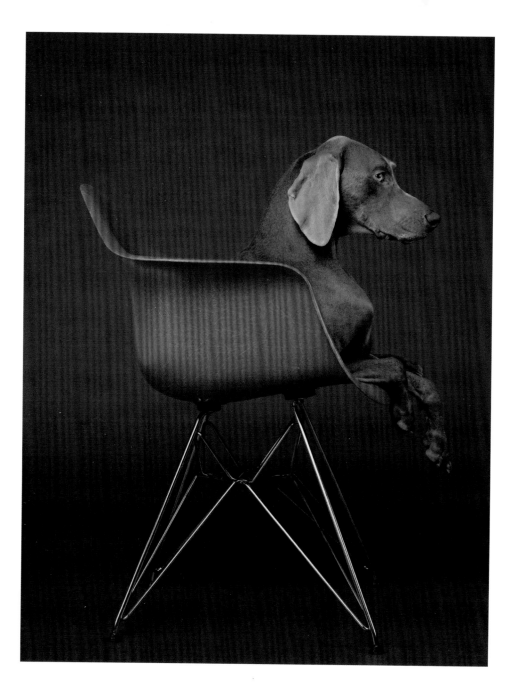

Eames Low, 2015

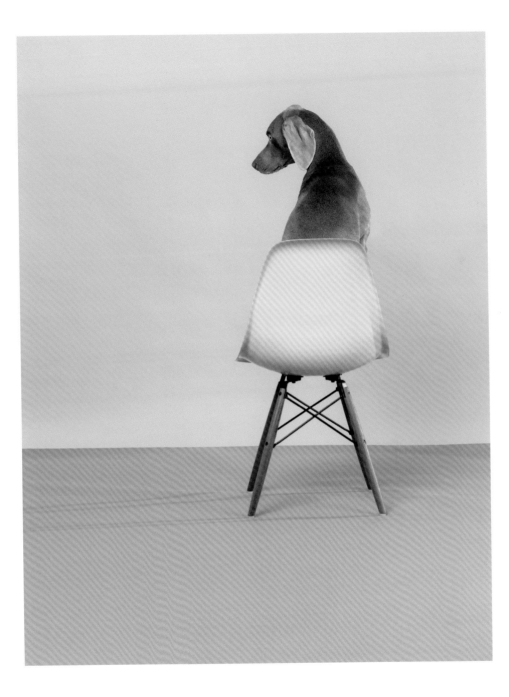

Ocean View, 2015

# TALES

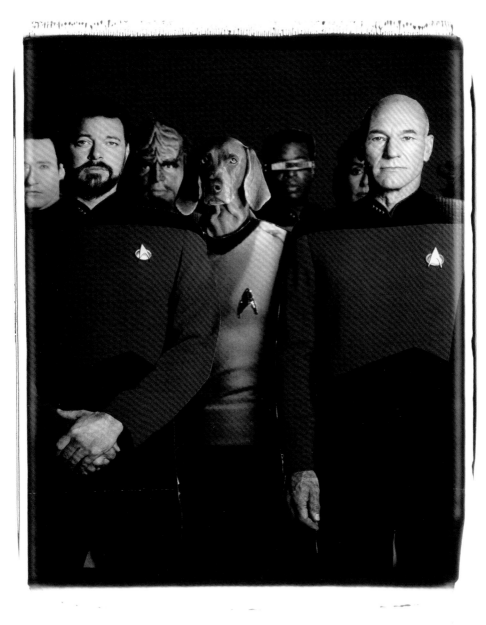

Crew, 1995

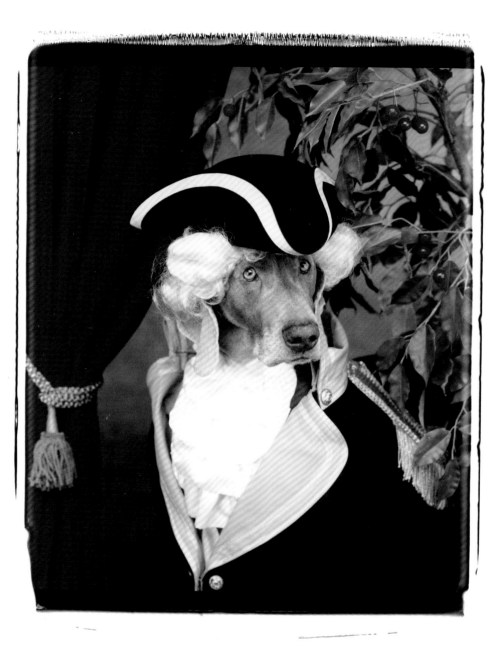

George Washington I Presume, 1997

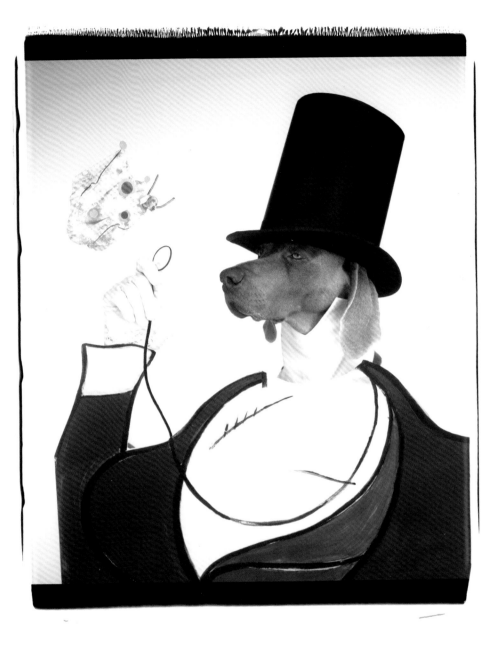

Eustace Tilley, 1999

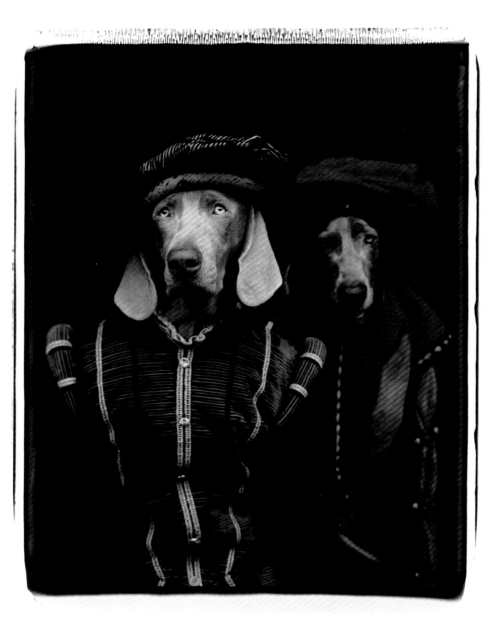

The Deal, 1996

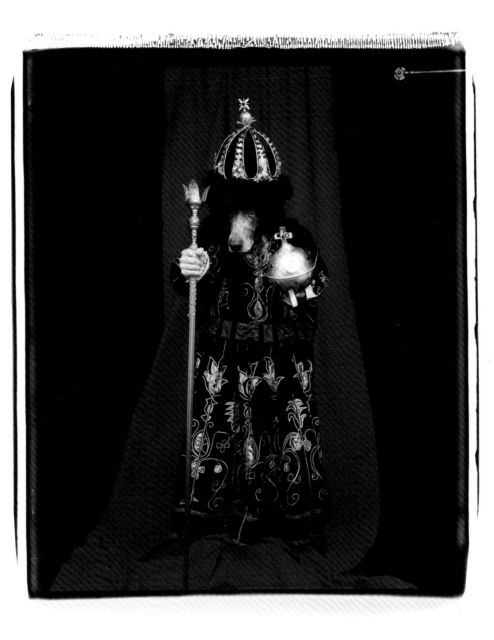

Boris' Stand, 1996

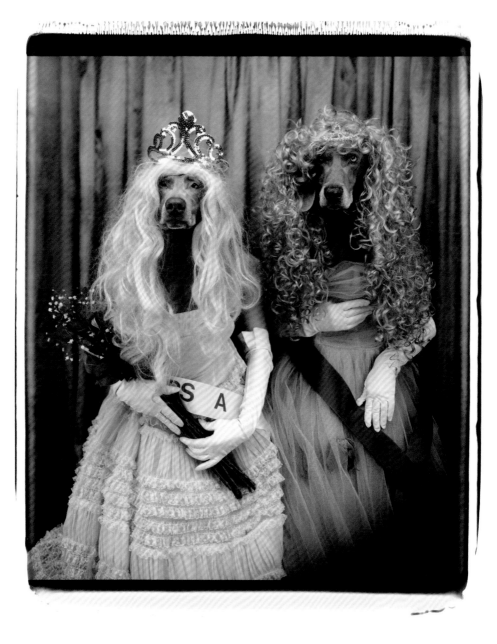

Miss & Misses, 1995

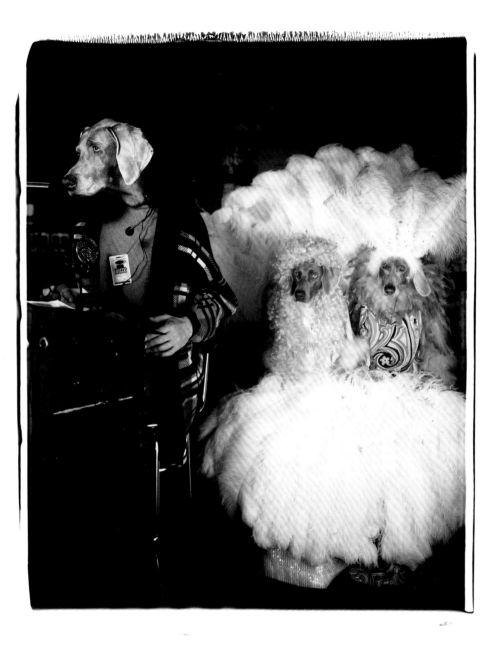

Lighting Director, 2002

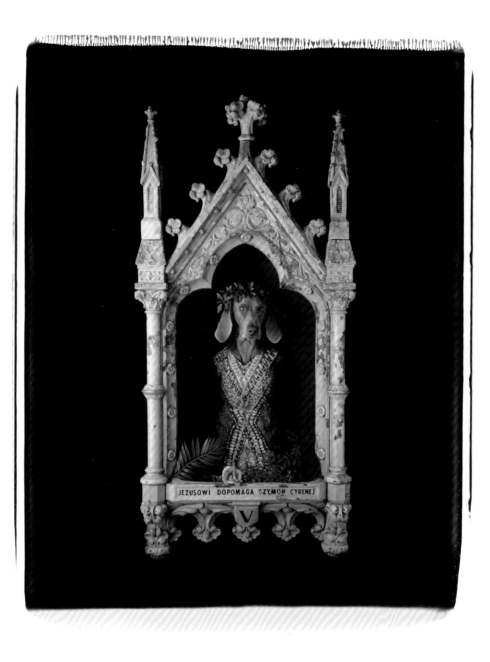

Niche, 1993

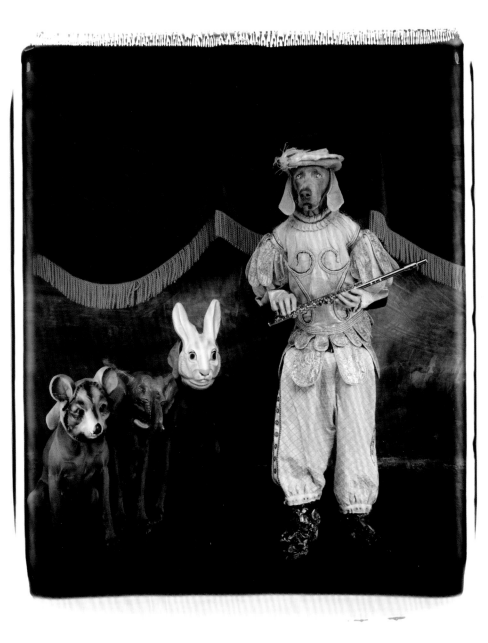

Tamino with Magic Flute, 1996

Madame Butterfly, 1997

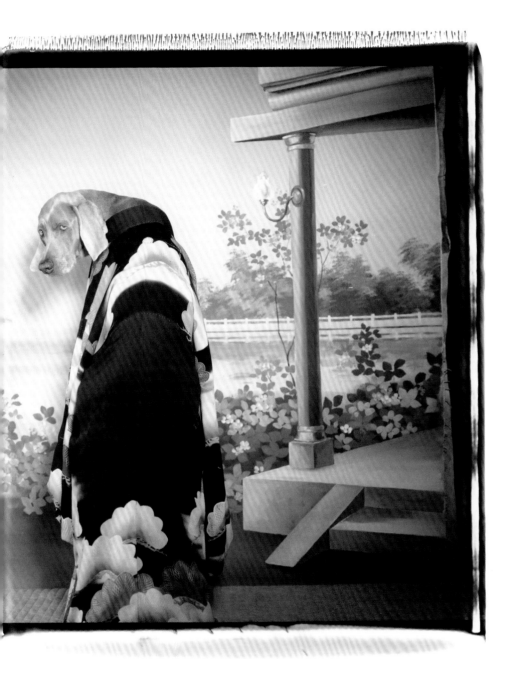

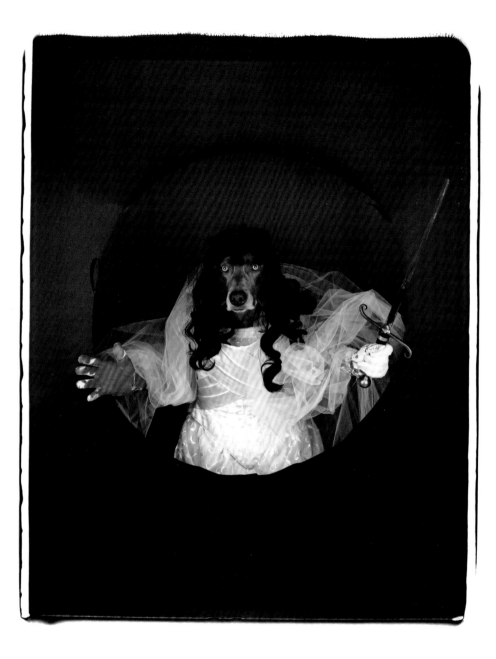

Lucia, 2007

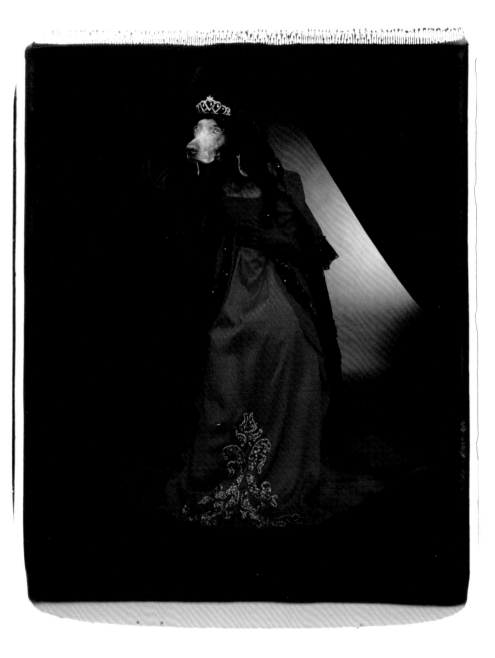

Tosca, 1996

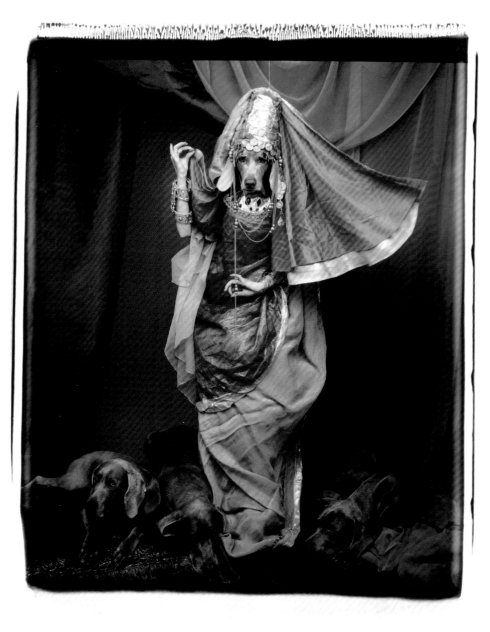

ABOVE: Salome, 1996

OPPOSITE: Canon Aside, 2000

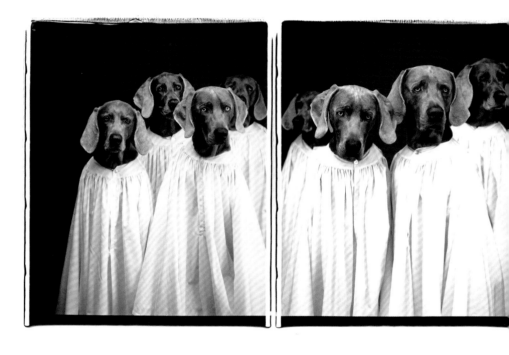

Choristers, 2000

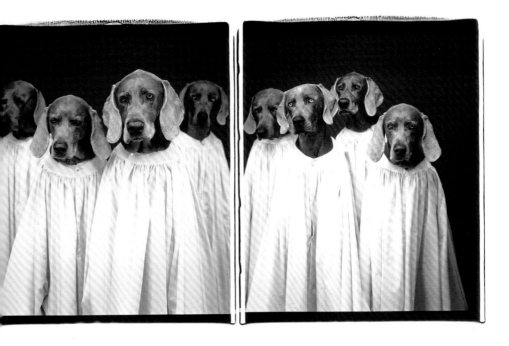

# COLOR
# FIELDS

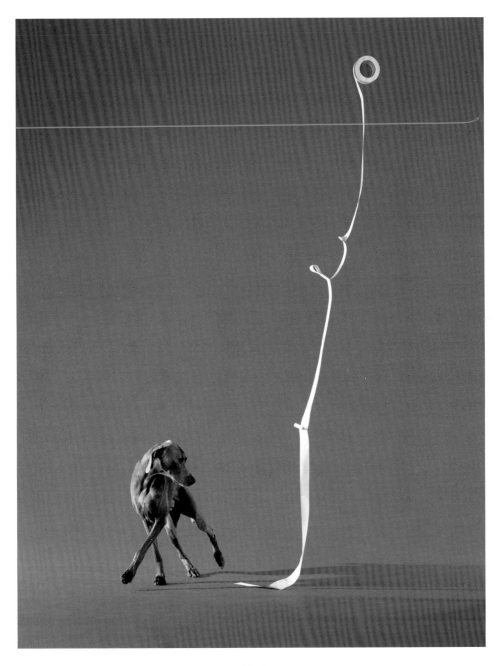

Cursive Display, 2013

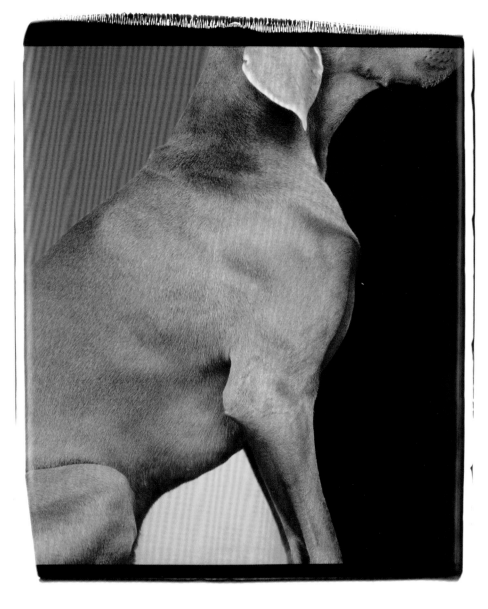

Léger, 1998

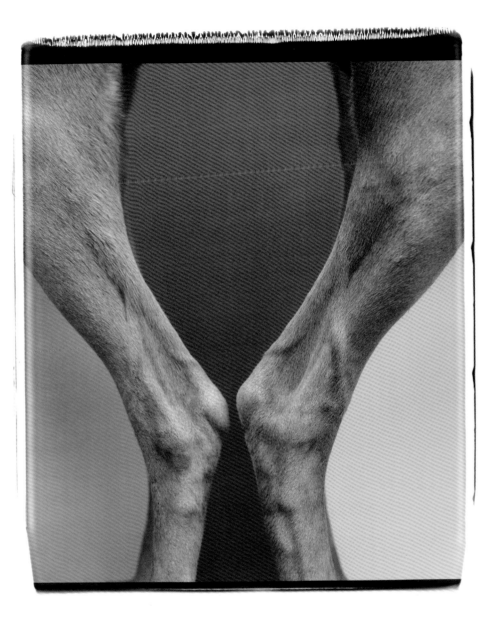

Red Wine, 1998

Two to One, 1989

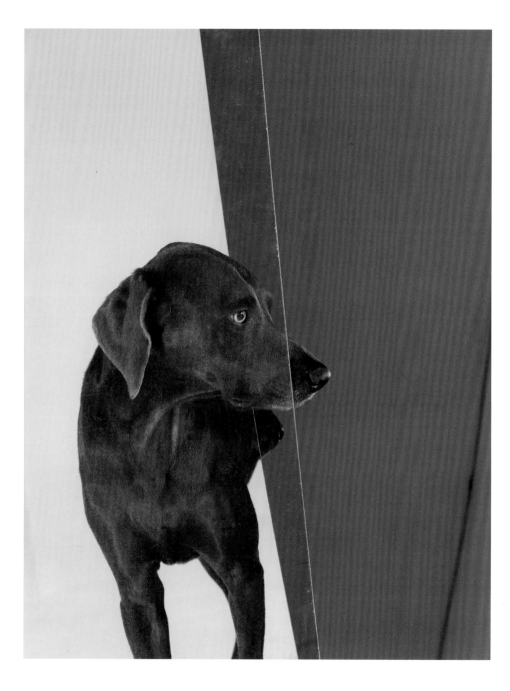

Nosy Blue, 2008

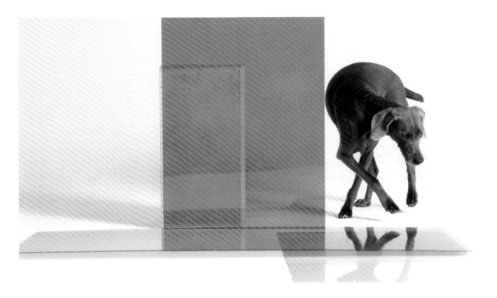

Hop To, 2008

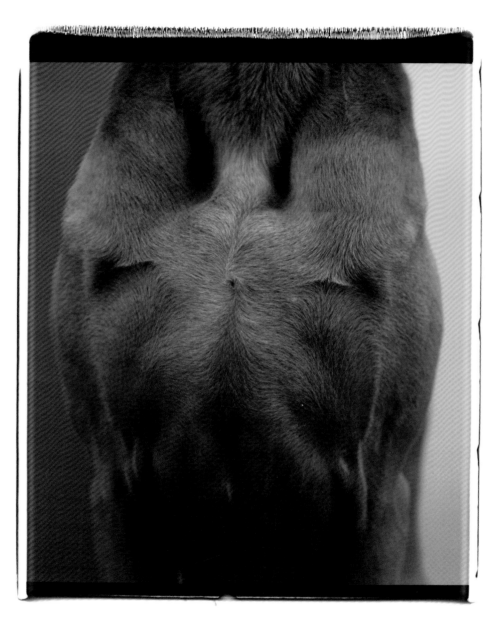

Frontal, 1998

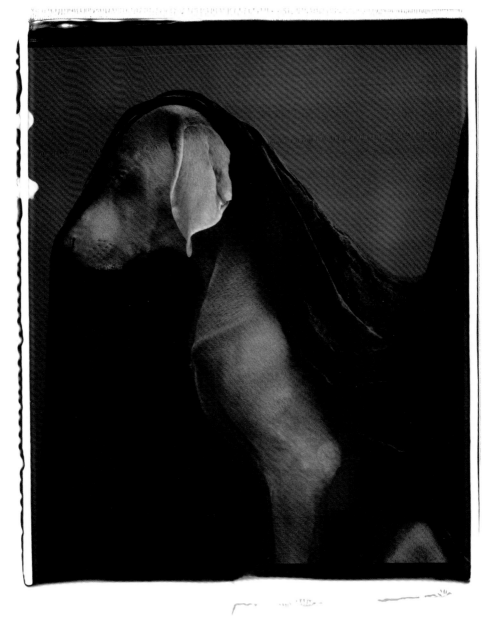

Cloak, 1999

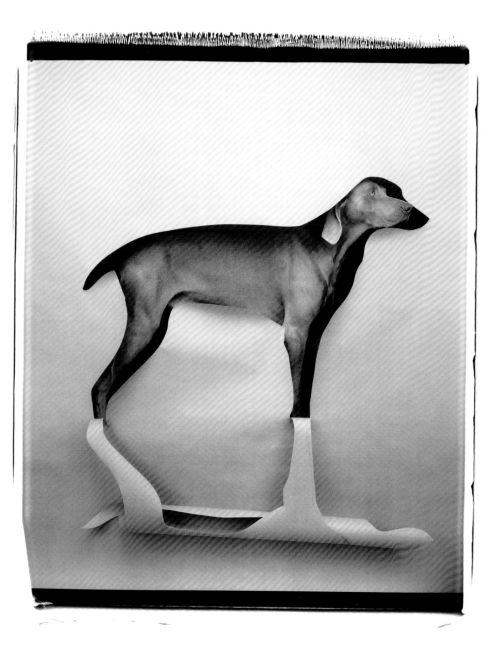

Cut to Reveal, 1997

Trotsky, 2008

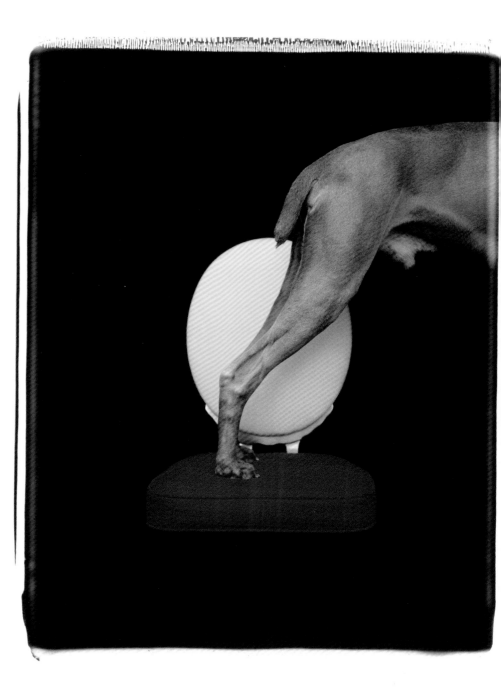

Red to Yellow, 1992

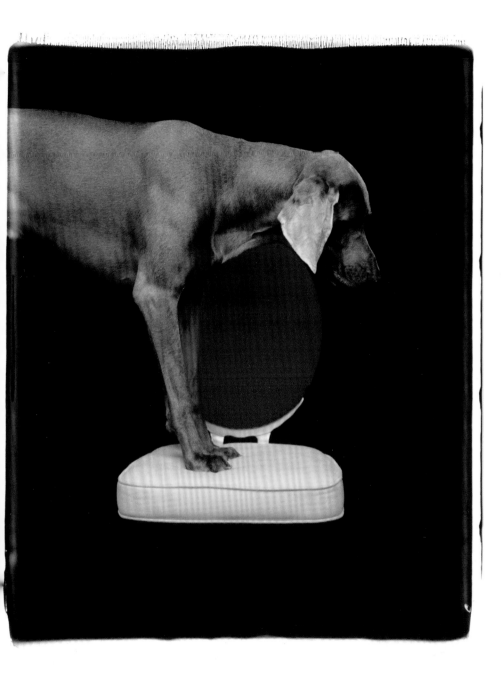

Place Mat, 2008

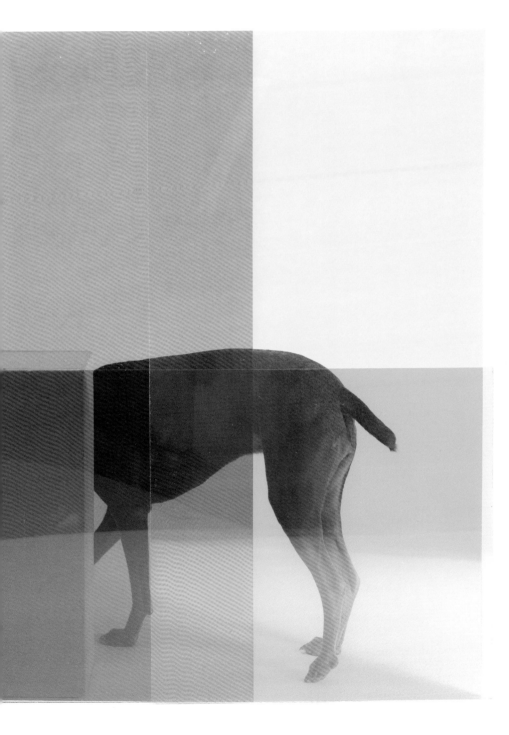

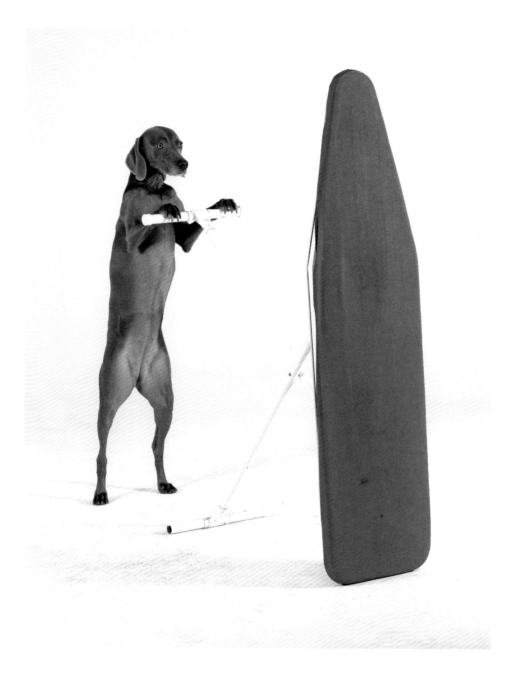

Driver, 2008

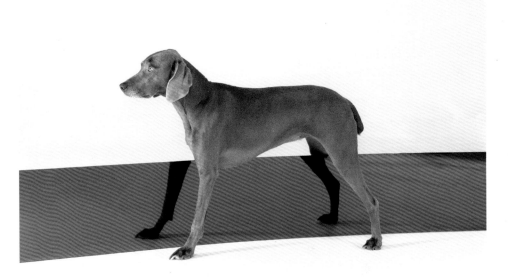

Leg Wand, 2008

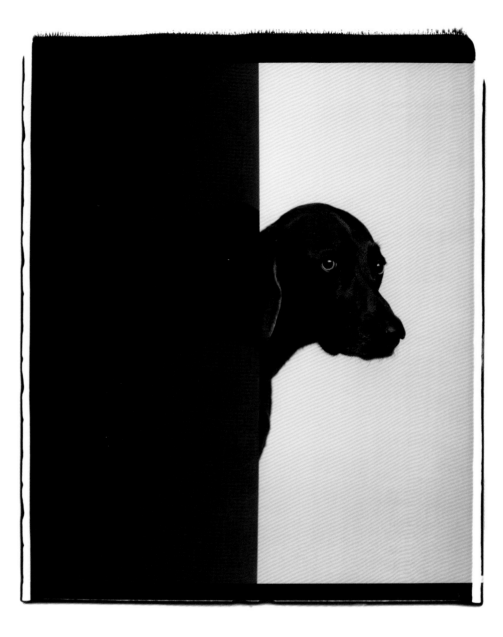

The Dark Side, 2007

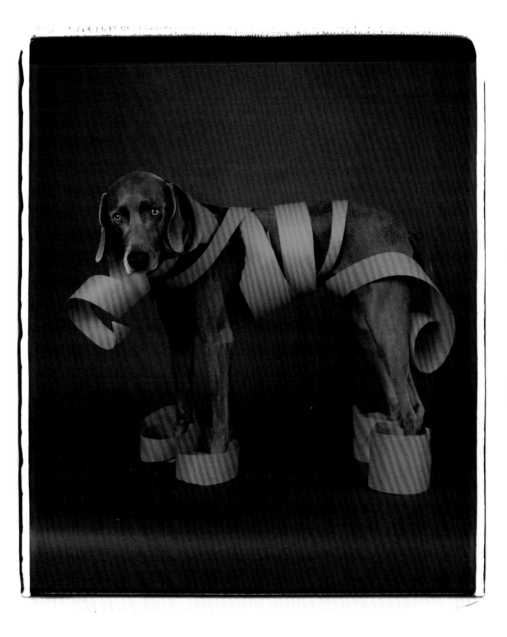

Spiralette, 2007

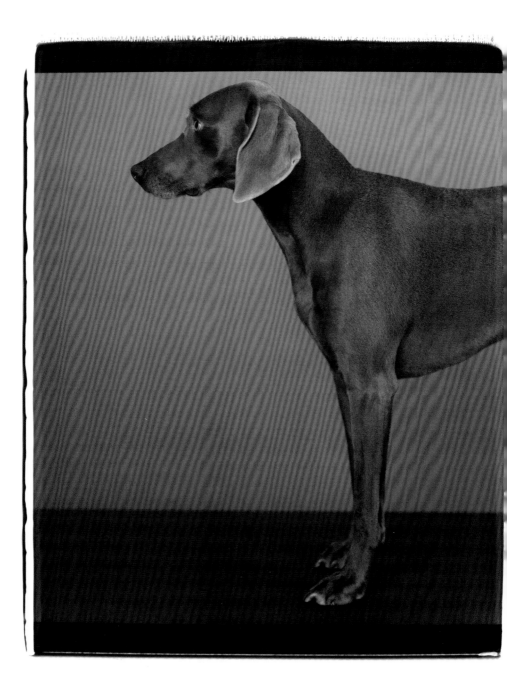

Rustic Placement, 2007

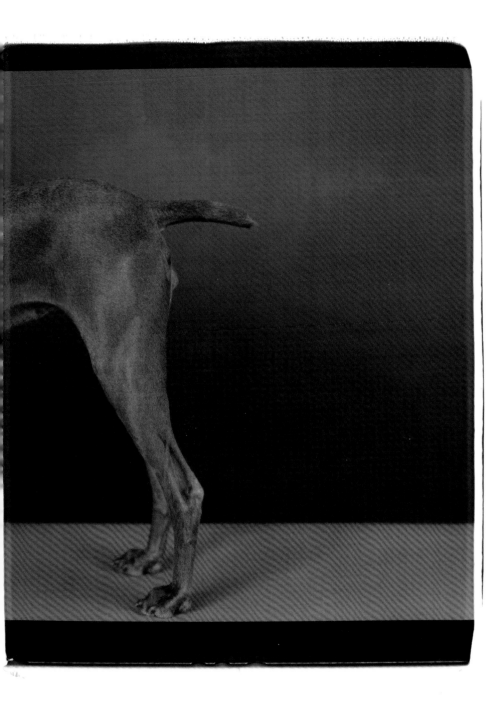

# DISGUISE

Fall Preserve, 1981

One of the Senses, 1996

Camo, 1990

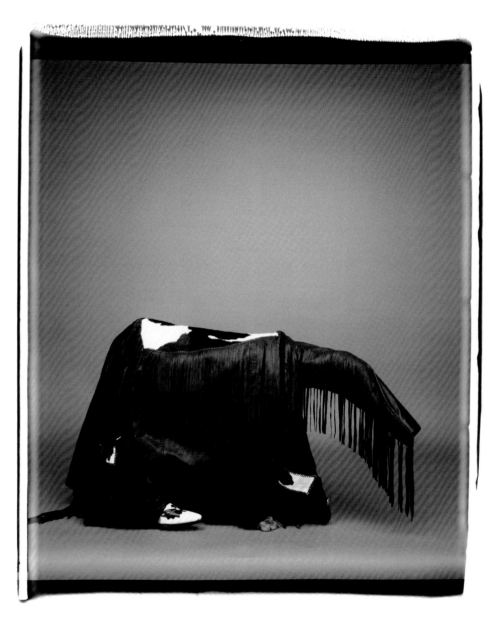

Fringe Benefit, 1989

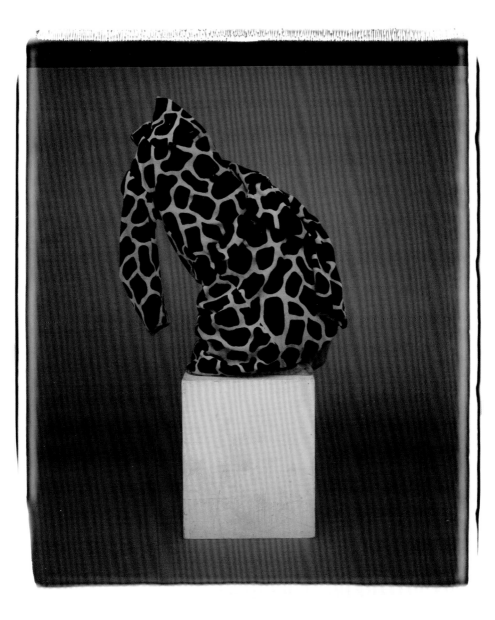

Giraffelant, 1987

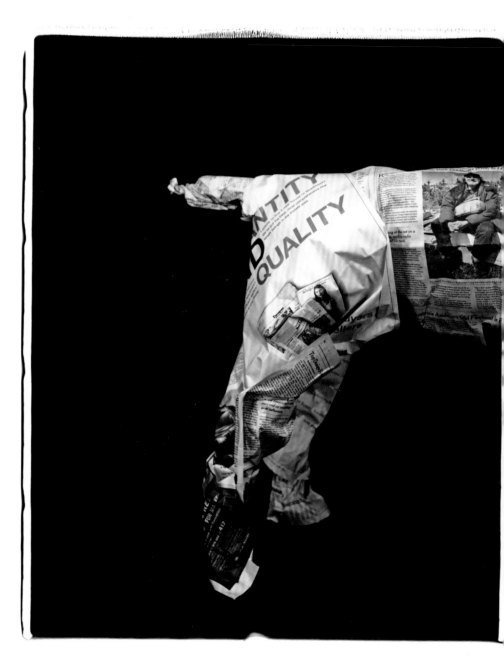

Newsworthy, 2004

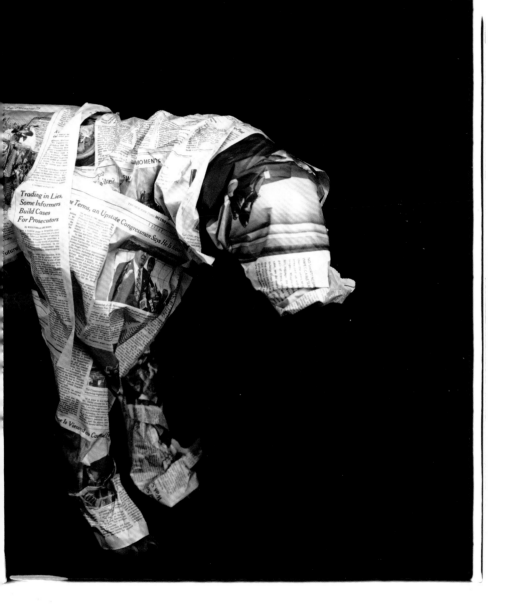

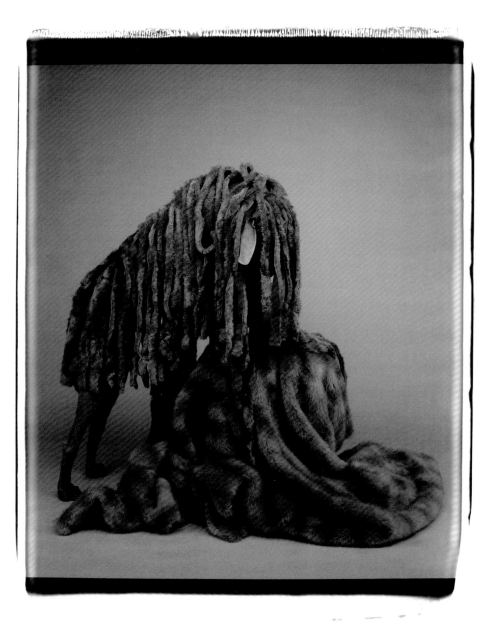

Grouped Fur, 1990

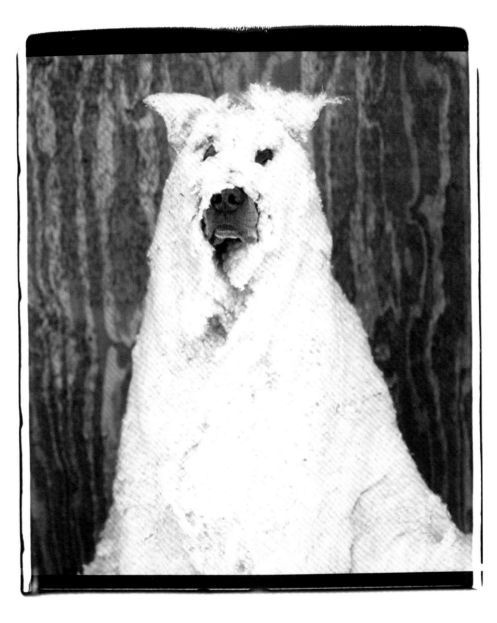

The Sheepish Dog, 2007

Floor Piece, 1990

Figurative, 1990

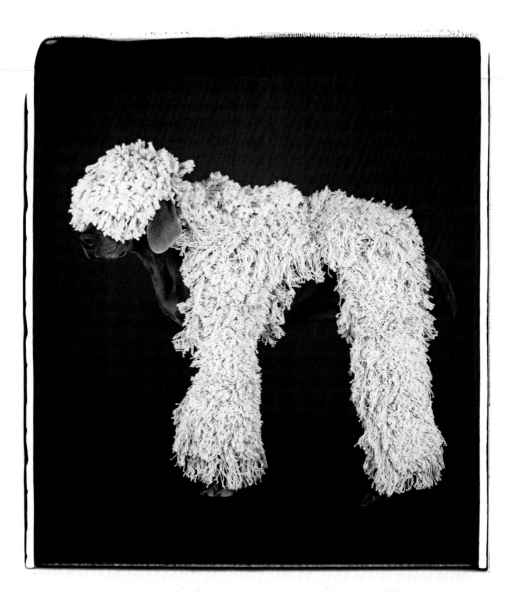

Pony Mop, 2007

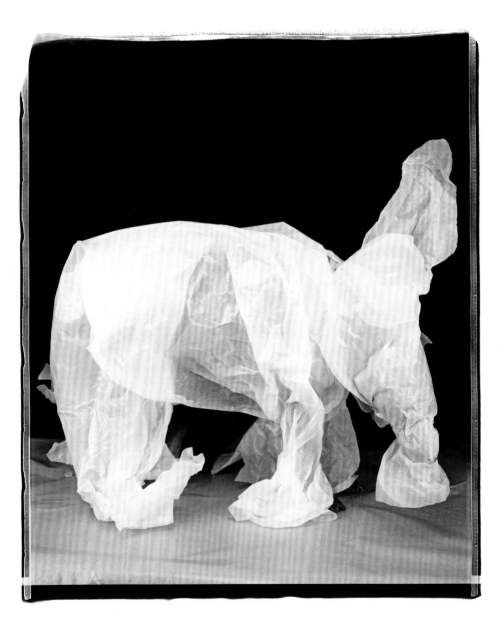

Tissue Tango, 2004

# TERRAIN

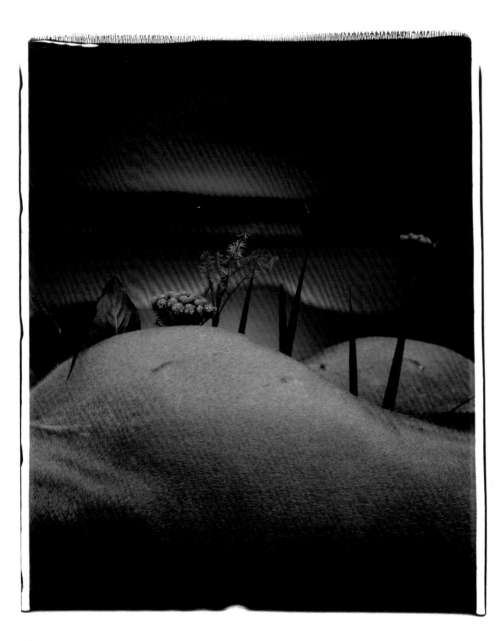

Time Garden, 2001

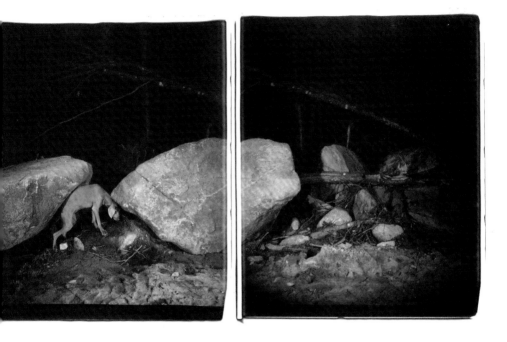

Mythological, 1997

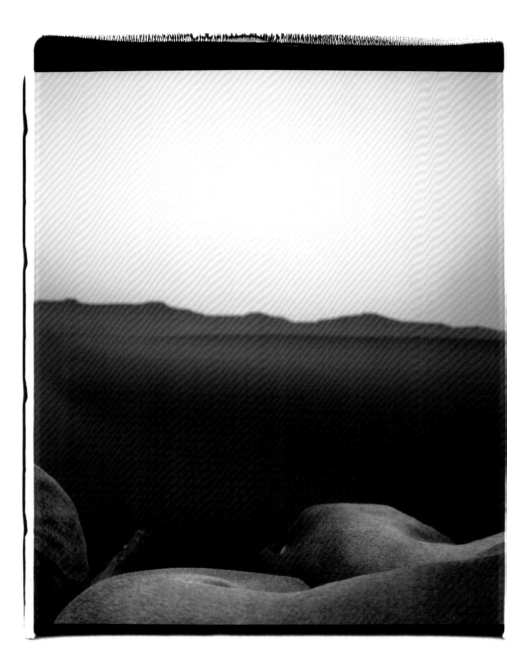

Nevadada, 2000

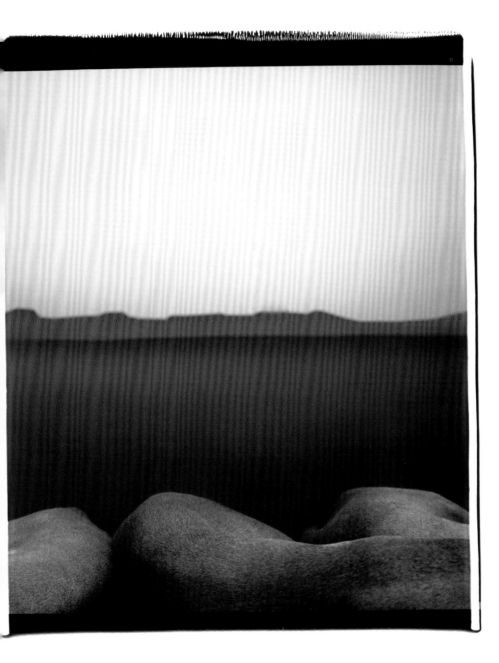

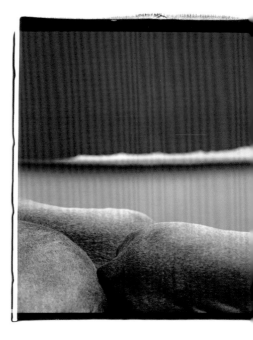

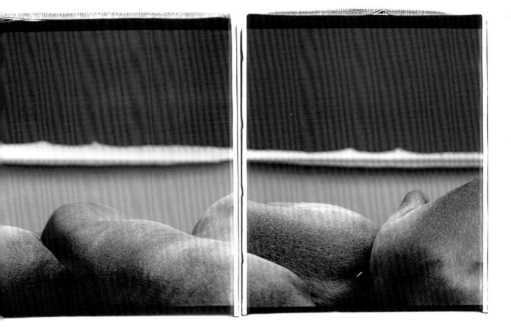

Breakers, 1999

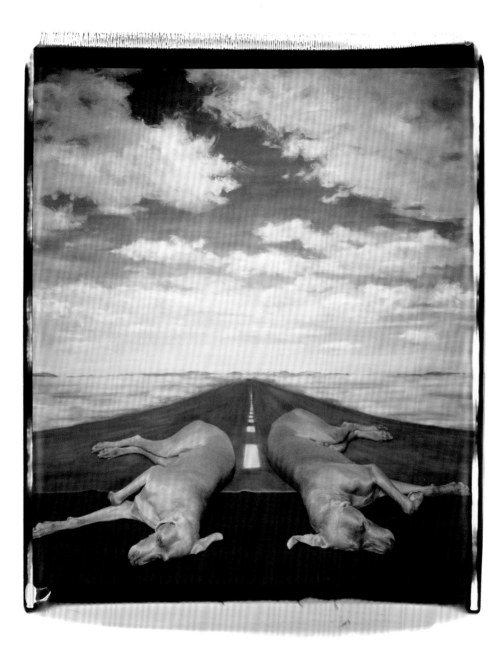

End of the Road, 1997

The Deal with the Surreal, 1994

Iceland, 2003

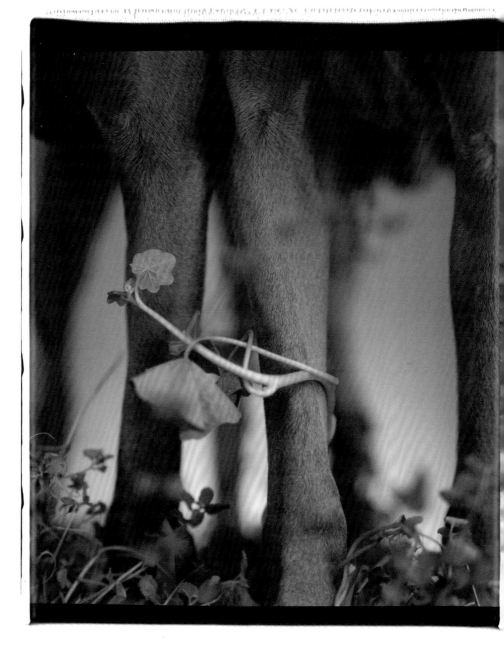

Garden, 2002

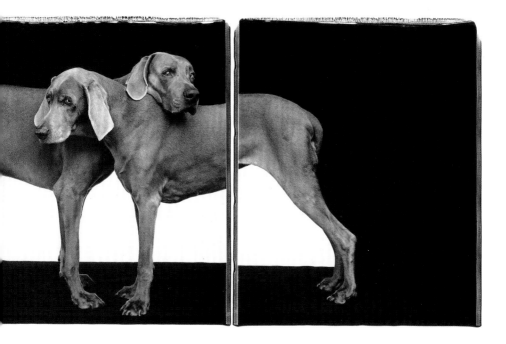

Cave, 2000

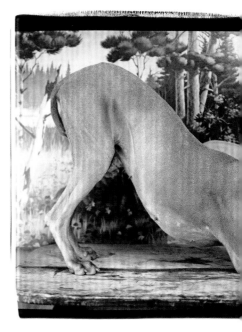

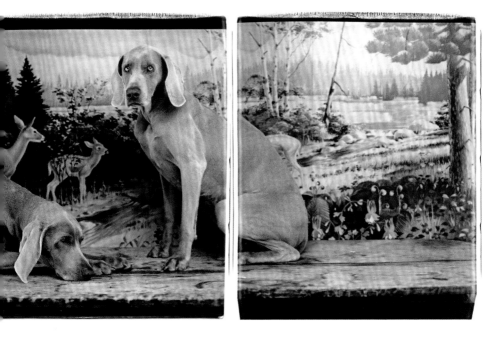

Diorama, 1997

# STYLE

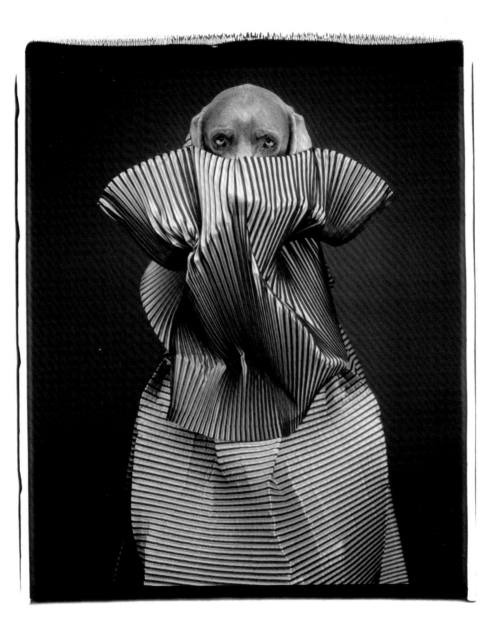

Evolution of a Bottle in Space V, 1999

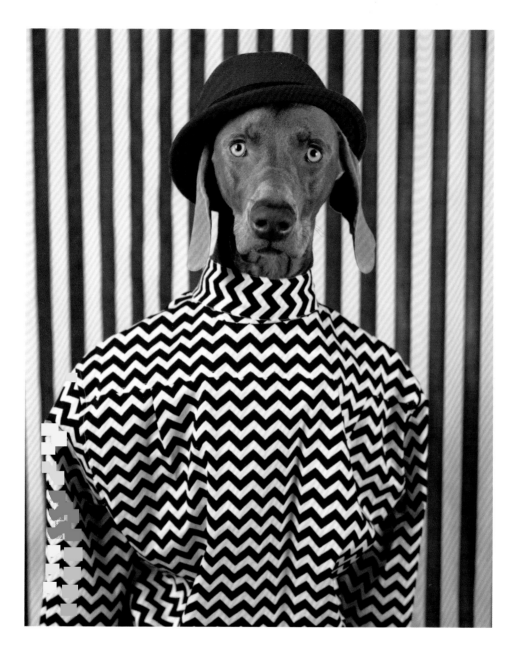

This & That, 2012

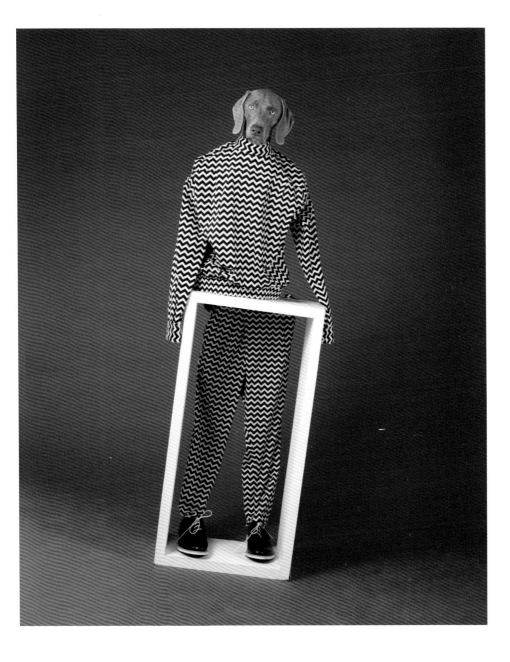

Upper Lower Inner Outer, 2012

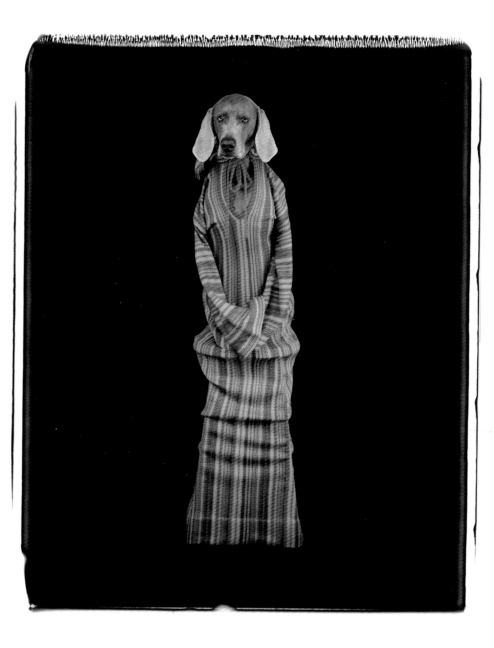

Vertical Lines, 1998

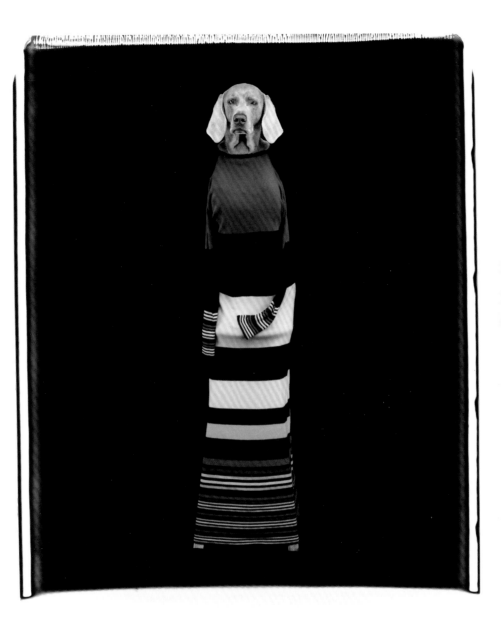

Horizontal Lines, 1996

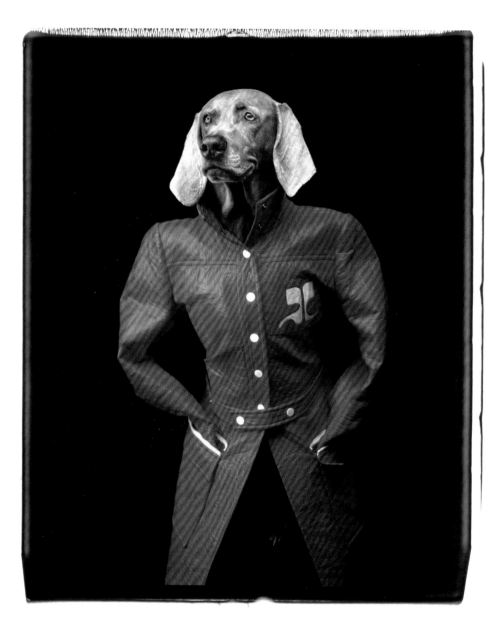

Courrèges, 1998

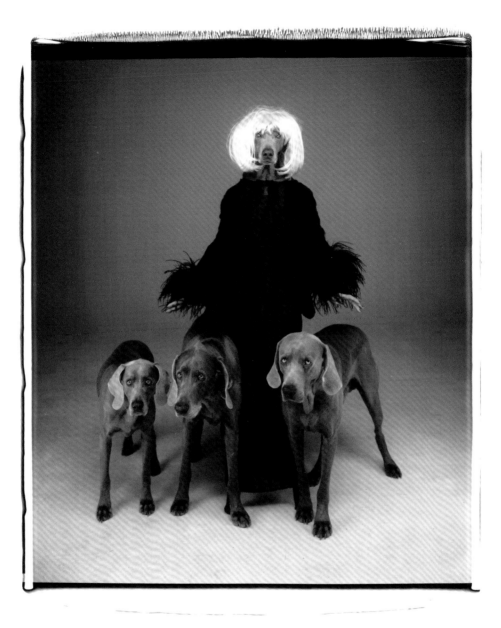

Posse, 1999

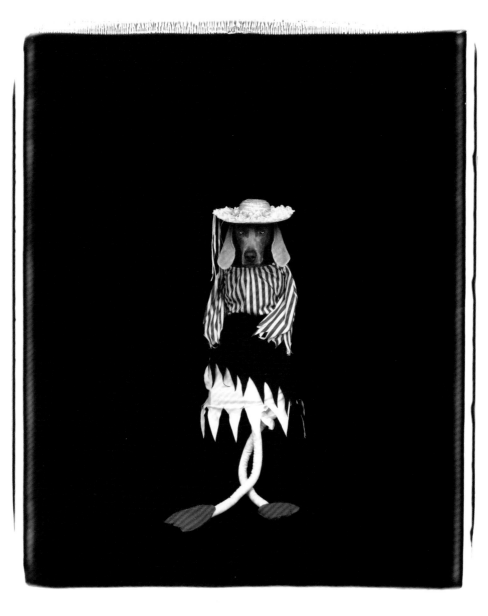

Kind of Bird, 1993

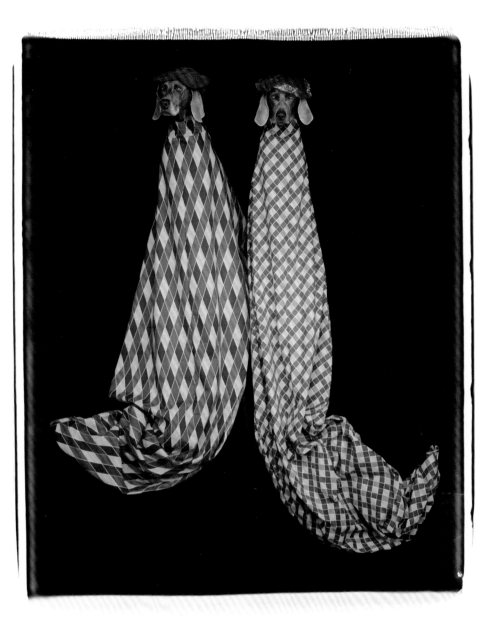

Twisted Sisters, 1992

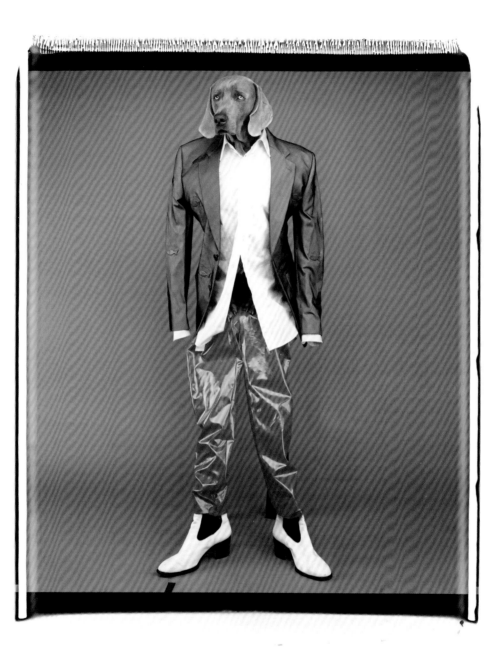

Dressed to Boots, 1996

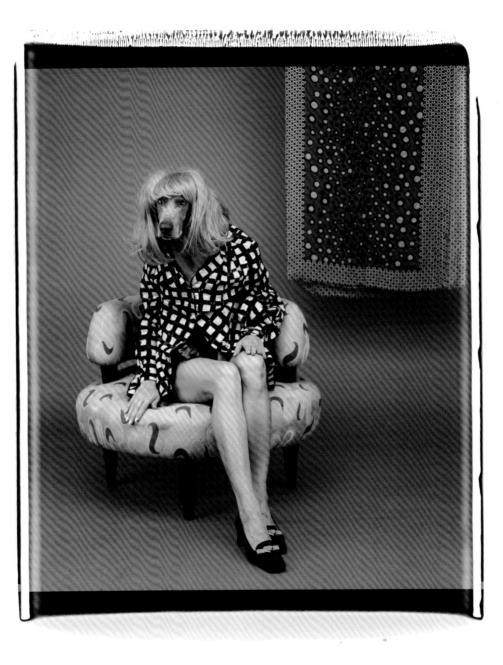

Seated Figure, 1996

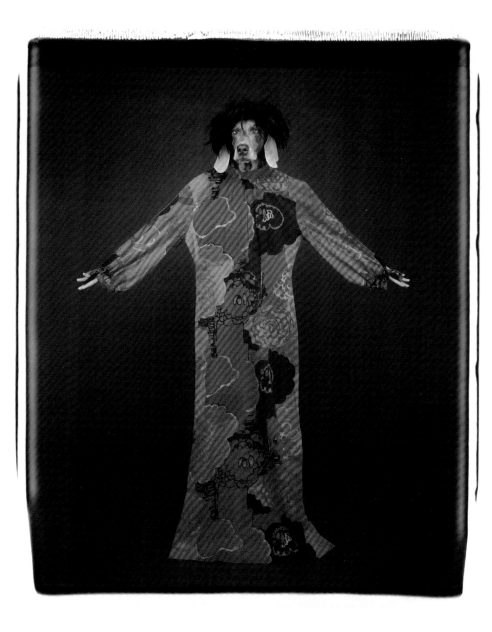

Behold, 1991

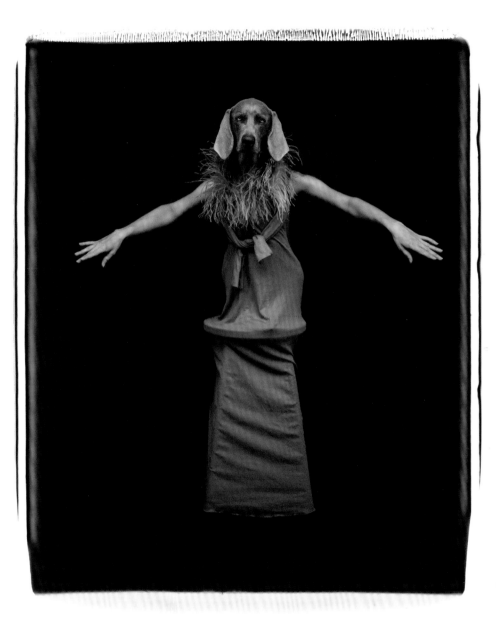

Beware, 1991

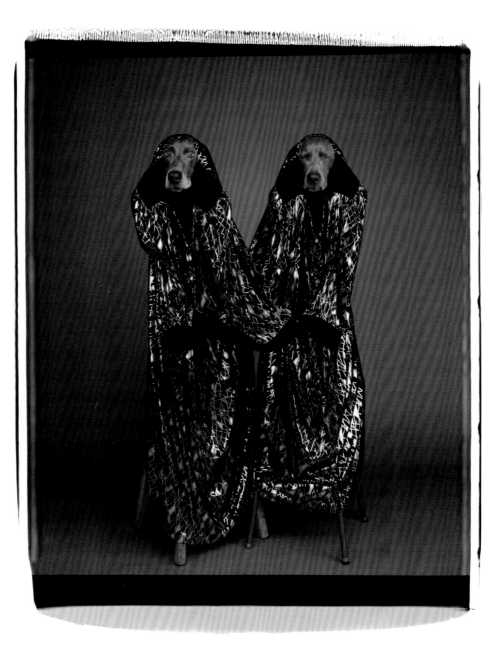

Lost, 1993

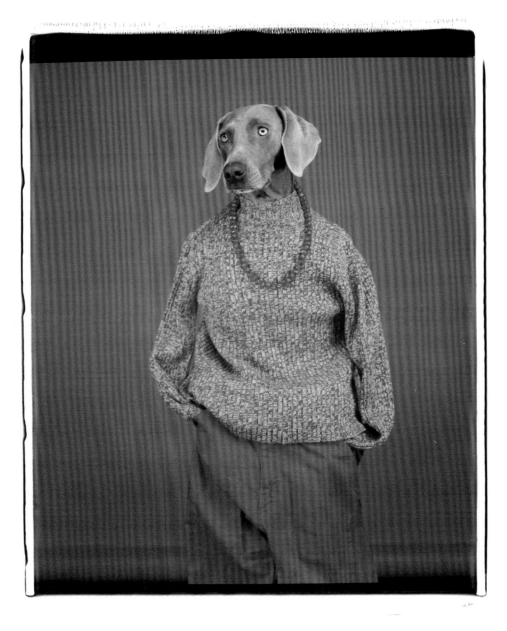

Casual, 2002

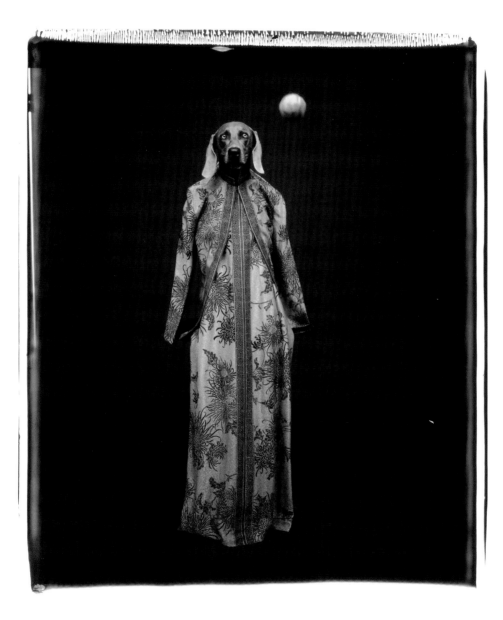

Dressed for Ball, 1988

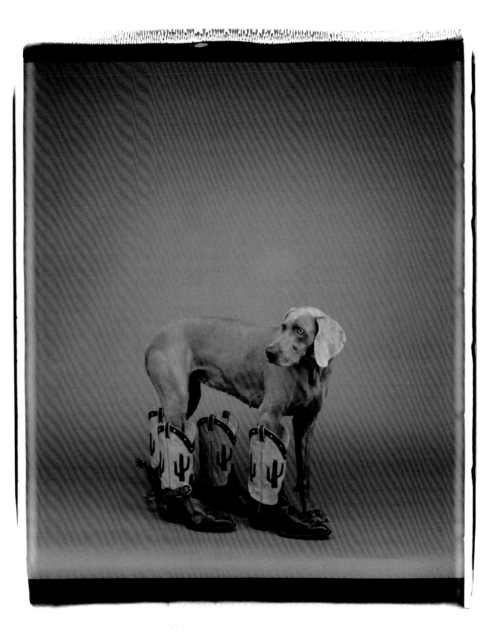

4/3 of a Kind, 1989

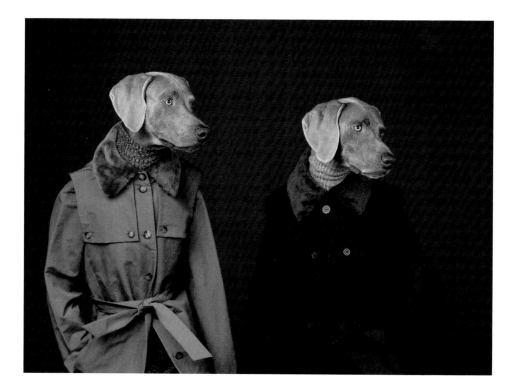

Looking Right, 2015

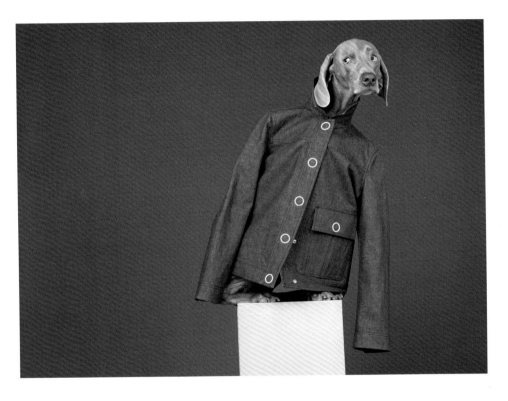

Apolitical, 2015

# STAY

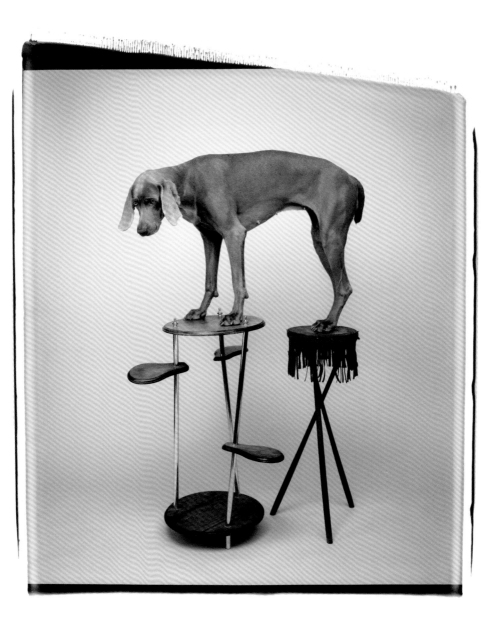

Kit, 1991

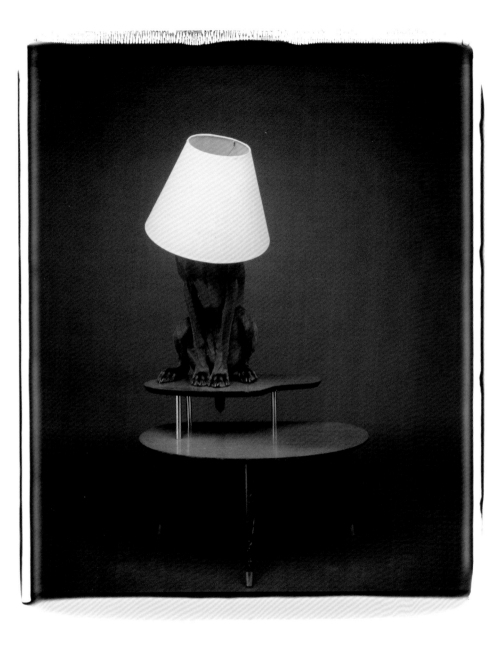

Lamp Stand, 1997

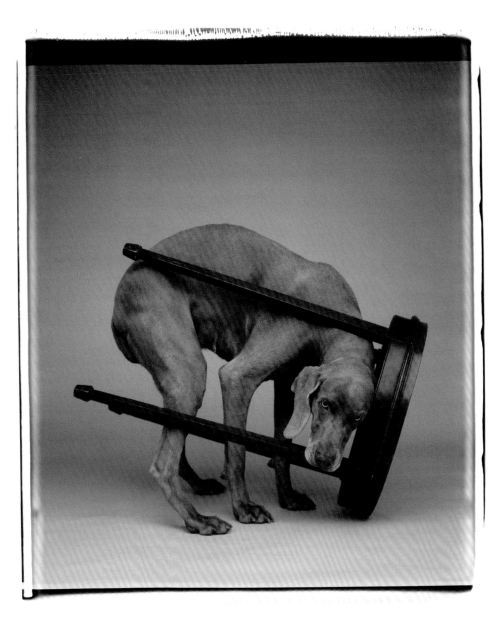

Caught Napping, 1990

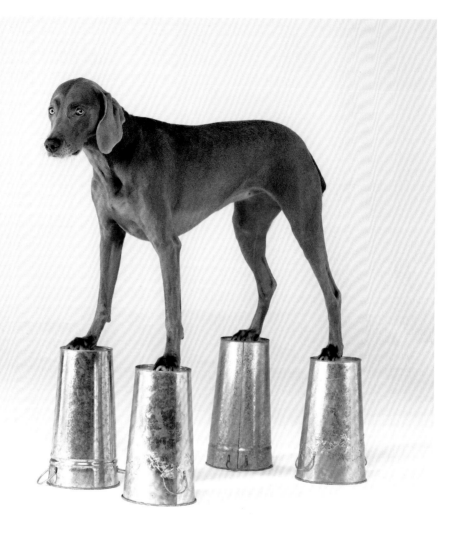

Platform Shoes, 2008

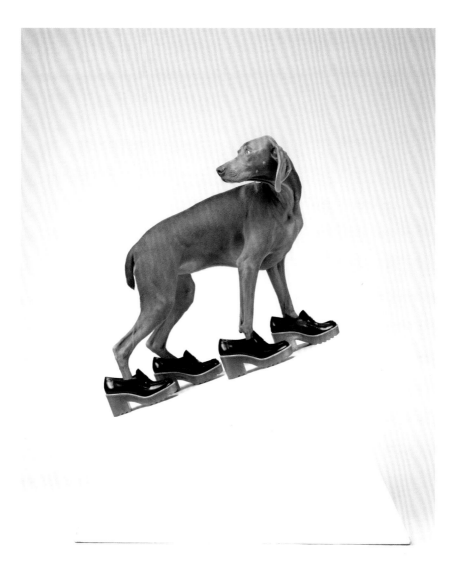

Climb, 2013

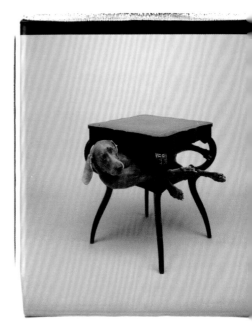

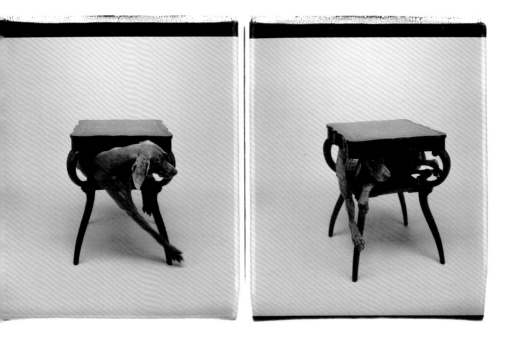

Twist and Hide, 1989

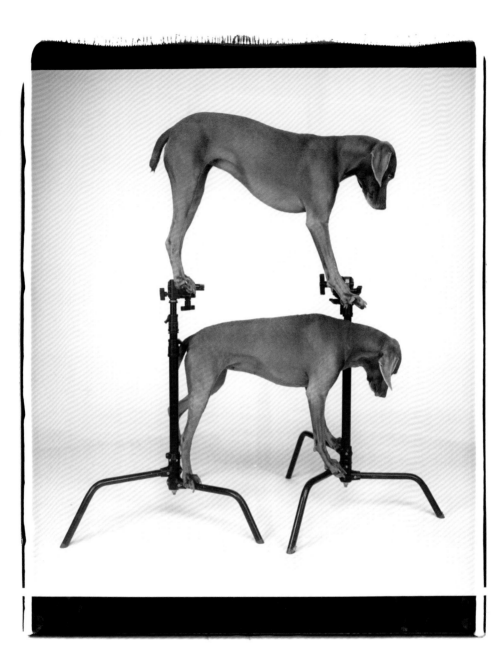

Upstanding, 2005

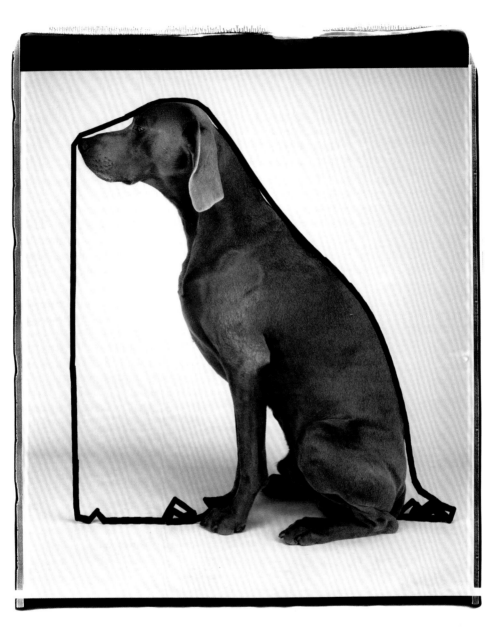

The Line About, 2004

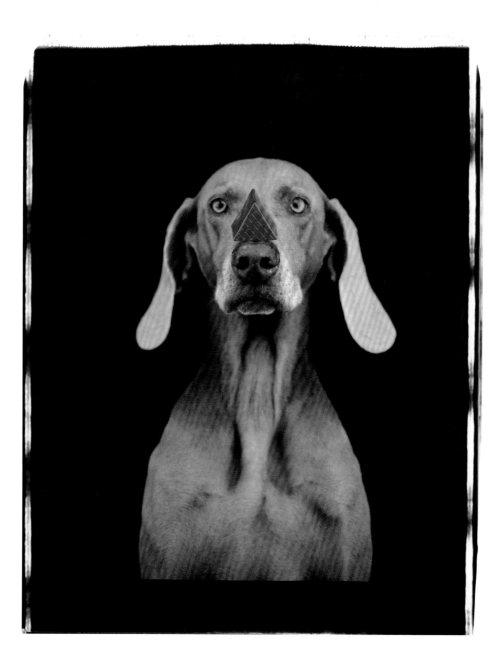

Red Triangle, 1993

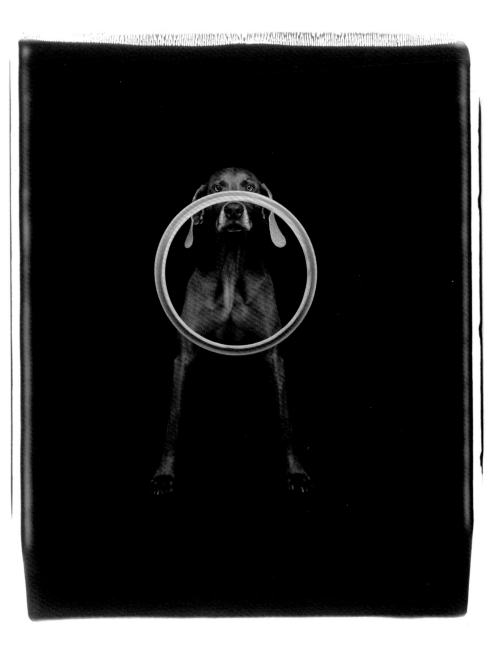

Headlight, 1992

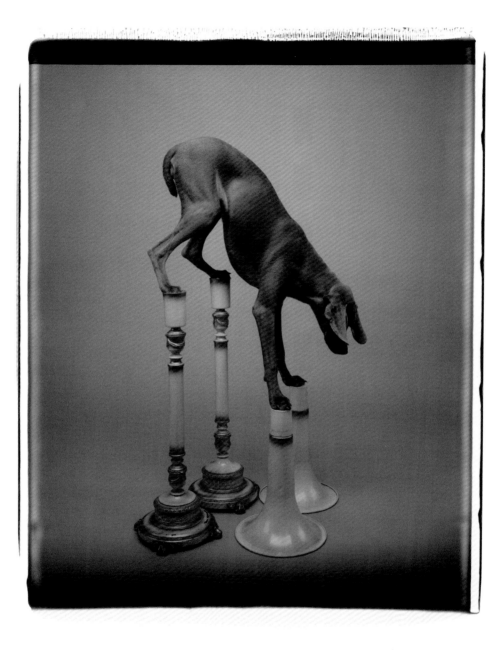

Lesson Learned, 1990

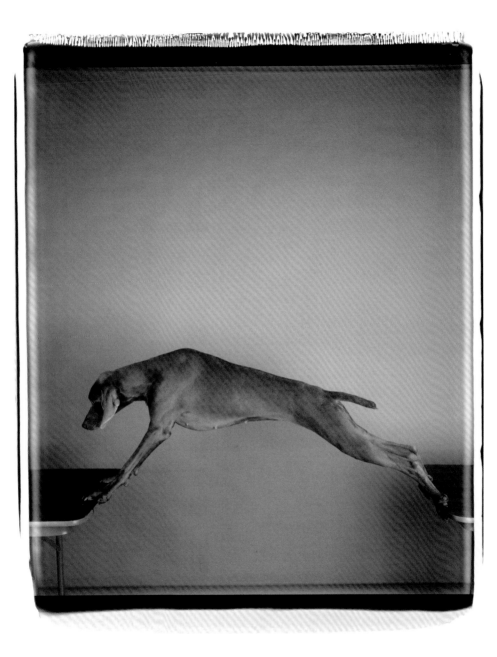

Footbridge, 1994

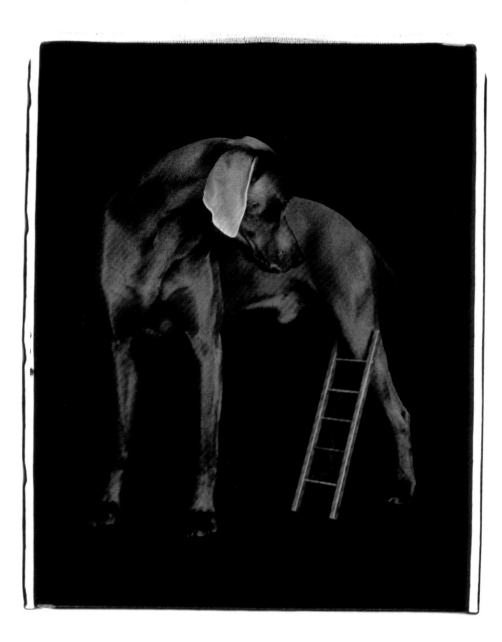

Leg Ladder, 2004

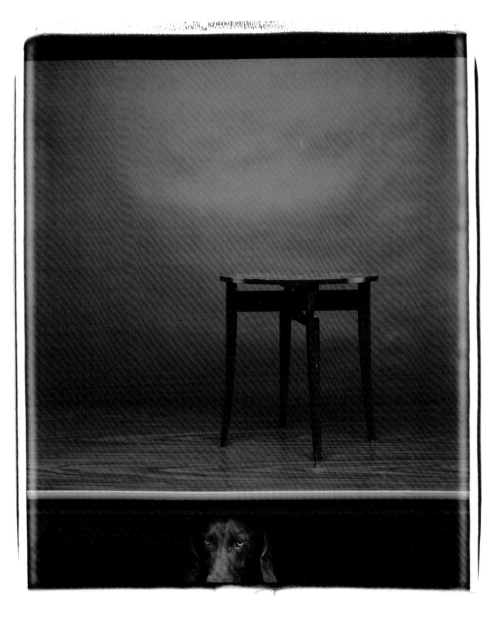

Table Overpass, 1998

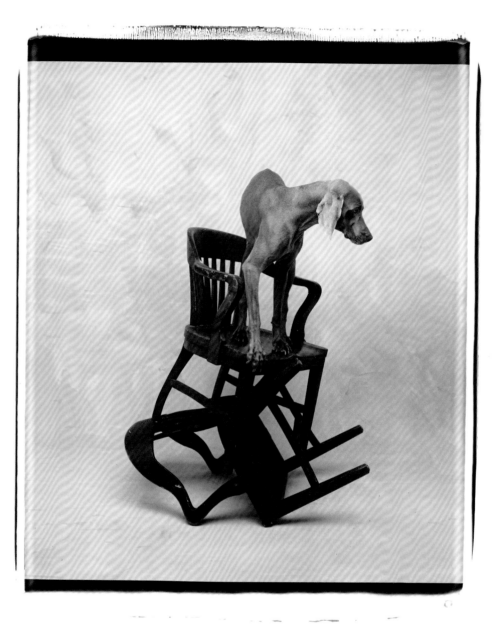

Cheddar, 1988

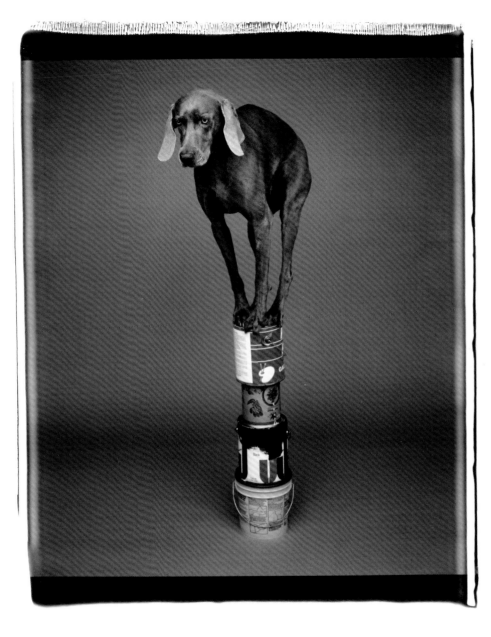

Paint Stand, 1990

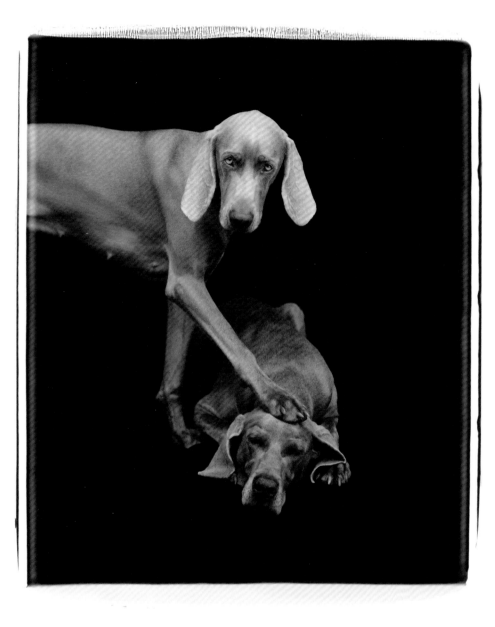

Paw Place, 1992

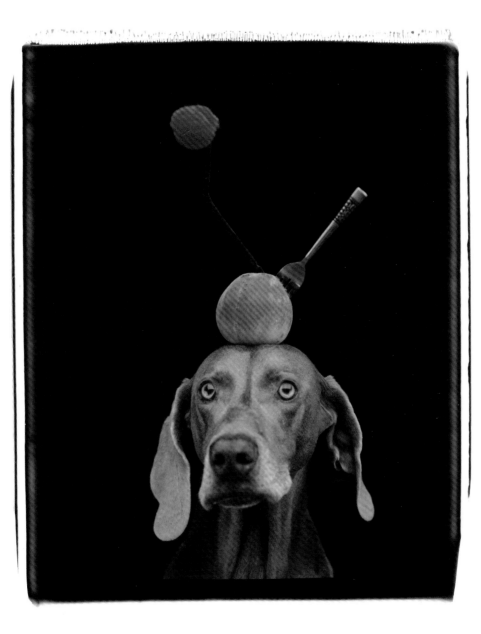

Gastro-astronomical, 1994

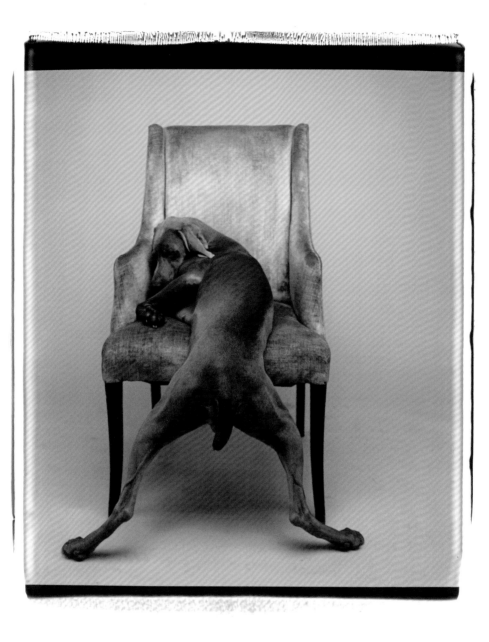

Widened, 1990

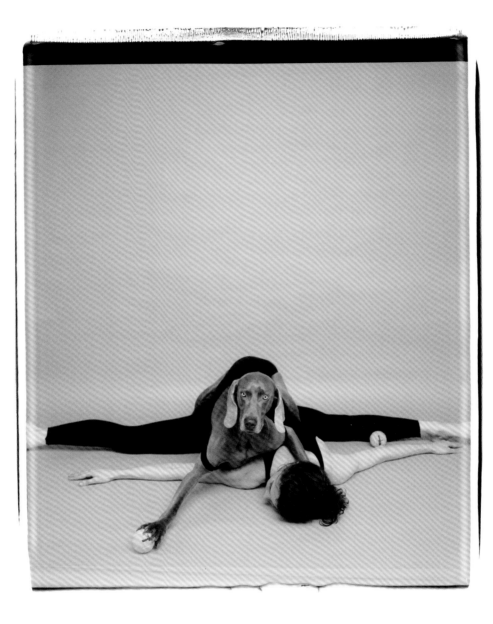

Wilson I, 1987

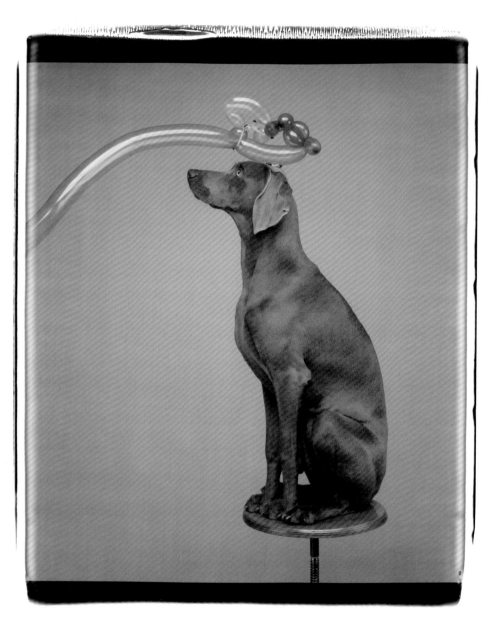

Party, 1990

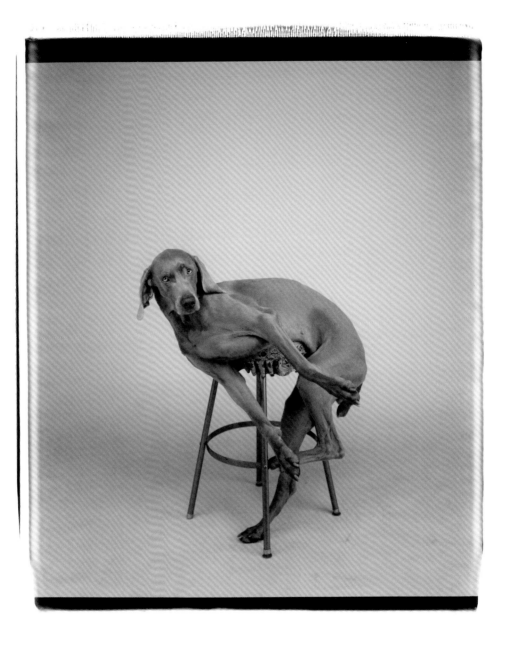

How It Works, 1993

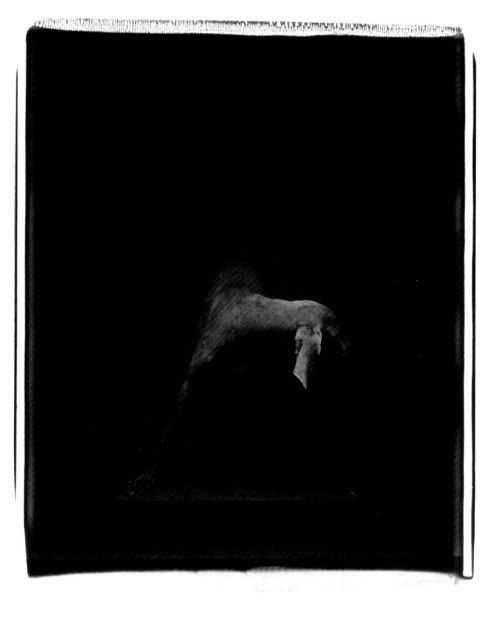

Out of Darkness, 1988

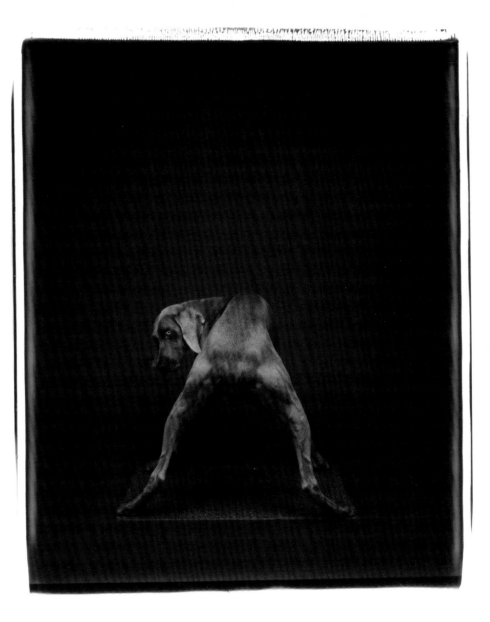

Into Darkness, 1988

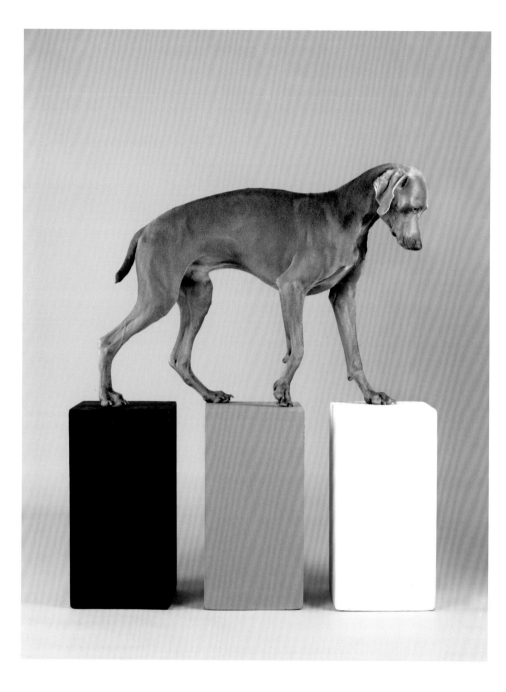

Contact, 2014

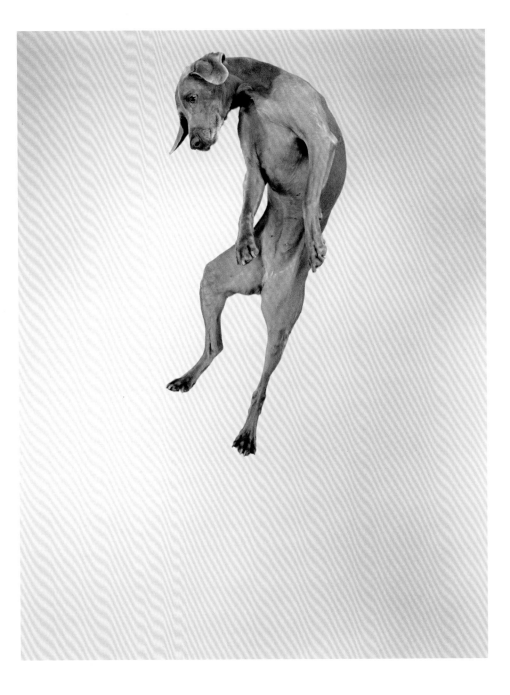

Airborne, 2010

# PEOPLE WE LIKE

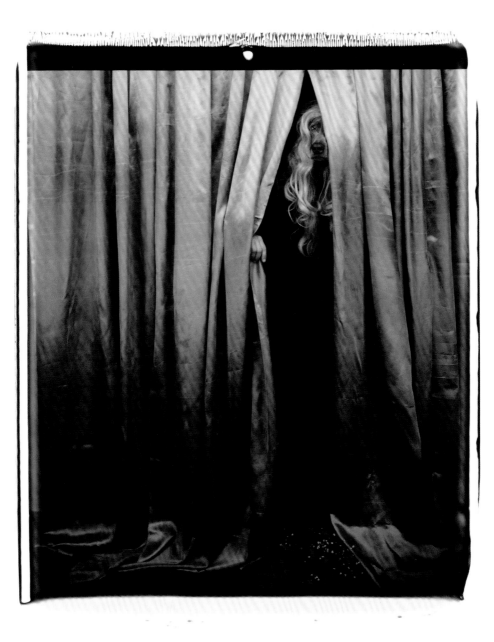

Curtain Call, 1995

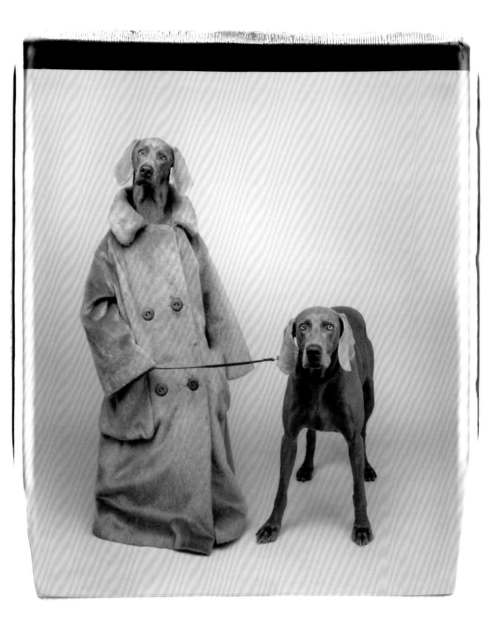

Dog Walker, 1990

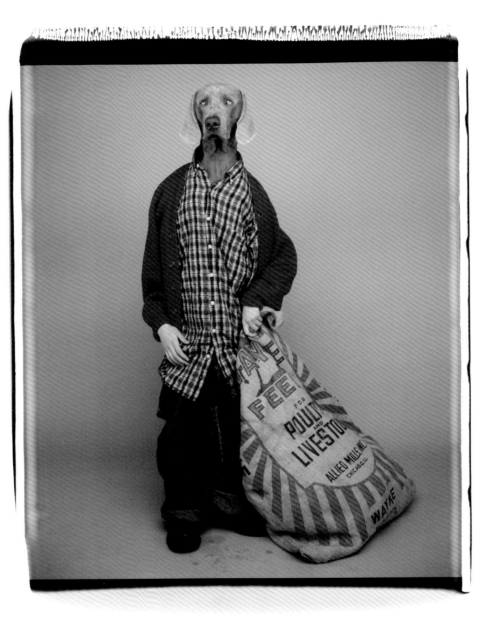

Farm Boy, 1996

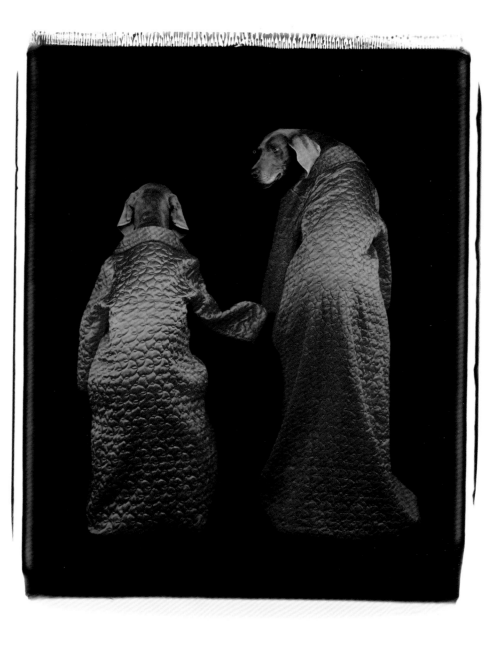

On the Way, 1995

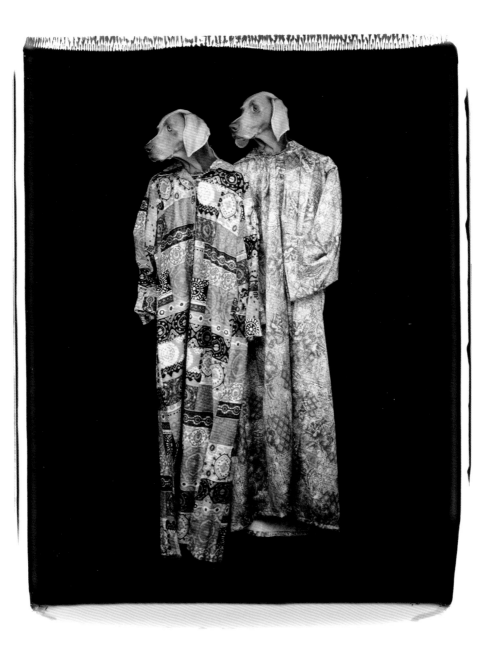

Look There, 1996

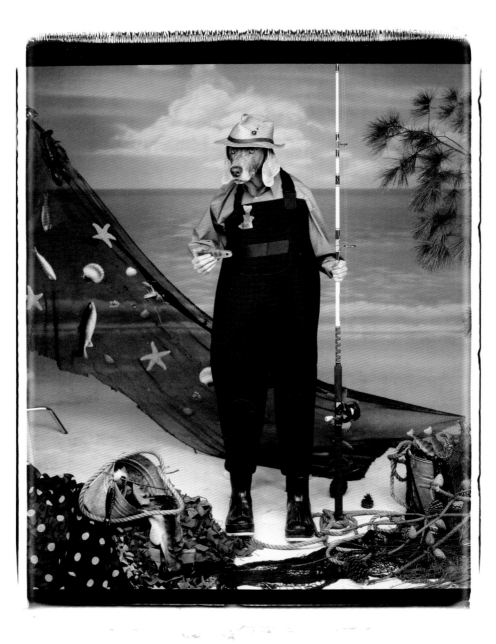

Ardent Angler, 1997

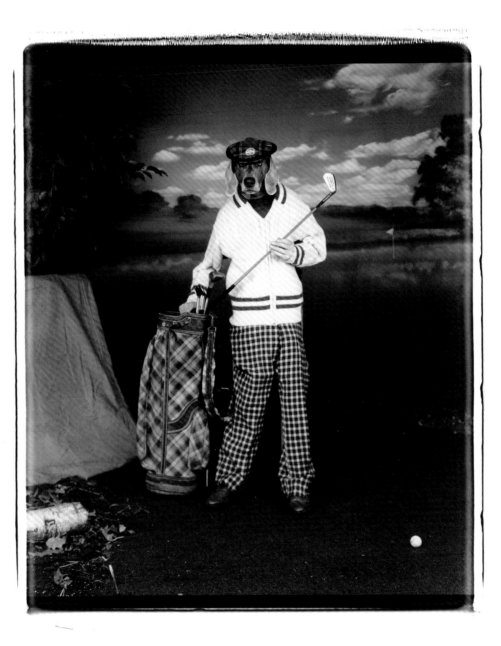

Ardent Golfer, 1997

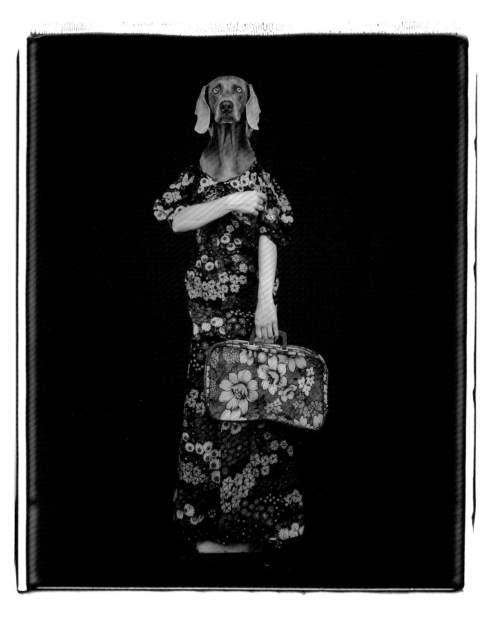

Armed and Matching, 1989

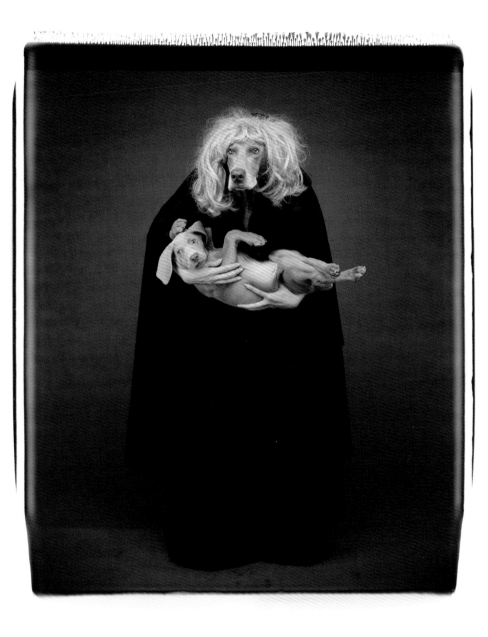

Kidnapper, 1993

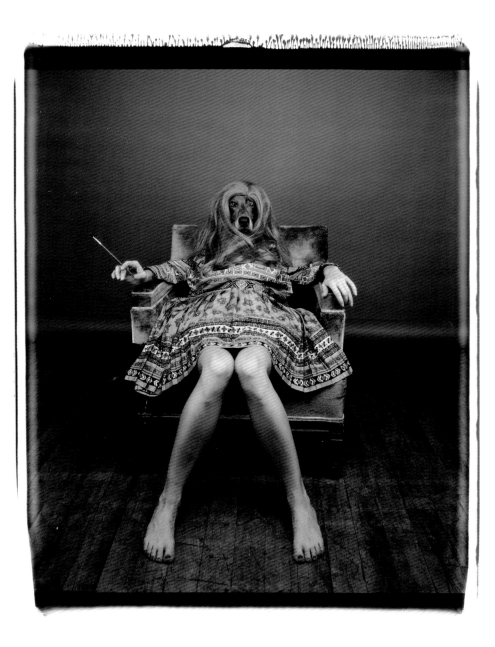

Artist Contemplating, 1994

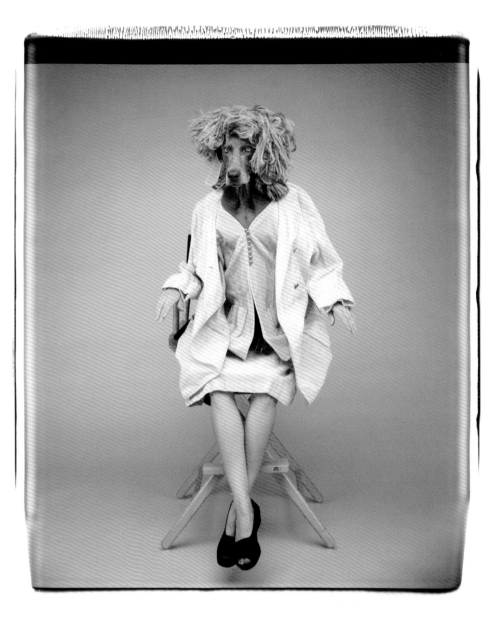

Sitting Tall, 1991

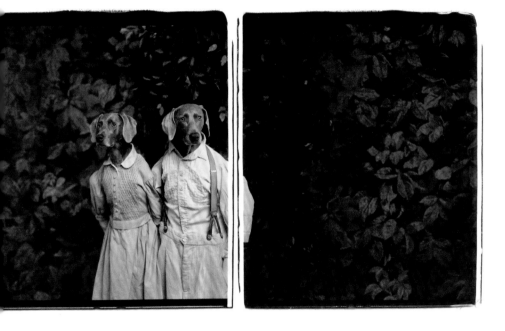

Hansel and Gretel, 2007

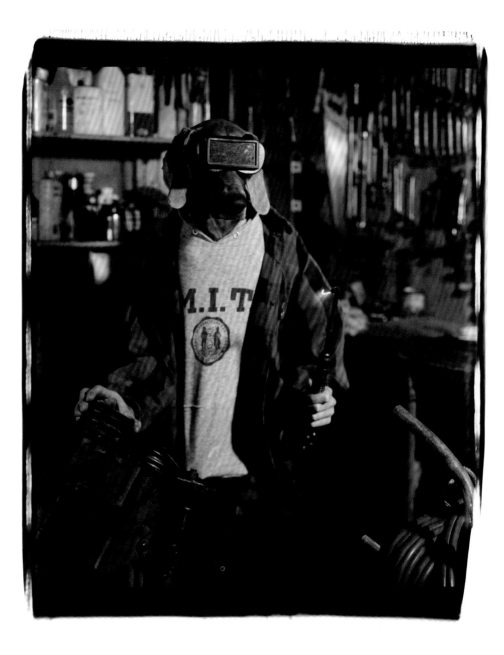

Acetylene, 1993

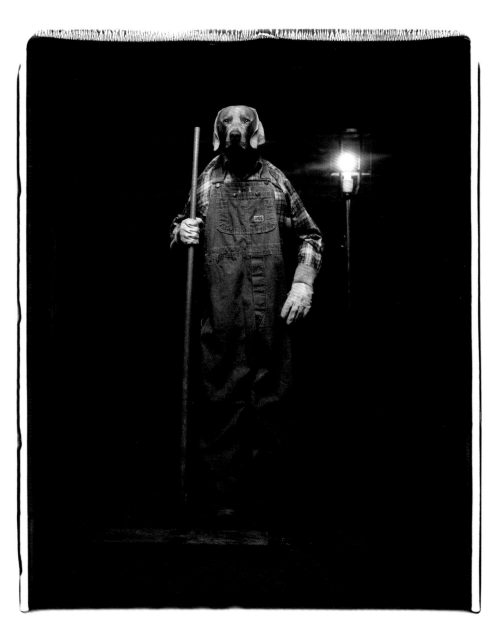

Night Man, 2002

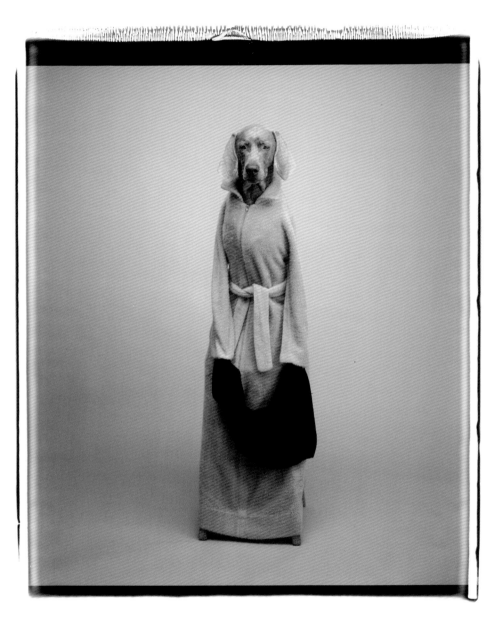

Toweling, 1993

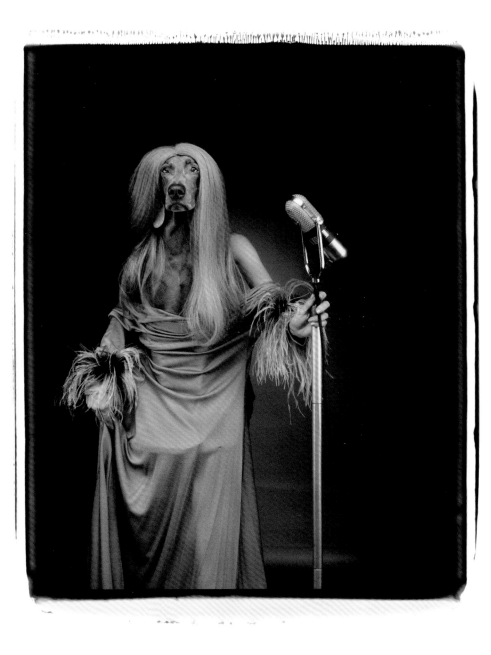

Entertainer, 1995

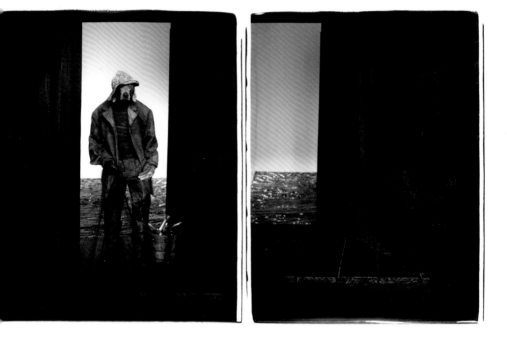

Peter Grimes, 2007

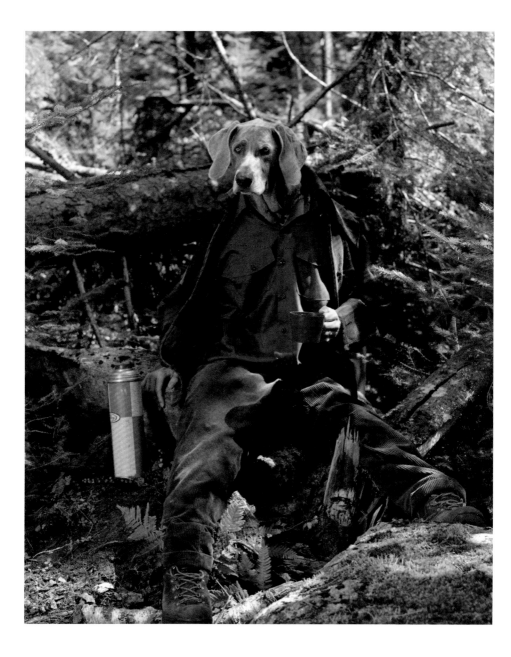

Coffee Break, 2001

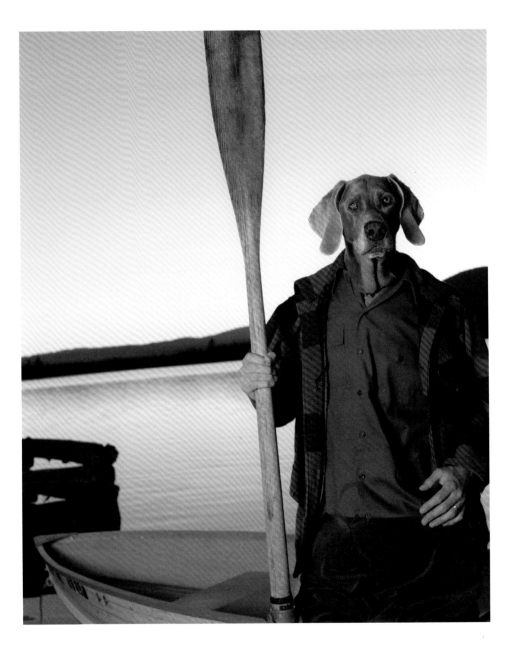

Oarsman, 2001

# NUDES

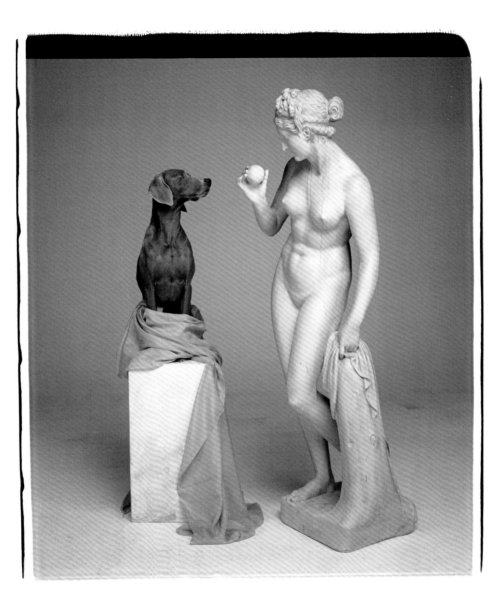

On Base, 2007

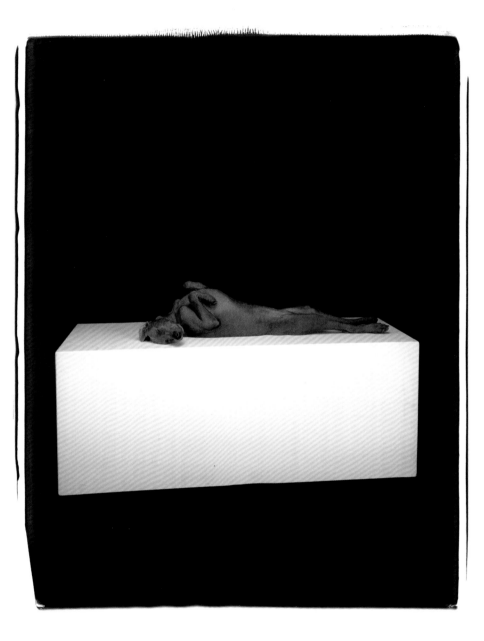

Being There, 2004

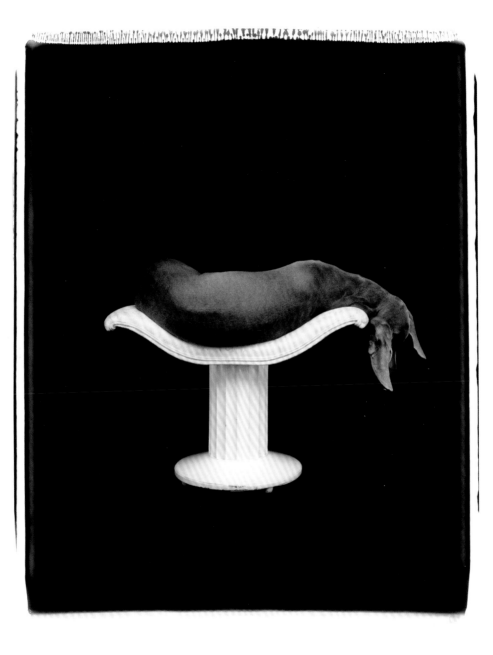

Vanity, 1994

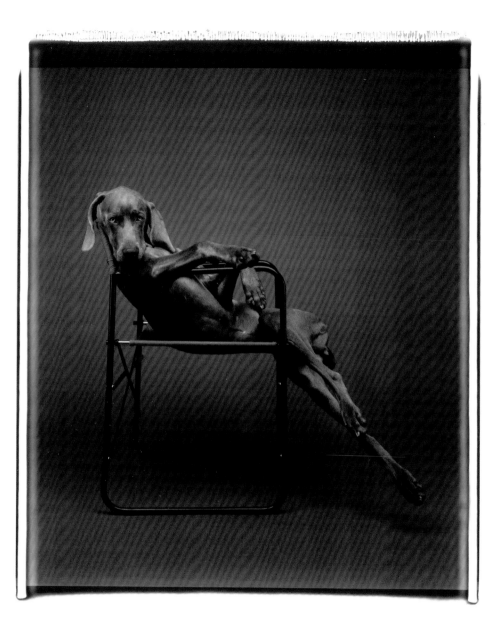

Lolita, 1990

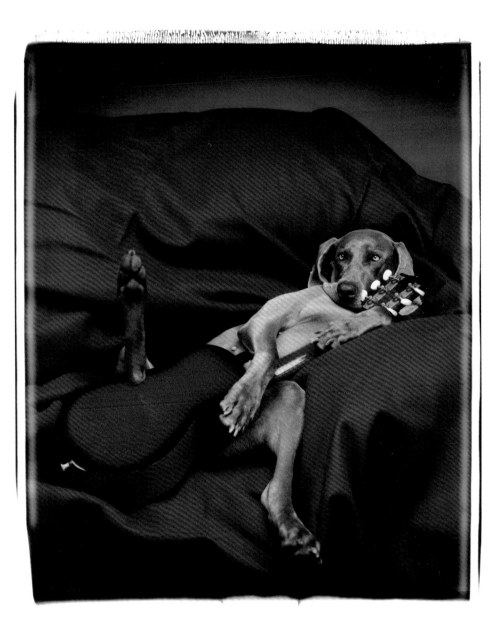

Slow Guitar, 1987

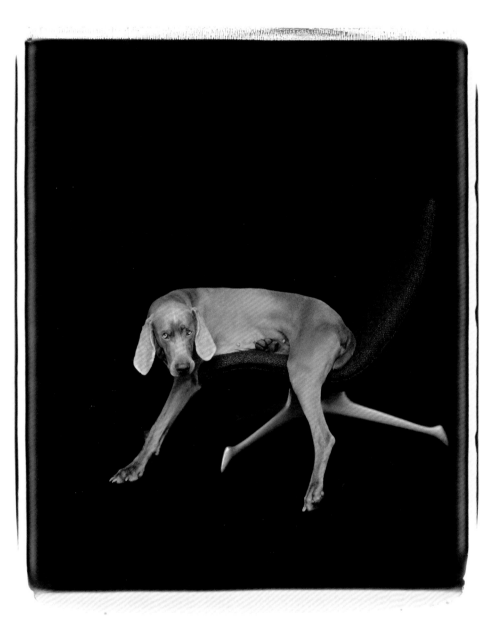

Working I, 1992

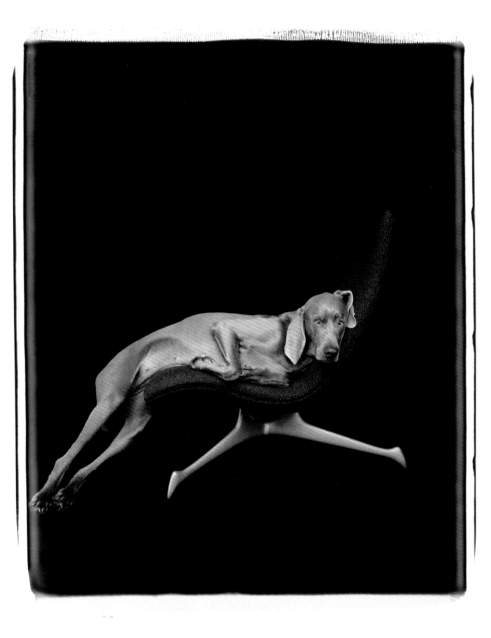

Working II, 1992

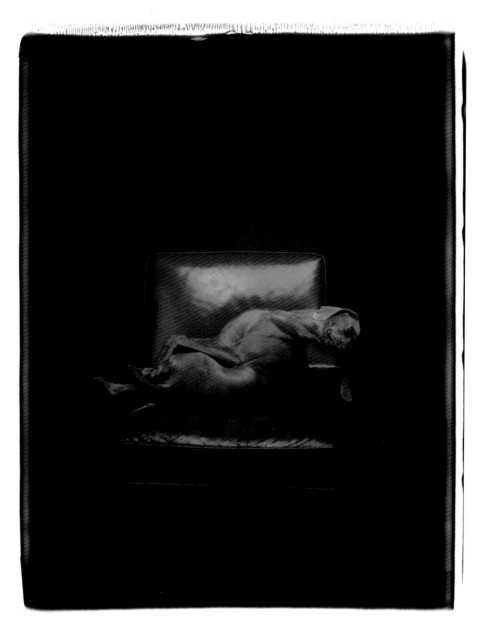

Like in the Painting, 1990

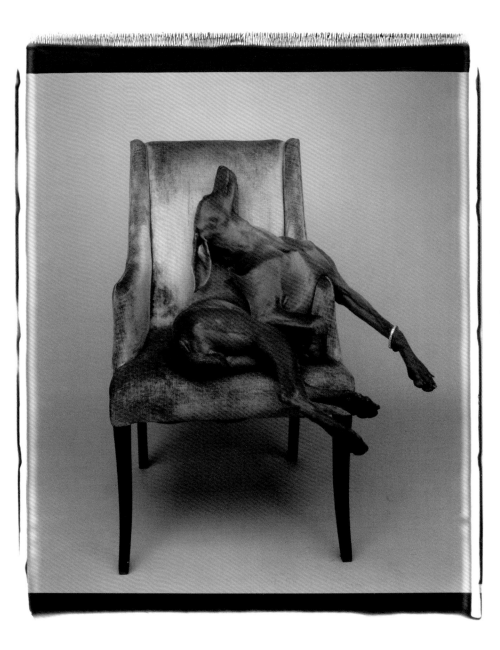

See the Bracelet, 1990

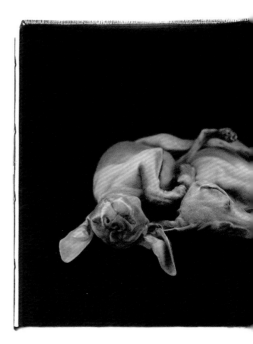

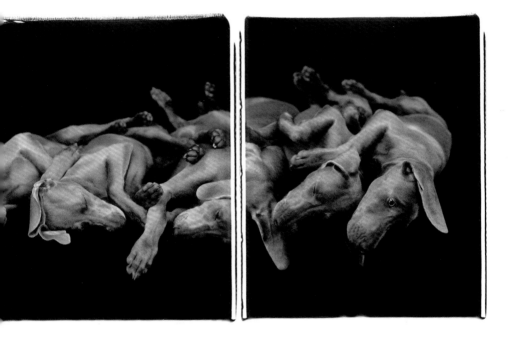

Tumble Down, 2004

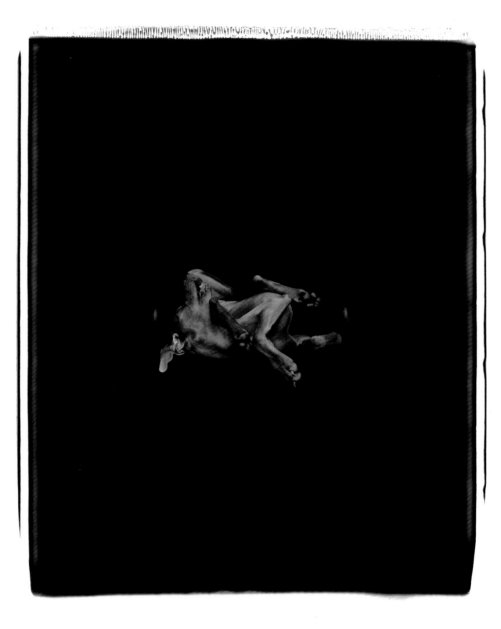

Eclipse, 1989

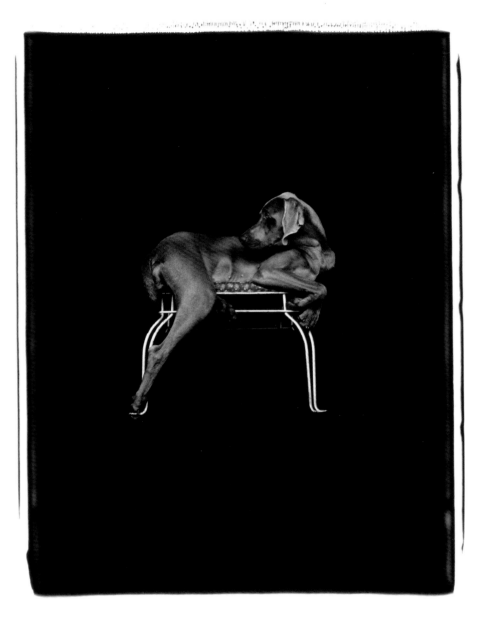

Folding Chair, 1990

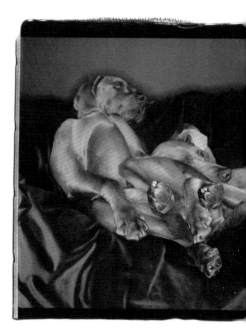

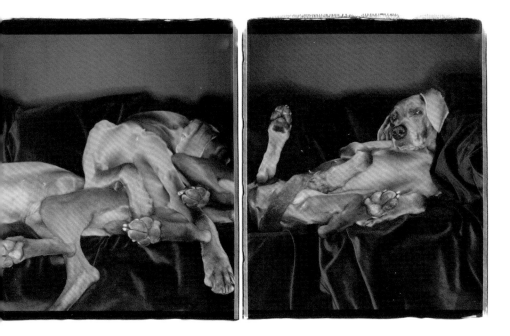

Tumbled and Dried, 2000

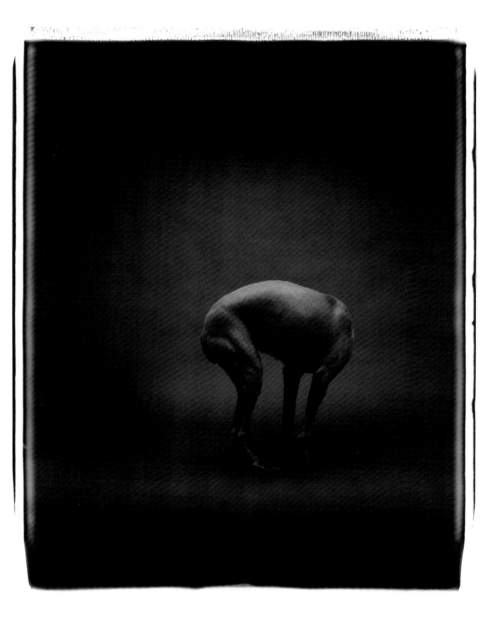

Headless, 1990

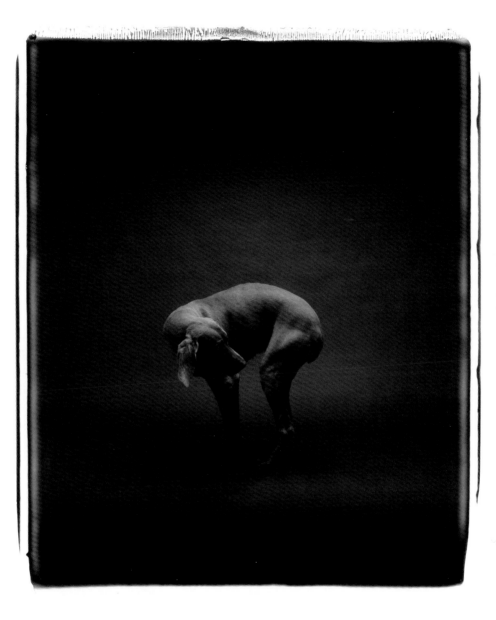

Base, 1990

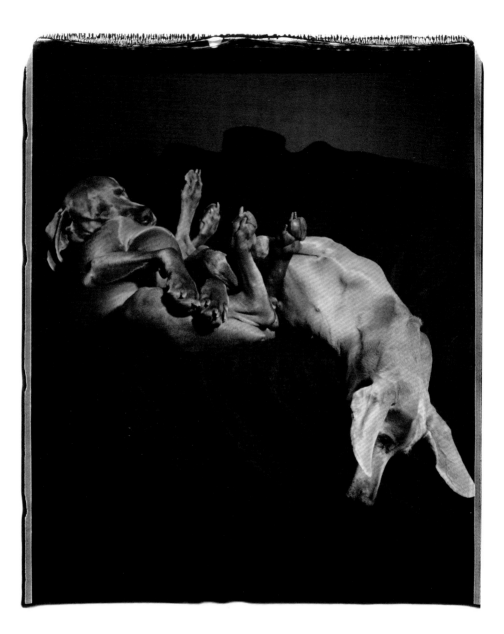

Up Down Over, 2000

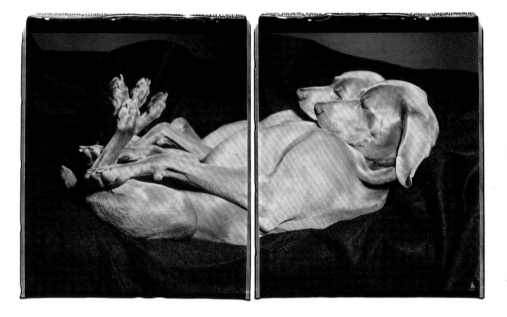

Two Heads, Many Legs, 2000

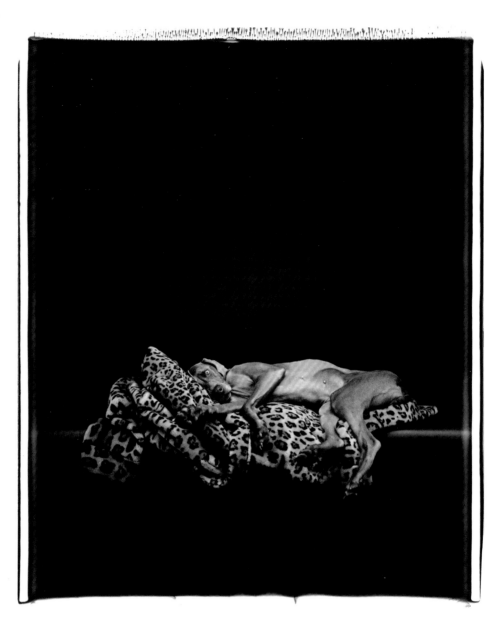

Fay Lay, 1989

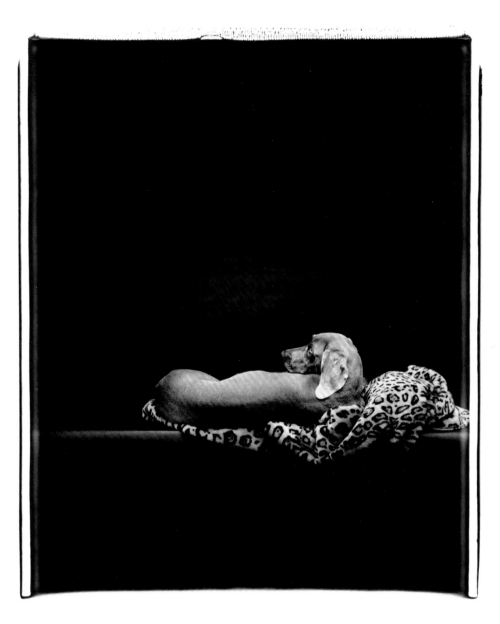

Le Douanier Fay, 1989

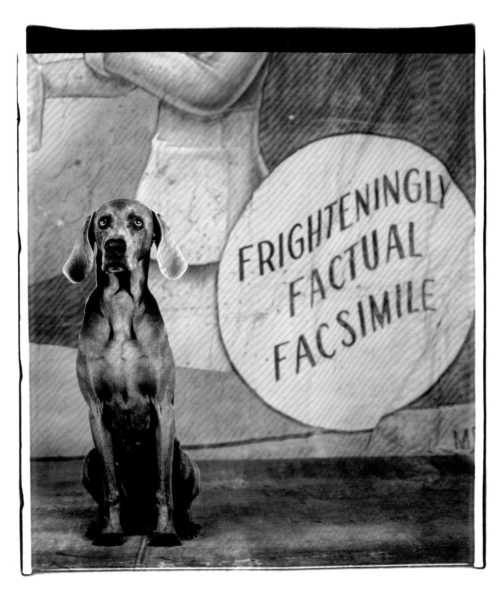

Facsimile, 1998

# A Conversation

*William A. Ewing and William Wegman*

WE: Bill, we've arrived at the stage where our selection of photographs is more or less finalized, and I'd say the back and forth process, where we've looked at every picture carefully, tried various pairings, and then looked deeper into your files to see what we've missed, or what might complement this or that picture, has been very stimulating. And the results reinforce my initial feeling, which came as a sudden revelation to me, that your work is ultimately about human beings, not dogs. How do you feel about this? Is it heretical?

WW: The title you proposed, *Being Human*, threw me at first, but then I looked more closely at the photo you were thinking of at one stage for the cover, the profile of my dog Chip's chest (page 19), and I began to think that maybe you were right. I have had an off-and-on aversion to anthropomorphism and for years I made a conscious effort to avoid it, but it is nevertheless embedded in much of the work. A dog does not need to be dressed up to appear to have human qualities. I made little to no effort to anthropomorphize Man Ray and yet he is clearly my counterpart in the work. I think that is how we are wired, to see ourselves.

WE: Thinking of the human angle, could you consider yourself a portrait photographer? I'm thinking of how portrait photographers work, and how they want to get under the skin of the person they are photographing, to break through defences. Arnold Newman, for example, when he was photographing the American presidents—and he photographed five during his career—would play the klutz a little bit, to loosen them up. The president would start by saying, "I've only got five minutes," and then Newman would purposely drop something, or make an awkward move, trying to disturb them a little bit, jolt them a little. And then to make them relax a bit, he'd say—you couldn't say this anymore now!—"Sit still or I'll shoot you." He liked to get them out of their polished routine because then they gave that little extra something to the portrait sitting—something human. Not that you do that with the dogs exactly, but you must have your tricks…

WW: I've always thought of working with the dogs as parallel play. The dogs play their game and I play mine. I sometimes play with language to get a certain look and each dog is different. Man Ray, for instance, was very close to my father, George, in Massachusetts. If I said "George," Man Ray would practically unscrew his head, hoping I would deliver the real George to him. "Cat" was a big word with many of my dogs. "Ball" has been an important word until recently, and "Bone" continues to be promising. But if you keep saying "Bone," and you don't deliver, the word crashes and you have to find another word. And there are other tricks. To make one of my dogs look evil I would walk far away from him. He would squint to try to find me and that gave him the sinister look I was after. As far as playing a klutz goes, they all know I'm a klutz so no special effect there.

WE: But it's still a collaboration?

WW: Yes, absolutely. The dogs look to me for direction. If I don't give them something to do, nothing happens. Most often the only direction I give them is "sit" and "stay." All the rest is up to me.

WE: Like with those American presidents! Would it have interested you at all to photograph people the way you photograph dogs, capturing a character as you do in the pictures that I refer to as "People Like Us"? Would it ever have occurred to you to, say, invite people in from the street to see what that might give?

WW: I've photographed people now and then, but I'm not very comfortable doing it. Staring at someone, even through a lens, makes me feel a little odd. But with the dogs it's really fine. Some dogs don't like being stared at, they find it threatening, but not mine. My dogs somehow crave it. Topper, for instance, stands right in front of the TV when I'm watching, just so I'll look at him.

WE: The categories, or chapters, we've come up with were the result of an organic process— they emerged naturally from the material. I certainly didn't come here thinking of those categories and what to put in them. I tried to let the material speak for itself, so we've ended up with "People Like Us," and "Masquerade," "Cubists," and so on. I came back today to suggest even a few more. Also, when I was looking at everything again yesterday, some of the categories seemed to need splitting, so, for example, the pictures we had called "Nudes" now seemed to me to divide into two distinct approaches: what we might call "classic" nudes, that is, the full figure reclining, and what we might call "fragmented nudes," or close-ups of bodies, which we're now proposing to group into "Physique."

WW: It's interesting to me that you are thinking about my work in this way and that you see these different groupings. It is not how I think about the work while I'm making it, but you are noticing something that is definitely there and worth commenting on. One of the reasons there are discrete groups of work is that each dog I work with has their own special characteristics—a majestic head, a beautiful chest, an impressive ability to balance stuff— and they each inspire and even demand a different approach that results in a different body of work.

WE: How long are the sessions? Are the dogs standing for a long time?

WW: The dogs and I will work together all day when I'm shooting but each individual set-up usually takes only 30 seconds or so. Just long enough. I'm always in a hurry when I work with the dogs. I'm not sure why.

WE: Maybe because the dogs have such a short lifespan compared to us!

WW: Yes, like the minute hand on the clock. You can almost see it move…

WE: You are also a painter. Have you ever thought about abandoning photography?

WW: Yes, but not as long as I have Weimaraners. They require it. My dogs are working dogs and working dogs need to work and feel part of your life. There isn't room for them in my painting and they aren't happy about that. When I'm painting they come into the studio and let out a sigh. They know it's not for them.

WE: You haven't worked with the Polaroid 20x24 camera since they closed the studio down years ago.

That was a hugely important tool for you. Can you comment on that?

WW: Working with the Polaroid 20x24 for so long was interesting in many ways, but one thing that occurred to me as I looked through all the images for this book is the way in which so many of my dogs had their whole lives recorded through one lens, one format. You could really see the development and evolution of the work we made together. It was also important that the camera wasn't mine and didn't live in my studio. To use it I would have to go to the Polaroid studio with props and dogs and work with John Reuter, who ran the camera for Polaroid, to get the pictures that I wanted. It was all a sort of performance and I think this is one of the reasons there is so much variety in the work from this long period. But I'm working digitally now and I really like it. One of the reasons I initially liked working with the Polaroid camera is that I could see what I was getting and this was important with the dogs. I have the same ability to see things as they are happening when I am shooting digitally and the whole process is faster. I can move quickly. I do miss the beauty of the actual Polaroids but working with the 20x24 camera was a challenge: the camera itself was cumbersome and prone to technical difficulties. Also, photography in my opinion should be of its time and Polaroid is of another time for me. The problem now is one of faith. It is important to me that the dogs are really present and that what you see is something that really happened, not something that has been Photoshopped. That is why I have more or less stopped dressing up the dogs. The viewer may assume that the dog's head is just dropped in digitally. There's no magic in that, no resonance. And the other issue for me now is scale. With the Polaroid it was 20x24 inches and that was that.

WE: Now you can make bigger prints?

WW: Back in 1970 I had the idea that photos should be as big as those in books and magazines and no bigger. I wanted the work to be accessible to everyone, not just dependent on a gallery installation. Working with the Polaroid camera I became accustomed to a bigger, poster-sized image. Now I'm never sure how big to make the photos. I usually don't want the dogs to be any bigger than they are in life, but it is still always a problem for me. It's probably a good problem.

WE: I'm intrigued, why good?

WW: Any time you are forced to change it opens up new possibilities. When I started working with the Polaroid 20x24 I had to deal with color and the larger format. The limitations and restrictions inherent in that format caused me to evolve a new way of working and opened up a myriad of possibilities. I now see this evolution in my work as a strength. Maybe that's the subject of this book.

WE: Okay, we're going to have to end it here, Bill. The dogs are getting antsy. I think they want us to stop talking and get back to work!

WW: Thanks, Bill.

WE: You're welcome.

WW: Don't forget your hat and coat. It's right here on the rack.

WE: Got it, thanks. Take care.

WW: You're welcome. Have a safe trip to Switzerland or Canada.

WE: Actually, I'm going to Paris. We're going to have a French edition. After all, Man Ray is much loved there.

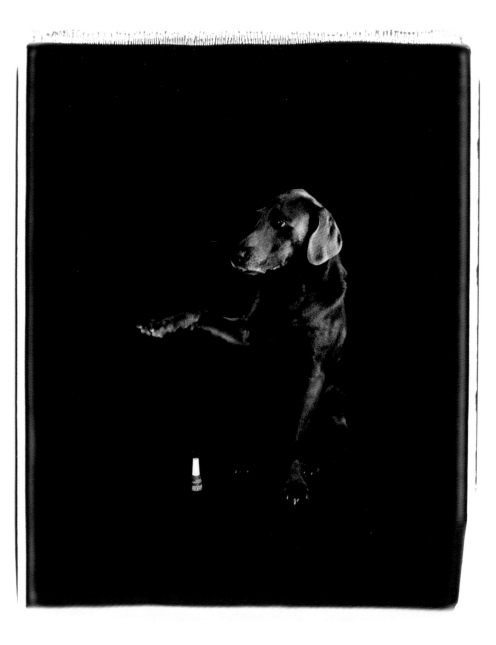

Fey Ray, 1979

# Picture Dogs

## William Wegman

My use of the Polaroid 20x24 camera was extensive. Beginning in 1979 and ending in 2007, I made hundreds of images every year, stored them away in archival boxes and, with the exception of those that made it into shows, I more or less forgot about them until my long-time assistant Jason Burch decided it would be a good idea for us to go through every box and select images to be catalogued and preserved digitally. Working through the boxes backwards from 2007 was an exhilarating experience for me. I could see all my beloved dogs, from Candy and Bobbin to Batty and Fay, grow younger and younger and younger; the images went back to a time before they existed, back to Man Ray, where it all began.

I got Man Ray, my first Weimaraner, in 1970 in Long Beach, California. I was teaching at Cal State and living nearby in San Pedro. I named him after the artist Man Ray, who was both a painter and a photographer. There were parallels between the work of Man Ray, an artist I liked, and my work. I never expected that Man Ray the dog would become the prominent subject of my work—if I had I would have chosen another name. But Man Ray stuck.

When I brought Man Ray home at six weeks, I naturally took his picture. And when I went to my studio a few blocks away I, of course, took him along. He emitted a piercing whine when I ignored him, so I naturally dropped everything and paid him the attention he demanded. He was impossible. Except when he was in front of the camera—then he was different. He sensed that what I was doing was something of interest to me and therefore to him. He wanted in and he made that clear to me. Because he could be so calm and focused it was possible for me to work with him like any other object or prop. I could build a picture around him. And the fact that he was gray helped too. Gray goes with everything. It was like having a blackboard that I could write on, erase, and start over and over and over.

In 1979, when Man Ray was nine, we began to work at the Polaroid 20x24 studio in Cambridge, Massachusetts. The 20x24 camera was originally designed for taking "instant" actual-size portraits. I was one of a few artists invited to work with the camera. I had low expectations. I didn't work in color and made no prints larger than 11 x 14 inches. I had rules.

My first day at the studio was a gloomy one. I made 30 or so images of Man Ray shrouded in black against black set paper with only a gray toenail showing. The studio got blacker and blacker. I continued in the same manner on the second day. But on the third day (sounding biblical) I brought in a bottle of Revlon red nail polish and painted the nails on one of Man Ray's paws. Behold. Color!

This unique camera provoked a radical departure from my previous work, both in concept and look, exposing me to aesthetic and expressive adventures I had been up to then careful to avoid. I was wary of cuteness, beauty, and anthropomorphism and steered clear of them all. But with two Polaroids in particular, the unabashedly beautiful *Double Profile* and the dangerously anthropomorphic *Man Ray and Mrs. Lubner in Bed*, two pictures that I loved and found I couldn't dismiss, my resolve was shaken and ultimately abandoned.

As Man Ray got older, I contemplated what might be his last picture. *Kennebago*, a haunting image of Man Ray in a canoe wearing a Native American headdress and floating into the sunset, felt right, but it wasn't his last. That would be *Red Head*, taken about six months after *Kennebago*, a close-up portrait, larger than life. Man Ray and I worked together for over 11 years. I think he lived up to his name.

With my next Weimaraner, Fay Ray, my ideas about what I did and didn't do were further challenged. Fay was in many ways Man Ray's opposite. Man Ray was a blue Weimaraner with a medium-dark gray coat. He made it indelibly clear that he wanted and expected to be a part of my work. Nothing much bothered him. But Fay Ray—named after the 1979 Man Ray Polaroid *Fey Ray* and the actress Fay Wray—was lighter in color, feminine, vulnerable, and intense. She was also somewhat fragile. City noises bothered her. She was particularly skittish about the metal security gates that are rolled down in front of stores at closing time. A thoroughbred in her prime, Fay needed to work. She reveled in it. The more difficult the pose, the better. Although within limits. For some reason she didn't like large potted house plants (who does?) and posing with metal objects could be challenging. Assistants at the Polaroid studio were cautioned to move lighting equipment carefully. Fay was great at balancing things. In a work titled *Harvest* (see page 45), an homage to the artist Arcimboldo, I piled and hung a large assortment of plastic fruits and vegetables on Fay. A cluster of walnuts was suspended from her lower canine teeth. As I was building the work, very close to the camera lens, she kept still and focused. Giving her lots to do took her mind off her anxieties. What those were we will never know.

One day in the studio I had Fay up on a pedestal and my assistant Andrea Beeman was helping to steady her. Fay loved being tall, as tall as those around her. As we were discussing the plan, Andrea's gestures became illusionistically attached to Fay. Fay had arms! I tossed a dress on her and thus began, thanks to Fay and her love of a challenge, a parade of increasingly outrageous dressed-dog images.

With the birth of Fay's eight puppies in 1989, a whole new cast of characters was born. The magical event took place in my studio in upstate New York on June 10, a week

Red Head, 1982

earlier than expected, on the couch! There was no time to finish building the whelping box. Chundo, the first born, was delivered breech, feet first. I had to reach in and pull him out. Chundo was by far the biggest of the eight. I named him after the biggest person I had ever met, which was during a visit to the south of Chile. And then came Battina, the little bat, who was known as Batty. She was so small and fragile. I had to hold her to Fay as she nursed through the night—and for the next few days. She weighed a mere four ounces (Chundo weighed 12!). The next to arrive was Crooky, who had a crooked white marking on her chest. She was followed by Dr. Green, Ken, Blaze, Glenn, and Speedy.

I photographed Fay's litter daily. I couldn't take my eyes off certain puppies. At eight weeks it was time for some of them to go to new homes. My sister Pam had lobbied for handsome Ken, but I persuaded her to take Chundo, the lion of the litter. Never have I been more right. Chundo was magnificent and grew to become even more magnificent. Spirited, spunky, perky Crooky was given to Dave McMillan, a friend in Maine, whose "can do" attitude and problem-solving brilliance would factor significantly in my work over the next two decades. There was never a doubt that Batty would be mine.

I couldn't stop looking at her. Independent and comical, Batty knew how to entertain herself and couldn't care less if I noticed. She was the opposite of Fay, who cared so very much. Fay both loved and tolerated her, but put her in her place if she thought she was getting too much of my attention. Fay was the boss and Batty accepted that.

In the studio they were the perfect pair: Fay, serious and proud; Batty, silly and seductive—Carole Lombard to Fay's Greta Garbo.

As Batty grew into her role as a model she became even more liquid, pouring herself into the set like furry syrup. No photo sums up her seductive presence and performing ease more than the one I titled *Lolita* (see page 318), which was taken when she was six months old. A child prodigy if ever there was one. As she aged she became ever more relaxed, to a degree bordering on narcolepsy.

Fay's other girl, Crooky, was Batty's opposite in both looks and personality. Round-eyed and hyper-alert, Crooky was a blast to work with, always ready for the next challenge. She was especially good co-starring alongside Batty in my film *The Hardly Boys in Hardly Gold.*

Of Fay's six boys, the great Chundo, who was gentlemanly and kind, sound of mind and warm of heart, and so steady and willing to work, soon found his calling as a leading man. He starred in every book and project we worked on: from George Washington for the cover of *George* magazine (see page 174) to the prince in my version of *Cinderella.* He was great at characters.

Not unlike the Redgraves and the Barrymores, the Fay family became something of a theatrical force in the early 1990s, starring in numerous children's books and appearing everywhere from Sesame Street and Nickelodeon to the Sundance Film Festival. In addition to portraying a plethora of human characters, they also created a dog alphabet. To do this I positioned them lying flat on the floor and photographed them from above. Fay and her family, even Crooky, were very good at lying still. When they

finished the alphabet they went on to perform numbers and punctuation. For the period, Crooky was called upon to sit and look straight up.

In 1995, Batty gave birth to a litter of four boys, including one exceptional puppy whom I named Chip after one of Chundo's many roles in the movie *The Hardly Boys*. Chip was handsome, wistful and calm, very calm. He was good at being still and tolerated anything you asked him to do, or wear. Nothing seemed to phase Chip.

Chip became the star of my books *My Town, Surprise Party, Farm Days*, and *Chip Wants a Dog*. The images for these books were made on location and production was intense, involving lots of equipment and assistants. Chip's serene and wistful demeanor pervades these images and drives the stories, the gist of which is: nothing works out as planned and that's OK.

Chip's son Bobbin, born in 1999, was one of a litter of three boys. As planned, I gave him to my sister Pam, who had recently lost her beloved Chundo. She gave him back to me. Nicknamed "bar guy" by my assistant Marlo Kovach (whose dog Mazzy, a blue Weimaraner like Man Ray, loved to be photographed and appears in a number of photos), Bobbin was more than a little pushy in his early years, but he matured into a wonderful companion and a dedicated performer. In my work he became a bit of a utility infielder, good at everything. He could look a little mean, although he was actually the opposite of mean. For Bobbin, greatness came in old age. He lived to be almost 16.

Candy came to live with us in 2001. She was named by my five-year-old son and was the smallest and most agile of all my dogs. If ever a dog could fly it was Candy. But the camera wasn't Candy's friend. She gave it an unhappy look and I had to find ways to work with her that made it fun for her and for us. When I shifted away from the large-format 20x24 Polaroid into the faster, portable, digital world, Candy found her element. She loved action and was first in line for anything that involved running, jumping, or balancing.

Bobbin and Candy had a litter of five puppies in 2004. I kept a female and named her Penny—Penny Candy. The sweetest of all my dogs, Penny was a stunning and incredibly patient model from the very beginning. She was small like her mother and pretty as a picture. When she was six she was diagnosed with lymphoma but with treatment lived well for two more years. During this time we got a new puppy, Flo, to keep her company. Flo watched attentively as Penny and I worked and she was standing by when Penny posed for the cover of *National Geographic* magazine. Commissioned to illustrate a cover story about the importance of the dog genome in research, I used an assortment of wigs and fabric and other paraphernalia to transform Penny into as many dog breeds as I could think of, a seemingly unending project with Penny my untiring collaborator.

I first met Flo in 2011 when Beth and Brian Meany brought her and her five-week-old sisters Stella and Mabel to my New York studio to be photographed for a puppy calendar. Of the three, Flo seemed especially interested in working. She grew to remind me of Fay with her intensity and her desire to please. How am I doing? Is this what you had in mind?

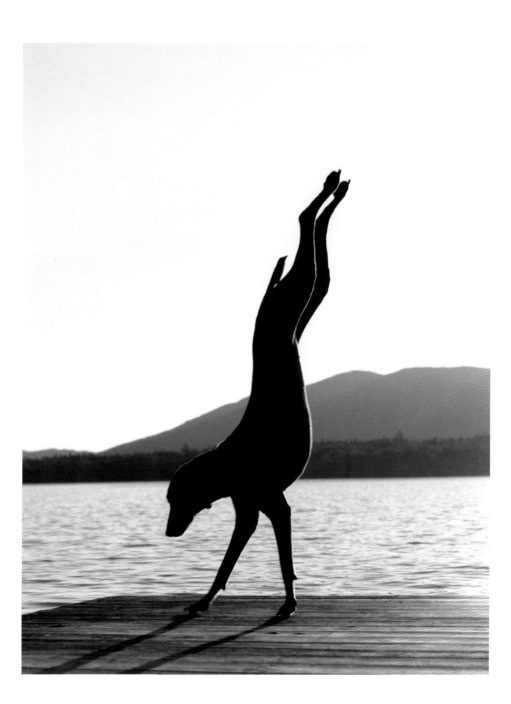

Handstand, 2011

But Flo was a bit too much for Bobbin and Candy, who were well into their senior years. She needed someone closer to her own age to play with. And that would be...Topper!

Flo's half-brother Topper came to me to be photographed, just as Flo had, when he was five weeks old. Flo was smitten. She couldn't take her eyes off him and I decided she should have him. By the time he was one year old, Topper had eaten, and had surgically removed, a doll's leg, my daughter's sock, and a dangerously large number of sticks. Fortunately, he outgrew this habit of eating anything and everything and went on to become a stellar subject and a wonderful companion to Flo and to us. Topper is the prettiest of the boys I have photographed, tall, lithe, and attentive. His carefree elegance complements Flo's psychic intensity. In the studio their eyes are always on me. I like that.

Who will follow Topper? Is this the end of the road? If so, it's been a long and winding one with eventful twists and turns, surprising detours and entertaining roadside attractions. I have loved working with all these dogs and can't imagine a life without them.

# Acknowledgments

I would like to thank, first and foremost, William Wegman, who liked my idea and let me loose in his files, both material and virtual. Secondly, my heartfelt thanks to Christine Burgin, who shared our enthusiasm for the book, and helped to pull it together while offering insightful criticisms. The final form of the book was very much a collaboration between the three of us, aided at every stage by Jason Burch, the rest of the team at the Wegman studio and the team at Thames & Hudson, who, under Commissioning Editor Andrew Sanigar, did their utmost to produce a publication of the finest quality. Lastly, a word of thanks to Todd Brandow of the Foundation for the Exhibition of Photography, whose Polaroid Project sent me to the Wegman Studio in the first place. Lastly, a profound thanks to the "people" pictured on these pages: we can all learn from their patience, discipline, and creativity.

W. E.

# Index: A Guide to Who's Who